que vous eut entendu dans le sens la ... vous avez en même
effet de votre phrase, était de me faire à l'instant fenêtre et de l'avaler dans un verre d'eau ... de cela ...
honneur le plus authentique. mais persuadé comme je le ... comme je le suis
qu'il est physiquement impossible que ma détention soit éternelle par mil raisons
qu'il serait trop long de détailler ici, dont la meilleure de toute est, qu'avec une
prison perpétuelle le jugement était parfaitement inutile et que s'il y eut du
suivre une prison perpétuelle ce même jugement a supposer que malgré cela
n'eut voulu aurait été infiniment meilleur. persuadé dis-je de ce raisonnement
certifié à moi là bas par mrs: Simeon, Rainaud, Gautteridi, en l'avocat général
et Mr du Bourguet mon rapporteur je me suis contenté de dire en voyant milli vouloir
tirer pour grande ressource un moyen qui ne s'employe jamais que dans les affaires
les plus terribles et les prisons perpétuelles les mieux constatées. Voilà une amie qui
m'abandonne qui devient l'écho et la marionnette de mes tirans et qui d'avance
et honnête. quelle était devient et bien traitre et bien fourbe. oui mademoiselle
voila ce que j'ai dit en arrosant si vous voulez ce dis cour de quelques larmes non de
crainte elle était bien nulle en l'honneur dans le cas la ... mais de regret de voir une
amie se charger volontairement de me donner un coup de poignard aussi sensible,
et croire que les vaines séductions de mes bourreaux pourroient la dédommager d'un
un malheureux qui se plaisait à l'aimer comme sa soeur.
ne femme et mes enfants se jetter aux pieds du roi mais scavez vous mademoiselle
que je les aime assez en entrant la pour preserver peutetre une prison perpétuelle
un deshonneur certain dont une telle manoeuvre les couvrirait à jamais croyez vous
me de montreuil une imbecile une femme capable de vouloir perdre ses petits enfants
et qu'en sortant de mon jugement elle n'eut pas plutot armé cinquante hommes s'il
eut fallu pour me rendre libre à cette époque la que de compromettre pour y reussir
et sa fille et ses petits enfants. une femme du nom de me de sade se jetter aux
pieds du roi avec ses enfants ah! scavez vous mademoiselle que cest une chose
qui serait consignée dans l'histoire que cela et que chaque règne n'a pas un pareil
fait ... celui de louis 15 n'en offre qu'un un de lali mais je suis bien bon
perdre mon temps a refuter une pareille chimere ... qui ne doit son existence
par la vile complaisance que vous avez en pour ceux qui me persecutent et qui vous
auront dit mandez lui cela ca sera charmant ca lui faira bien tourner la tête
et se transport mademoiselle ne lui pas en la tête que ce bien fait mal .. cest
un peu plus bas ... (comme vous disiez dans des temps plus heureux) oui cest la que le
coup en porté et d'une maniere bien sensible se lit par une piquure que cela en
fait cest une trainée et le venin dont était infecté le poignard qui la faite en
rendra la blessure incurable.

*Donatien Alphonse
François de*

Sade

Dedicated to the memory of Xavier de Sade,
and of his wife, Rose, too soon departed.
To Pierre Cardin, for his contagious enthusiasm.
To Pierre Leroy, for his much appreciated help.
To Donatien, who will understand why…

Front endpapers: Letter written by Sade to his uncle the Abbé de Sade.
Photo © Collection Pierre Leroy.
Back endpapers: Letter written by Sade to his wife during his years in prison.
Photo © Collection Pierre Leroy.

© 2014 Assouline Publishing
601 West 26th Street, 18th floor
New York, NY 10001, USA
Tel.: 212-989-6769 Fax: 212-647-0005
www.assouline.com
ISBN: 9781614282020
Design by Cécilia Maurin.
Color separation: Planète Couleurs (France)
Printed in China.
Translated from the French by Christopher Caines. All translations of
quotations from the works of Sade and other authors have been made
by the translator especially for this volume.

JEAN-PASCAL HESSE

Donatien Alphonse
François de

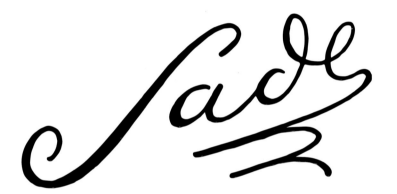

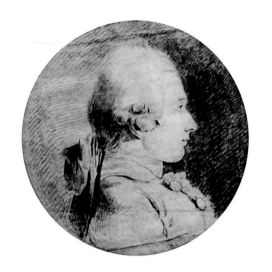

ASSOULINE

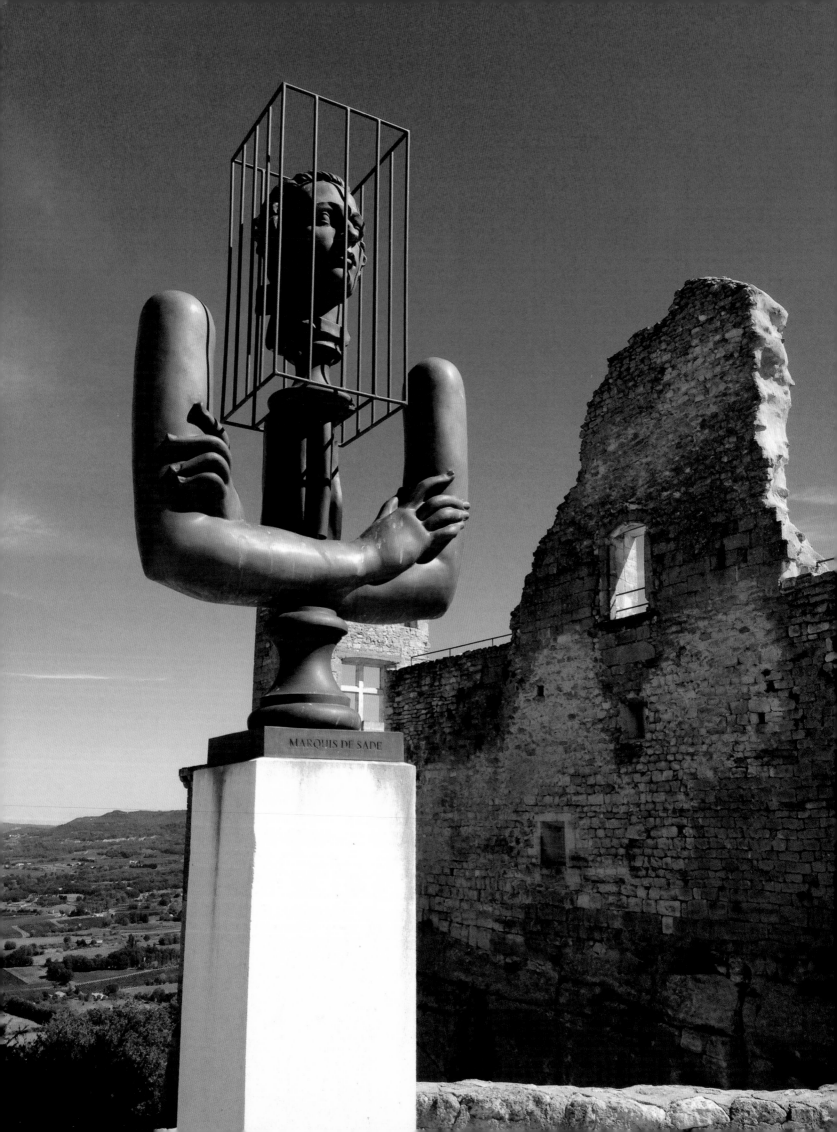

Previous pages: Profile of the Marquis de Sade c. 1760, by Charles-André van Loo.

Opposite: Bronze sculpture by Alexander Bourganov installed on the esplanade of the Château de Lacoste, 2008.

PREFACE

I t was just after the war that, as very young newlyweds, my husband and I arrived at the Château de Condé-en-Brie. We found the château, the Sade family seat, whose last occupants had been the German army, abandoned to wind and weather, uninhabitable, devastated by yet another in an endless series of invasions. Standing at the confluence of five valleys, the château had seen every war that had ever led the armies of Europe to Paris. Originally a Gallo-Roman villa, then a feudal castle, seat of the Coucy, Luxembourg, and Bourbon-Condé families, the château had known such figures as La Fontaine and Richelieu, Oudry, Servandoni, and Watteau, among others.

We thought that our life would consist of restoring this jewel while starting our family. We could not imagine that our personal story would turn out to be different—very different—after the Marquis de Sade burst upon the scene. And he had come to stay. Such a totally overwhelming eruption in our lives was entirely unexpected. But one day a man arrived in Condé, a poet, a writer, an impassioned devotee of the Marquis de Sade: Gilbert Lely. He soon infected us with his passion.

The Marquis de Sade was at the time totally unknown to us. We recalled hearing only one story: A few years before the war, another writer similarly obsessed, Maurice Heine, had come to Condé to talk about Sade. He was told in no uncertain terms, "Don't speak about him, and above all not in front of the children and the servants!" The Marquis de Sade, as we were to discover, had disappeared from the family's history after his death in 1814. Ever since,

6

an absolute taboo had held the family in its grip: Sade did not exist, and some even claimed that he had never existed, that he was a mythic figure created out of whole cloth in order to frighten people. Barely twenty years of age, we could not grasp that we were about to embark on a journey that would direct our life toward experiences and horizons we could never have imagined.

Lely was thus the first to open the trunks where, for more than a hundred and thirty years, the Marquis de Sade's manuscripts had lain dormant. In so doing, he had opened the strange Pandora's box that Sade's correspondence was and still remains, revealing Sade the man, the writer, and the prisoner. His letters enable us to discover the real man behind the myth.

Day after day, year after year, thanks to our reading of his correspondence, we discovered a man at once astonishing, provocative and ironic, extravagant, ahead of his time, violent and tender; a man who, with his brilliance, swept all before him, under the monarchy, the Revolution, Napoleon's Consulate and his Empire—and who, under all these regimes, was a political prisoner. Step by step, he was led to engage in a relentless struggle against injustice and for liberty—for freedom absolute, uncompromising, extreme.

Finally, thanks to the vast research of historian and writer Maurice Lever, we came to know a man who became ever more fascinating, enthralling, the more we read, a man who destabilized and even dismantled the established order but who in his suffering, his isolation, seemed so close to us, a man who seemed always "alone against the entire world"—an indomitable man who hated compromise, whom nothing could stop, whom nothing and no one could ever lay low.

From this time on, we felt the need to defend against one and all this man who was so different from ourselves. What paths littered with obstacles awaited us, what painful confrontations with his writings, what shocks oftentimes— for no one ever emerges unscathed from reading Sade. He carries you along with him, so far—too far!

We resolved nonetheless to fight for him. Not to make excuses for him, not to cover him with some sort of veil, but to speak: to speak the truth, the whole truth, and nothing but the truth, without censure or censorship, rejecting

nothing, forgetting nothing. We wanted to avoid the lies and the exaggerations of those who want a Sade in accordance with their own aspirations. As the Fourth Republic was drawing to a close, at the dawn of the Fifth Republic, while the events of May 1968 were not yet imaginable, we found ourselves compelled to confront a man whose thinking has continued to trouble minds across the centuries, whose ideas were capable little by little of inflaming and devastating the most tranquil souls.

In order to get to know him better (or as we would say, to *feel* him), we also recovered his Provençal roots, in Avignon, Aix-en-Provence, Saint-Rémy-de-Provence, Carpentras, Mazan, Saumane—and Lacoste. Lacoste, Sade's treasure, his refuge, his breathing space, his realm of liberty. Lacoste, a dark silhouette tattered at the edges (like Sade's soul), perched on the somber bulk of the Luberon Massif—black on black, and yet so luminous. Lacoste came back to life, around Sade, and with him. From the Provençal seigneur of the eighteenth century to the dominant tutelary figure of the twenty-first, Sade still seemed to reign—he who consecrated himself to the shadows.

On the threshold of the twenty-first century, we knew that our battle for Sade was legitimate, and that it had been won, for a Sade who belongs to us, who is close to us, and who we understand better—a little. Thus, Sade writes on the subject of his art, "Woe be to the low, dull writer who, seeking only to flatter fashionable opinion, renounces the energy that he has received from Nature to offer us nothing but the incense he burns complacently at the feet of the party in power." Regarding the subject for which had the greatest predilection, Sade notes in *The Crimes of Love,* "I repeat: Never will I depict crime but with the colors of hell; I want it to be seen naked, to be feared, to be detested, and I know no other way to achieve this than to show it with all its characteristic horror. Woe to those who surround it with roses!" And finally, in *Philosophy in the Bedroom,* he declares, "I expound the ideas that since the beginning of the Age of Reason have been identified with me and that the despicable despotism of tyrants has opposed for so many centuries. Too bad for those whom these great ideas would corrupt, too bad for those who, liable to be corrupted by anything at all, know how to extract only evil from philosophical opinions!

Who knows but that they might not contract gangrene from reading Seneca and Charron? It is not at all to them that I speak: I address only those capable of hearing me, and *they* will read me without danger."

This is the Sade we had come to know—from the fortress of Vincennes to the Liberty Tower at the Bastille, from Lacoste to Charenton. The Sade who had, secretly, left his mark on all the writers of the nineteenth century, and, openly, on every artist of the twentieth, from Dalí to Bellmer, Éluard to Cocteau, Flaubert to Aragon, Jarry to Camus, Buñuel to Dubout, Apollinaire to Verlaine and Baudelaire, among others.

This book by Jean-Pascal Hesse takes its place in that lineage. A devotee of Sade who loves Lacoste, he is for me a true "Sadist"! This is why I agreed, for his sake, to write this preface, while my husband—who, as Sade's biographer Maurice Lever wrote, quoting the marquis, has like "the eagle regained the 'seventh region of the air'"—holds this pen along with me. And that is why, out of friendship, for the first time ever, I have recounted a little about our lifelong battle on Sade's behalf, waged as a couple, and as a family.

Comtesse de Sade

INTRODUCTION

"The final revelation is that Lying, the telling of beautiful untruths, is the proper aim of Art."[1] Donatien Alphonse François, Marquis de Sade, is one of the masters of the imagination and fantasy. He has come down to us as a man of letters, a novelist, a philosopher, and a man of politics (in the primary sense of the term).

Yet to undertake a thorough and detailed study of the Marquis de Sade is difficult; one soon discovers that, despite the zeal of his biographers, his life and his career remain largely unknown. There is no absolutely authentic portrait, only mediocre descriptions by third parties. It is often therefore necessary to have recourse to legal documents, which can be subjective. This situation encourages an aura of mystery around the figure in question. Since the truth is hard to ascertain, he becomes the subject of inventions, dreams, fantasies.

One of the essential characteristics of Sade's life is that he spent much of it confined, as a recluse, a prisoner, an inmate in a mental asylum. He wrote constantly, producing thousands of pages, but the bulk of his writings were lost or destroyed. Time and human intervention have left us only part of his oeuvre: His periodic imprisonment enabled the authorities to confiscate his writings and scatter them to the four winds. On July 14, 1789, the fall of the Bastille, a great part of his masterpiece, *The 120 Days of Sodom, or, The School of Libertinism,* was said to have been lost (most of the novel exists only in outline). Michel Foucault liked to quote Sade's remark that, on account of this, the marquis wept "tears of blood."[2] As for the essence of his writings, Sade's appeal to the reader's senses and emotions constitute for some a kind of incitement—at least to the form of sexual stimulation caused by frequent reading of his work.

Stylized profile of the Marquis de Sade by Roberto Di Costanzo, 2013.

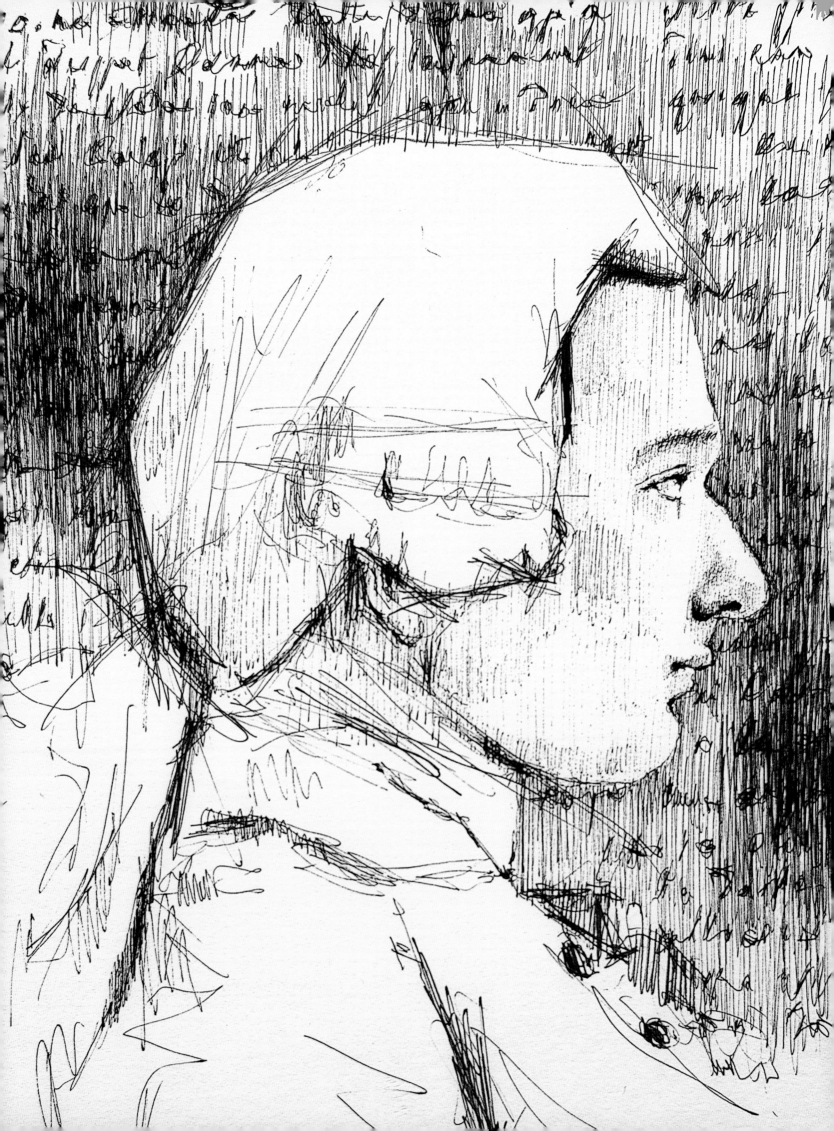

Atheist, disciple of a fierce eroticism, drawn in his imagination and/or in real life to acts of violence and cruelty, Sade remains a kind of hero outside normal bounds, in a genre little represented in French literature. Over the centuries, a number of authors (Boccaccio, La Fontaine, Diderot, Apollinaire, and Aragon, among others) have devoted themselves to such exercises, either under their own name or a nom de plume. Overall, however, such texts have remained within the realm of the scatological or the transgressive. Sade is without doubt the first man of letters to have sought to make this an accepted genre.

Sade exercised the seigneurial rights common in his period, enjoying almost unlimited power over the bodies and minds of those who served him. Ultimately, he behaved no better and no worse than many other feudal lords—but he wrote about what he did. Psychoanalysis, nearly a hundred years later, would borrow his name to label a syndrome.

Often referred to as "the Divine Marquis" (in memory of Pietro Aretino, a sixteenth-century Italian author of books that were also libertine), Sade based his texts on reasoned arguments that most often held up to derision the society of his time and its most cherished symbols, marriage and religion. The nineteenth century, prudish and devoted to upholding moral order, sought as much as possible to suppress Sade's writings, considering them fiendish, and it succeeded. The first part of the twentieth century, preoccupied with absorbing the crushing impact of two world wars, did likewise. But in the 1950s an extraordinary publisher, Jean-Jacques Pauvert, reprinted Sade's complete works despite the objections of bigots and conservatives. Brought to trial in 1957 for publishing obscenity, he won on appeal. Gaulism, then ascendant, preferred "official" writers such as André Malraux and Maurice Druon, yet it succeeded no more than had the Fourth Republic in silencing Sade. His little books, bound in green covers, were bought and shared. In the 1970s and '80s, Foucault's courses at the Collège de France, and the subsequent publication of some of the recovered "lost" works in the Pléiade collection in 1990, restored Sade's reputation as an author.

Some writers create archetypal characters: Aragon's Aurélien, Hugo's Cosette, Defoe's (and Michel Tournier's) Robinson Crusoe, Camus's Meursault. Yet Sade *himself* is a literary archetype, whose presence weighs so heavily in French history

that he has lent his name to a type of literature and of sexuality: sadism—a synonym for evil, perversion, cruelty, a word translated into many other languages. And yet, what kind of man was Sade, really? A soldier and a libertine who presided over a Jacobin faction; a man of letters; a playwright and stage director; a fugitive from justice; an inmate of the Charenton asylum; a descendent of an august lineage who, understandably, sought to perpetuate his name and his blood.

Sade was descended from the *noblesse d'épée,* ancient feudal families whose ancestors carved out their place in society with the sword. Sade was nonetheless attracted by the bourgeois spirit of the Age of Enlightenment: He created the concept of "healthy pleasure" and strove (without succeeding) to find an ideological ground for cross-class alliance. He concluded that the interests of the master and of the slave were irreconcilable. The paradigm of this theory provided the basis for *The 120 Days of Sodom.* We cannot help but feel fear before this man of extremes and extremism. As Simone de Beauvoir writes, "To confront injustice as such is to recognize that there is another justice, to call into question one's life and oneself."[3] In the end, Sade succeeded, as much through his incendiary writings as by his scandalous life, in making his way through a particularly rich period in French political life, the Enlightenment and the Revolution, without ever attracting the least sympathy. Writer Henry de Montherlant liked to say, "Making friends is a pastime for shopkeepers... Making enemies is the recreation of an aristocrat!" With Sade, we are among the very high nobility.

Coat of arms and device of the De Sade family: a black double-headed imperial eagle with its wings spread, with red crowns, beaks, legs, and talons, in the middle of an eight-pointed yellow star, all on a red background.

1. Oscar Wilde, *The Decay of Lying—An Observation* (1889, revised 1891).
2. Lecture by Michel Foucault at New York University, March 1970.
3. Simone de Beauvoir, *Faut-il brûler Sade?* Éditions Gallimard, 1972.

> **"All human felicity lies in man's imagination."**

Imaginary portrait of the Marquis de Sade by H. Biberstein, "Sade Subjected to Devilish Incitements by the Four Winds," printed in a selection of Sade's works edited by Guillaume Apollinaire in 1912.

I

A LIFE LIKE A NOVEL
From the Hôtel de Condé to the Charenton Asylum

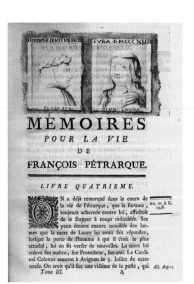

The story goes that in 1325 the Marquis de Sade's ancestor Hugues de Sade married Laure de Noves, famous for inspiring Petrarch and even becoming one of his muses. Whether this is true or not, Laure gave birth to eleven children and died of plague in 1348. As was the custom in such circumstances, Hugues remarried; his second wife, Verdaine de Trentelivres, bore him six more children.

At the grim fortress of the Château de Vincennes, during the torments of his imprisonment, in a letter to his wife dated February 17, 1779, Sade recalled Laure with these words: "My only consolation, here, is Petrarch. I read him with pleasure, with an avidity that can be compared to nothing else. But I do as Madame de Sévigné did with her daughter's letters: I read them slowly, fearing *to have read* them.... Laure makes my head spin; she makes me feel like a child; I read her all day long, and at night I dream about her."

The Sade family furnished Provence with officials lay and religious: provosts, canons, deputies. Prominent members included Jean de Sade, who in 1538 transformed the Château de Saumane into a fortress in order to resist attacks from his neighbor, the Baron des Adrets; the estate was already much coveted. Equally distinguished was Balthazar de Sade, an "illustrious and magnificent seigneur"; his son, Richard, vice-governor of Ravenna, became bishop of Cavaillon in 1659. In the fourteenth century, the Avignon popes also drew upon this noble family as the source of many a cavalry officer, naval captain, municipal official, and clergyman.

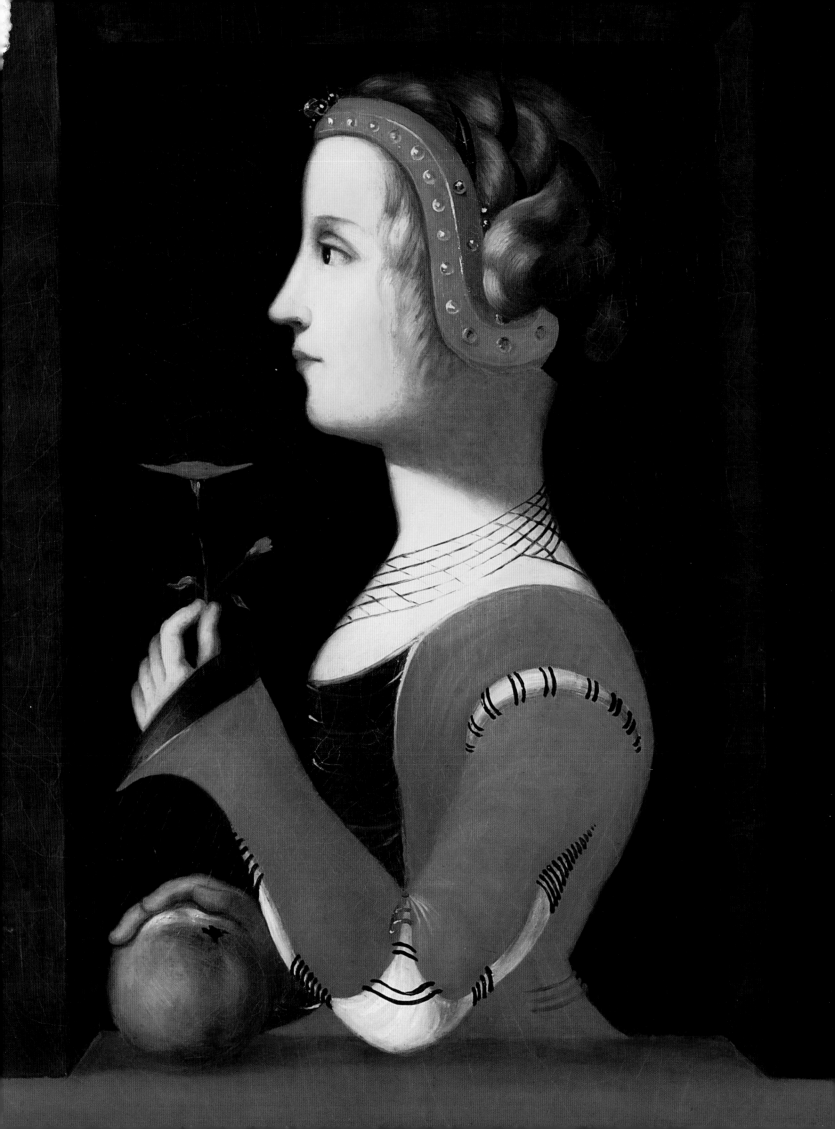

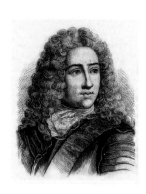

Gaspard-François de Sade, Donatien de Sade's future grandfather and a judge in Avignon, had three sons: Jean-Louis-Richard was a knight in the order of the Knights Hospitaller, a commander of the Order of Malta, then a bailiff and grand prior in Toulouse. Jacques-François-Paul, commendatory abbot of Ébreuil, in the Bourbonnais, known as the Abbé de Sade, would become the tutor of his nephew Donatien, whom he welcomed into his home when the boy was four or five years old. The abbé lived, unfettered and happy, in the Château de Saumane; very erudite, he was also deeply libertine. His career was brilliant. Finally, there was the youngest brother, Jean-Baptiste-François-Joseph, Donatien's father: soldier, diplomat, poet, philosopher, adventurer, and libertine, Donatien would owe much to him.

The brothers also had five sisters. One of them, Henriette-Victoire, wife of the Marquis de Villeneuve-Martignan, lived in a delectable mansion in Avignon (today the Calvet Museum), emblazoned with the family's coat of arms (with an eight-pointed star and a double eagle). While the four other sisters all joined one of France's most esteemed orders of nuns, this aunt, as we shall see a little later, would play an essential role in young Donatien's education.

It was at the beginning of the reign of Louis XV, around 1720, during the Regency, that Jean-Baptiste de Sade—barely eighteen years old, already a colonel in the papal light cavalry—left his home, the Château de Lacoste, the family estate near Avignon in the Comtat Venaissin. He moved to Paris, not only the capital of the French kingdom but also the largest city in Europe. There he found two protectors. One was Jean-Baptiste Arouet, otherwise known as Voltaire, who was close to Jean-Baptiste's brother François. The other was Louis-Henri de Bourbon-Condé, Duc de Bourbon, known at court as Monsieur le Duc, a member of the Regency Council during the minority of Louis XV, who would become prime minister in 1723, upon the death of the regent, Philippe d'Orléans.

Religion and religious bigotry weighed heavily upon the last act of the grandiose opera that was the Grand Siècle, as the aged Louis XIV, sick and remorseful,

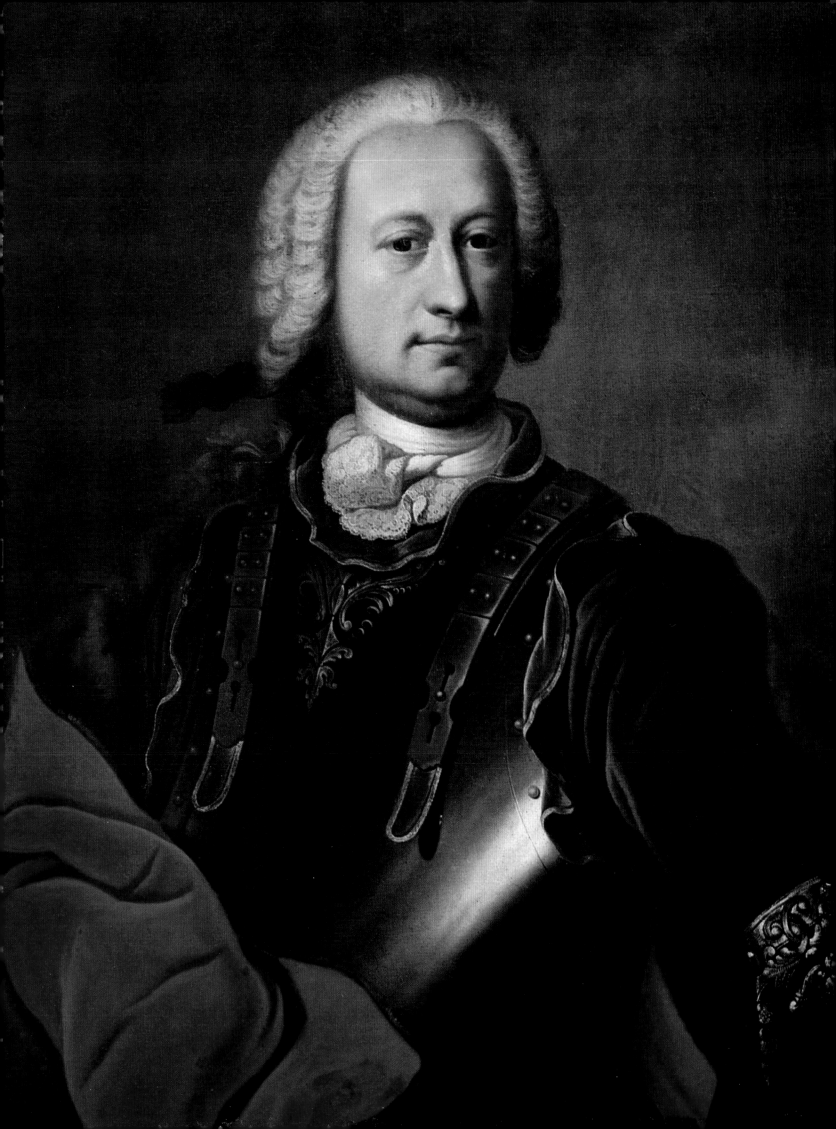

Copie d'une Généalogie
de la famille de Sade, Copiée sur
celle écrite au milieu du 18e Siècle
par le fameux Marquis de Sade
lui même —

Sur le dos de cette Généalogie en 8 pages
on lit: Généalogie Sade — par Mr de Baujin
Sur les originaux — plus bas on lit:

Généalogie de la famille, présentée
au Roy par Mr de Lauzun

" De Sade — au Comtat-Venaissin.

De gueules à l'étoile à 8 raies d'or
Chargée d'un aigle éployée de sable
Becquée onglé et diademé de Gueules.

La maison de Sade recommendable
par son ancienneté par les alliances,
et par les employs qu'elle a occupés
dans les cours des papes et des Comtes
de Provence doit particulièrement
la Considération dont elle jouit à la
Célèbre Laure, (dont on parlera dans
la Suite) qui a donné occasion à
plusieurs auteurs français, italiens, allemands

L'an 1177 selon nostradamus Page 145 L'on commença
a bastir le pont du Rhosne et la mesme année a cequy
rapporte le P. Theophile Reynaud en son Livre de St.
Benezet Louis de Sado Estoit Viguier de la Ville
d'avignon

L'an 1355 et le 15 Avril hugues de Sado second du nom
fils de Baul pour L'amour de Dieu et en consideration
du Pape Innocent Sixiesme a la requisition du Cardinal
d'ostie commis par Sa Sainteté donna 200 fl. d'or pour
la reparation du pont de St. Benezet comme Conste par
acquit public qu'illuy fut le Cardinal Evesque de frescati
deputé par le Pape pour recevoir cette Somme.

Cet hugues second eust entre autres enfants Audibert
et Baulet.

Audibert fut en 1358 Sacristain de l'Eglise de
Tarascon, En 1362 Doyen Administrant de l'Eglise
d'avignon, et en 1395 Il estoit Prevost de Pignans
et selon Nostradamus Page 485 Il assista l'adr'année
avec L'evesque de Sisteron pour les Prelats et le premier
ordre aux Estats de provence Soubs le Regne de Louis
2 Roy de hierusalem, Sicile & Comte de provence qui
estoit pour lors Soubs la Tutele de marie de Blois sa
mere.

Baulet fut Conseiller du Roy d'aragon l'an 1397
comme Conste par lettres patentes de ce Roy et en
1406 Il fut pourveu de l'Evesché de Marseille, Prelat
Si recommandable par ses rares qualités qr la Reyne
yolande d'aragon Veuve de Louis 2 et mere de
Louis 3 de laquelle Il estoit conseiller en 1419 confioit
entierement en luy, Il deceda en 1433 et fist son heritier
Le Chapitre de la majour sa Cathedrale

hugues de Sado Troisiesme du nom eust entre autres

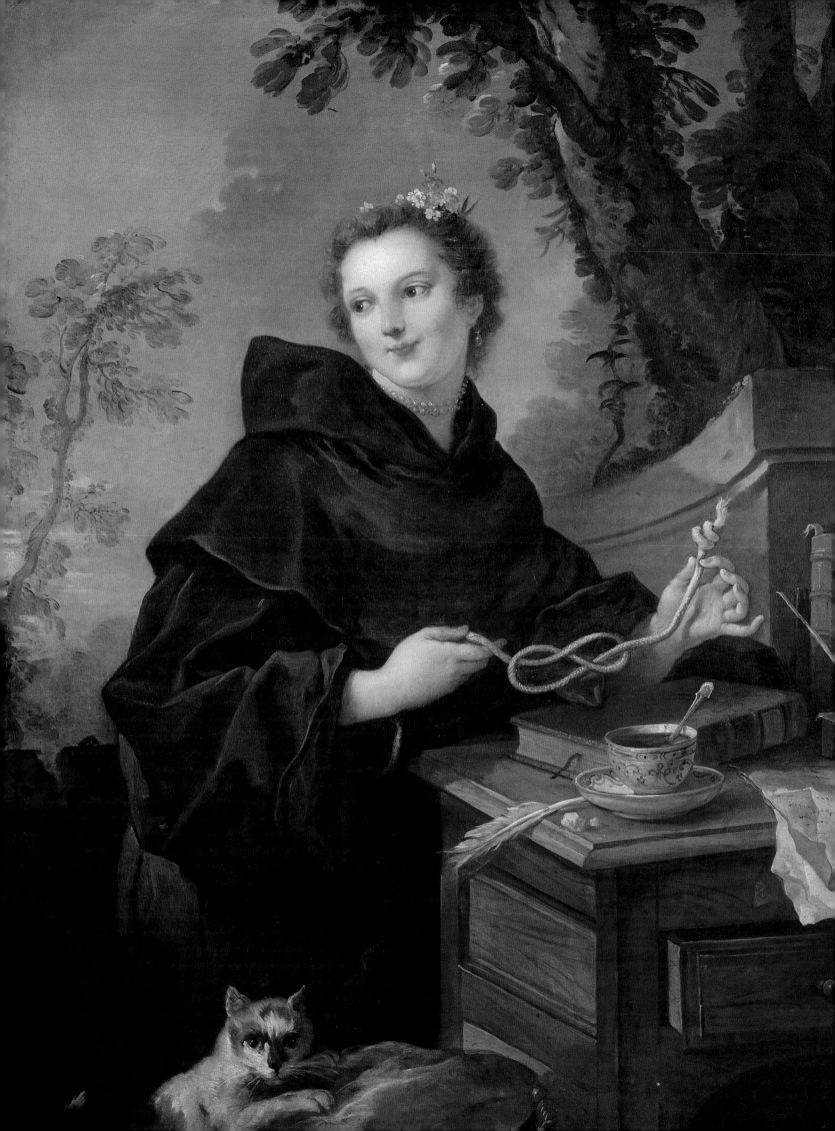

slowly withered away. Now, the court of the very young new monarch—Louis XV, the Sun King's great-grandson, acceded to the throne at age five—frolicked in the evenings in the gardens and beneath the arcades of the former Palais-Cardinal, thereafter called the Palais-Royal. It is easy to imagine Jean-Baptiste, later in years, regaling his son Donatien with countless libertine adventures that would inspire the future writer. The young Jean-Baptiste, energetic and predatory, wove himself a first-class social network. He loved both men and women; he knew how to write; he had wit. He became the lover of Mademoiselle de Charolais (1695–1758); the daughter of Louis III de Bourbon-Condé and Louise-Françoise de Bourbon, she had chosen a life of pleasure rather than submitting to the duties of her sex. She was called "Mademoiselle" at court, a much-coveted title to which in theory only a princess of the blood could claim a right. She liked to receive her lovers wearing only a Franciscan monk's robe, because it was easy to take off. She was also the mistress of her cousin, Louis XV, which earned her another much-coveted title, the "royal madam." Jean-Baptiste also had affairs with the Duchesse de Trémoille, the Duchesse de Clermont, and the young Comtesse de Condé.

Jean-Baptiste was one of the monarch's favorites, and became a captain of the dragoons in one of Louis's regiments, dividing his time between Paris and Chantilly, one of the loveliest châteaux in the Île-de-France. He was a member of the Condé family's court, where Monsieur le Duc himself was known for his fiendish debauchery—especially with his "handsome soldiers."

Jean-Baptiste was also close to the Argenson family, and in 1723 he was entrusted with diplomatic missions in Europe. In 1724, he was arrested by the police while in pursuit of a young man in the Tuileries Gardens. A few years later, in 1730, Jean-Baptiste was named ambassador to the Russian court at Saint Petersburg, and in 1733 to London. He was then thirty-two years old, and those close to him pressed him to marry. He decided to take the plunge. Jean-Baptiste was the lover of Caroline-Charlotte,

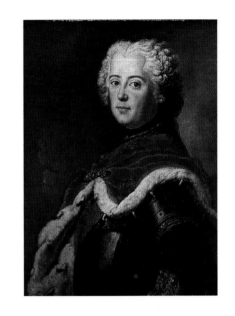

Above: Portrait of Frederick II of Prussia, known as Frederick the Great (1712–86).

Opposite: Portrait of Louise-Anne de Bourbon-Condé, known as Mademoiselle de Charolais (1695–1758), costumed as a monk and holding Saint Francis's rope belt (Charles Joseph Natoire, 18th century, Château de Versailles). In the gallery of Lacoste was an identical portrait of Mademoiselle de Charolais disguised as a Franciscan nun.

Below: Portrait of Louis XV, the Well-Beloved (engraving by Salvador after Rigaud; BNF-Paris).

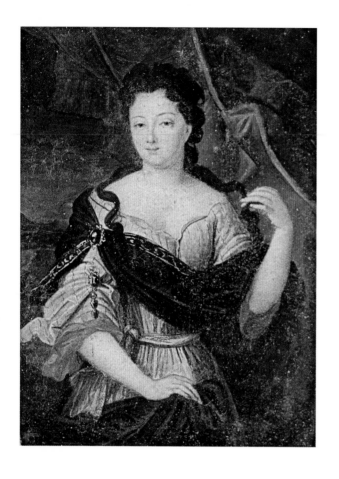

Above: Miniature on ivory sheet depicting Marie-Éléonore de Maillé de Carman (1712–77), mother of the Marquis de Sade.

Opposite: Collection of gouache portraits on ivory depicting the marquis's relatives. *(Left to right, top to bottom)* Françoise-Hippolyte-Leriget de la Faye, Marquise de la Tour-du-Pin (d. 1814); Jean-Baptiste-Joseph-David de Sade, Marquis de Montbrun (1749–1836); Françoise-Émilie de Bimard (1750–1832), wife of Jean-Baptiste de Sade d'Eyguières; Charles III François-Lucrecius-Henri de la Tour-du-Pin, Marquis de Lachau (1738–1806); Louise-Gabriele-Laure de Sade (1772–1849), the marquis's daughter-in-law, wife of his youngest son, Donatien-Claude-Armand de Sade (1769–1847), who is buried at the Château de Vallery in the Yonne; Louis-Marie de Sade, the marquis's eldest son (1767–1809).

Following pages:
(left) The Church of Saint-Sulpice (etching; Musée Carnavalet, Paris); *(right)* an engraved portrait of François-Marie Arouet, known as Voltaire (1694–1778).

the German child-bride princess who was Monseiur le Duc's second wife. In order to get around the problems posed by such a forbidden affair involving a family as powerful as the Condés while remaining close to his patron, Jean-Baptiste shamelessly conspired with his lover to marry the daughter of her recently deceased lady-in-waiting, a relative, a noble girl just fifteen years old: Marie-Éléonore de Maillé de Carman, a young cousin belonging to the Bourbon-Condé family's wealthy junior branch. The girl was named head lady-in-waiting to the princess, and the couple moved into an apartment in the Condé palace, a great privilege. But the nuptials soon gave way to bitterness: The marquis was fickle, bisexual, libertine—for his young wife, it was too much. In 1734, Jean-Baptiste become aide-de-camp to Marshal de Villars (1653–1734) who, though beaten at Malplaquet in 1709, had been victorious and saved the kingdom at Denain in 1712, both key battles in the War of the Spanish Succession.

The dialectic of the Enlightenment set villainy and puritanism side by side; there were immense fortunes to be made, and almost anything was permitted. The Enlightenment was the name chosen to describe their era by writers who called themselves *les Philosophes.* They expressed their ideas not only in drama, poetry, and novels, but also in pamphlets, letters, dialogues, theoretical treatises, and even dictionaries. The *Encyclopédie,* edited by Diderot and d'Alembert, is the ideal incarnation of the spirit of the age.

Among the Philosophes we find such writers as Voltaire and Diderot, jurists such as Montesquieu, mathematicians such as d'Alembert—members of both the rising bourgeoisie, much more prominent than in previous centuries, and the *noblesse de robe,* aristocrats elevated to the nobility by virtue of judicial or administrative posts. Rationalist, positivist, utilitarian, these thinkers sought clarity, reason, and first principles, with logical arguments based on simple truths and observed facts. Nature, created by God, leads men to live in society,

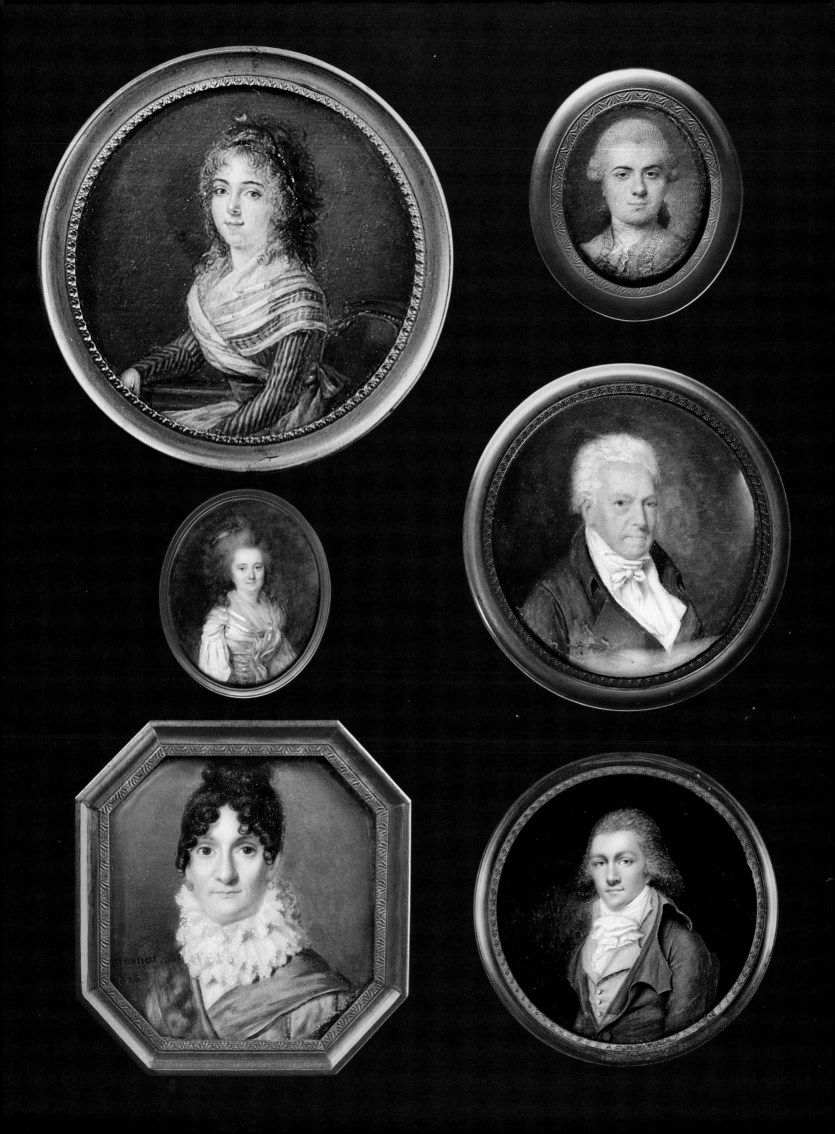

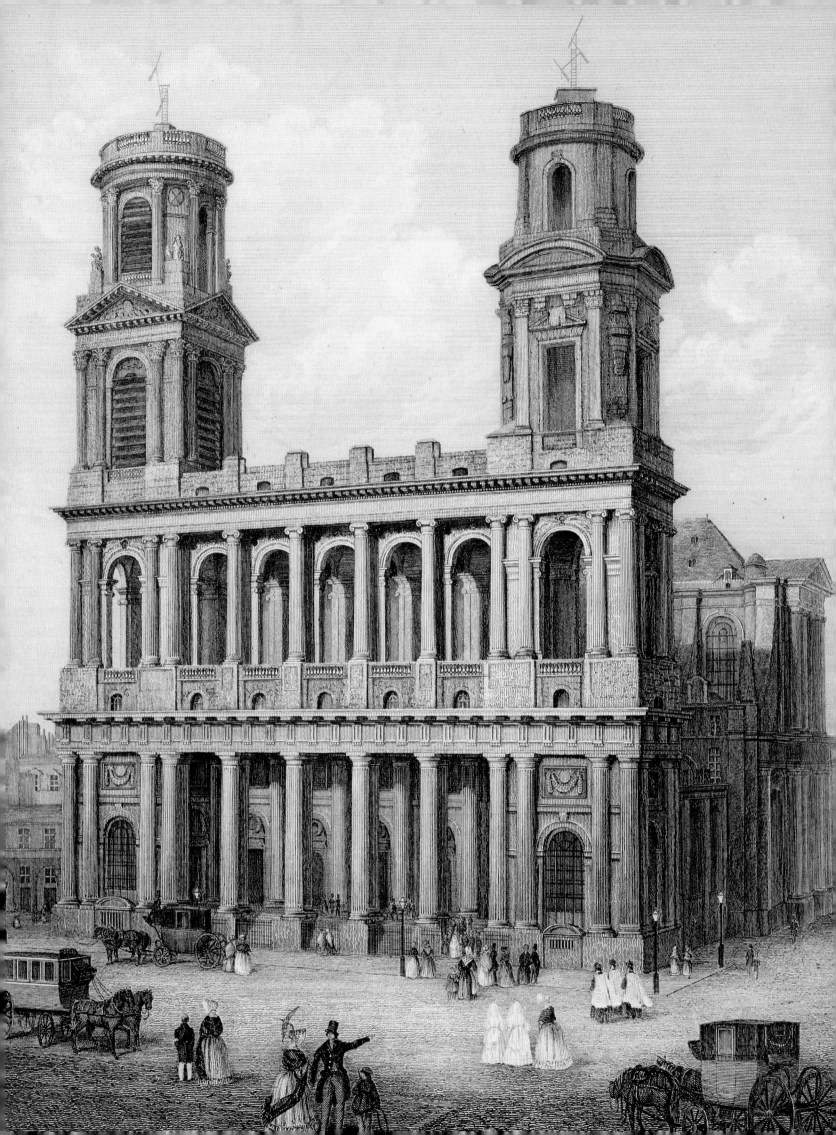

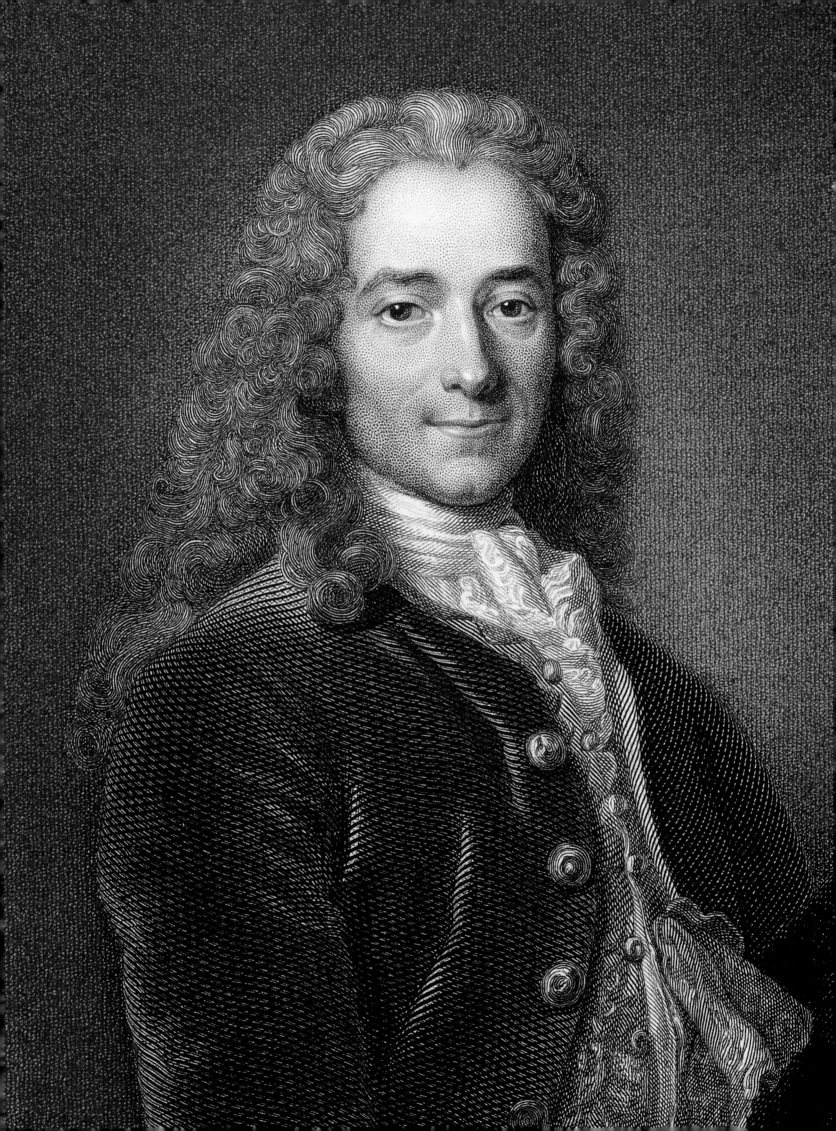

PRÉFECTURE DU DÉPARTEMENT DE LA SEINE.

N.º 1.
ETAT CIVIL.

VILLE DE PARIS.

DÉPT. DE LA SEINE. 75 C

Paroisse Saint Sulpice.

EXTRAIT du Registre des Actes de
Naissance de l'année 1740

Registre — 4.
folio — 71.

Naissance
de DeSade.

L'an mil Sept cent quarante Le trois Juin, a été Baptisé
= Donatien alphonse François, né hier, fils de haut Et
Puissant Seigneur Messire Jean Baptiste François, Comte =
: De Sade Lieutenant général des Provinces de Bresse, Bugey,
valromey et Gex, Seigneur de Mazan et autres lieux, Et de
haute et Puissante Dame Madame Marie Eleonore DeMaillé =
= DeCarman Son Epouse Demeurante hotel de Condé. —

Le Parrein haut et Puissant Seigneur Donatien De Maillé
Marquis de Carman Grand Pere de L'Enfant, Representé par
Antoine Bequelin officier de Monsieur Le Marquis De Sade
La Marreine haute et Puissante Dame Madame alphonse
Dartnand de Murs grand-Mere de L'Enfant Representée par
Silvine Bedie femme D'abel Le gousse officier de maison
Le Pere absent et ont Signé. Ainsi Signé au Registre
Bequelin, Bedie Legousse & Bertrand vicaire. /

Délivré

942

GREFFE
du Première Instance
du Dépt. de la Seine.

REGISTRE
Deuxième Minute
de l'État Civil.

Délivré par Nous Greffier en Chef du Tribunal de Première Instance du Département de la Seine, comme Dépositaire des Registres, secondes Minutes, de l'État Civil, en exécution de l'Article 45 du Code Napoléon.

Au Greffe, séant au Palais de Justice, à Paris, le trente un Janvier mil huit cent Onze.

Pinart

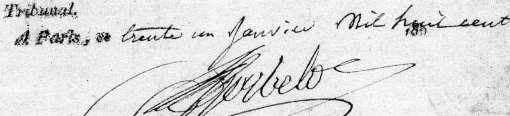

NOUS Président de la 2me Chambre du Tribunal de Première Instance du Département de la Seine, certifions que la Signature ci-dessus est celle de M. PINART, Greffier en Chef dudit Tribunal; en foi de quoi Nous avons fait apposer le Sceau du Tribunal.

à Paris, le trente un Janvier mil huit cent onze.

and our senses show us that we are formed for the pursuit of happiness—that is, of pleasure. Pleasure is moreover a right and selfishness the basis of morality. From this there follow a certain number of rules, including "Do not do unto others what you would not have them do unto you." Certain that the soul is immortal, the Philosophes advocated ideals of tolerance, charity, and humanity, and a degree of moral lenience. In their view, fundamental human rights should be guaranteed by hereditary rulers who ensure equality before the law, protection of persons through a reformed, less harsh justice system, and who resort to warfare only in cases of absolute necessity and legitimate self-defense. Finally, the Philosophes considered education—intellectual, physical, and practical—as a fundamental value.

Foremost among the period's greatest names is Voltaire, a restless scribbler who spent his time in Paris and at his estate at Ferney, near Geneva. A passionate advocate of liberty, he nonetheless drew part of his income from the slave trade. Adept at managing his contradictions, he was also a close friend of the Abbé de Sade, the future marquis's libertine uncle and mentor. Donatien would find another supporter in King Frederick the Great of Prussia, a benevolent sovereign, more or less enlightened despot, brilliant thinker, author of the famous 1740 treatise *Anti-Machiavel,* and homosexual. Frederick was evidently highly concerned with military reform, at a time when European armies were largely made up of boors and thugs. Donatien was thus born into an era steeped in the values of openness and curiosity; yet he would also devote himself to the search for pleasure—every kind of pleasure.

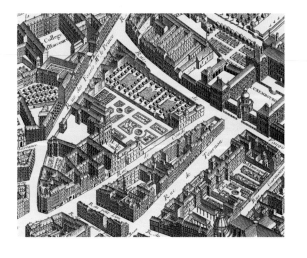

Previous pages: Birth certificate from the registry of births for Saint-Sulpice parish, Paris, recording Donatien's baptism in 1740.

Below: Detail of the great map of Paris by Michel-Étienne Turgot, showing a view of the Hôtel de Condé as it appeared c. 1736.

In 1737, Jean-Baptiste de Sade's wife gave birth to a girl, Caroline-Laure, who lived only two years. On June 2, 1740, Donatien was born in the Hôtel de Condé (today the site of the Théâtre de l'Odéon) in Paris. He was baptized the next day in the church of Saint-Sulpice. His parents being absent, their proxies managed to garble his intended forenames (Donatien-Aldonse-Louis), and he

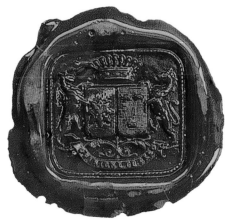

was christened Donatien-Alphonse-François instead. As an adult, he would become, like his father, seigneur of Lacoste and Saumane, as well as co-seigneur of Mazan. He belonged to the old nobility, a family that had held its title for many generations. Their coat of arms bears the two-headed eagle of the Holy Roman Empire, a privilege granted by Emperor Sigismund of Luxembourg (1368–1437) in Avignon in 1415, the year of the battle of Agincourt. The family's heraldic emblem is a black double-headed eagle, its wings spread, with red crowns, beaks, legs, and talons, in the middle of an eight-point yellow star, on a red background.

While his father styled himself the Comte de Sade, Donatien was given the title of marquis in his youth, a courtesy title that did not entail direct tenure of land, but one he would bear all his life, in addition to that of count, which he would acquire upon his father's death. (In theory, he could have borne the title of viscount while his father was alive.) In 1772, the parliament in Aix officially gave him the title Marquis de Sade. On her gravestone, his wife is called "Madame Renée-Pélagie de Montreuil, Marquise de Sade." In 1789, when Sade was confined in Charenton, he was referred to as the Comte de Sade, which was also the title used after his death in 1814. It is worth noting that, starting in 1800, he signed his name "D.-A.-F. Sade" and that his will was headed "Donatien-Alphonse-François de Sade, man of letters."

Donatien's early childhood was spent in the Hôtel de Condé, largely in the absence of his father (not uncommon in this period), since, following the death of his patron, Jean-Baptiste had been named minister plenipotentiary to the court of the Elector of Cologne. As a child, Donatien played a great deal with Louis-Joseph de Condé, his elder by four years, who was in effect his foster brother and mentor. The young prince had himself lost his father in January 1740, and had as his tutor an uncle, the Comte de Charolais, a man who could be considered debauched. The two boys were raised, if at all, by Madame de Roussillon, who was little inclined to education. Described as tyrannical and quarrelsome, the boys fought "like paupers." Early on, Donatien is described as violent, bad-tempered, and despotic.

Above: Seal of the Sade family.

Following pages: (left) Memorandum from the Seigneur de Saumane (presumably at this date the Abbé de Sade, the marquis's uncle) regarding a dispute over land tenure with his tenants in 1770, with notes and corrections in the marquis's hand; *(right)* the façade of the Château de Mazan, in the Vaucluse, built c. 1720. It was at Mazan that the marquis produced the first-ever theater festival in Provence, in 1772. The château remained the property of the Sade family until 1850.

MÉMOIRE

POUR RÉPONDRE A UNE CONSULTATION

DONNÉE EN FAVEUR

DE LA COMMUNAUTÉ DE SAUMANE

QUI DISPUTE LA FONCIALITÉ A SON SEIGNEUR.

LA Communauté de Saumane, mal conseillée, a entrepris de disputer au Seigneur la Foncialité. Il vient de paroître en sa faveur une consultation datée du 30 Mars 17?, sous le nom de Mrs. B... D... & J..., trois Avocats du Parlement d'Aix, qui jouissent dans leur état d'une réputation bien méritée.

L'objet de ce Mémoire est de répondre à cette consultation. On ne sauroit le faire sans démontrer qu'une production aussi foible (~~pour ne rien dire de plus~~) ne peut être l'ouvrage des hommes célebres, sous le nom desquels on ose la faire paroître. Ce Mémoire servira en même temps pour instruire ~~les Juges~~, devant qui l'affaire doit être portée. *la cou*

L'Auteur qui n'est pas Avocat, comme on le connoîtra aisément à son style, a besoin de toute leur indulgence. Il n'auroit pas entrepris de traiter sous leurs yeux une matiere aussi importante, s'il n'avoit senti qu'il seroit ridicule d'employer le ministere des Avocats pour répondre à un écrit qui ne peut être sorti que du cabinet obscur de quelques Praticiens du Comtat, qui osent porter *és de cette* le nom d'Avocats, & exercer cette profession sans avoir la plus légere teinture du Droit. Voici le fait sur lequel roule la cause qui a donné lieu à la Consultation.

Le Seigneur de Saumane n'a pas cru devoir employer le ministere des Avocats pour répondre à cette écriture une simple exposition du fait suffira pour faire connoître qu'on n'auroit pas dû 526 ont embarquer une Communauté pauvre et illitérée dans un pro où elle plaide contre l'évidence et contre son propre intérêt.

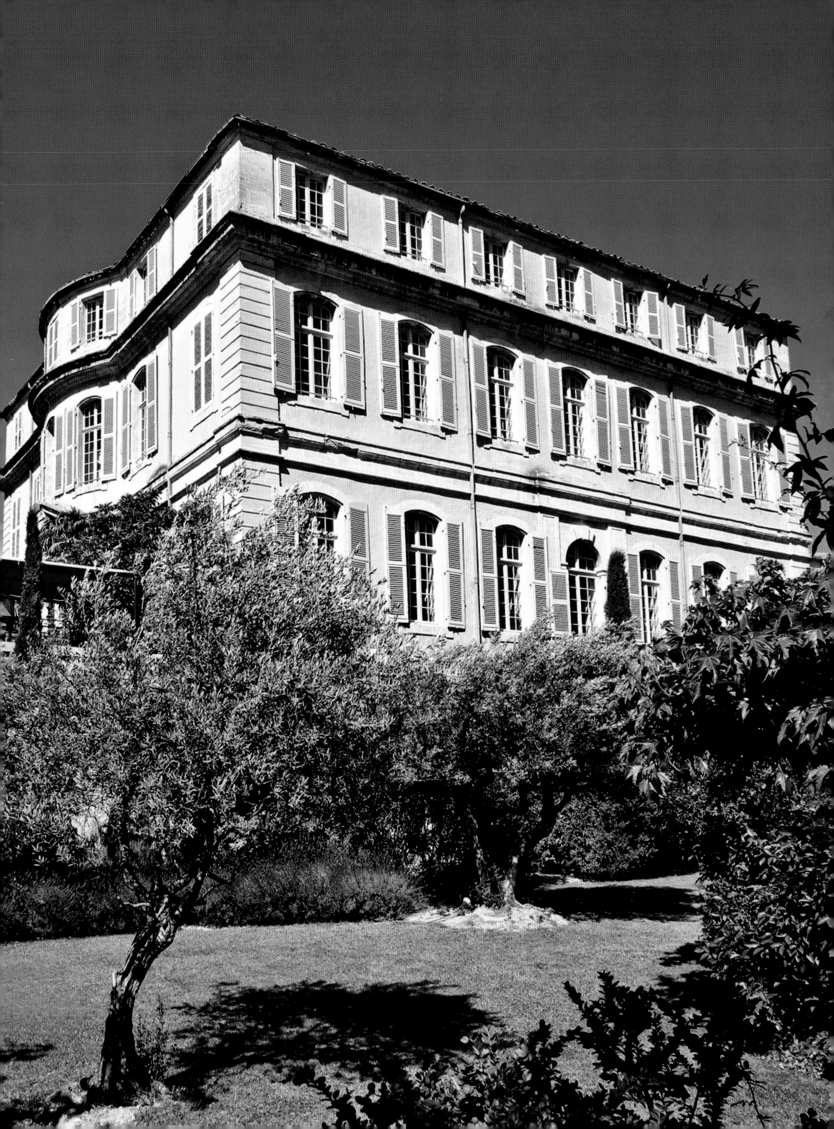

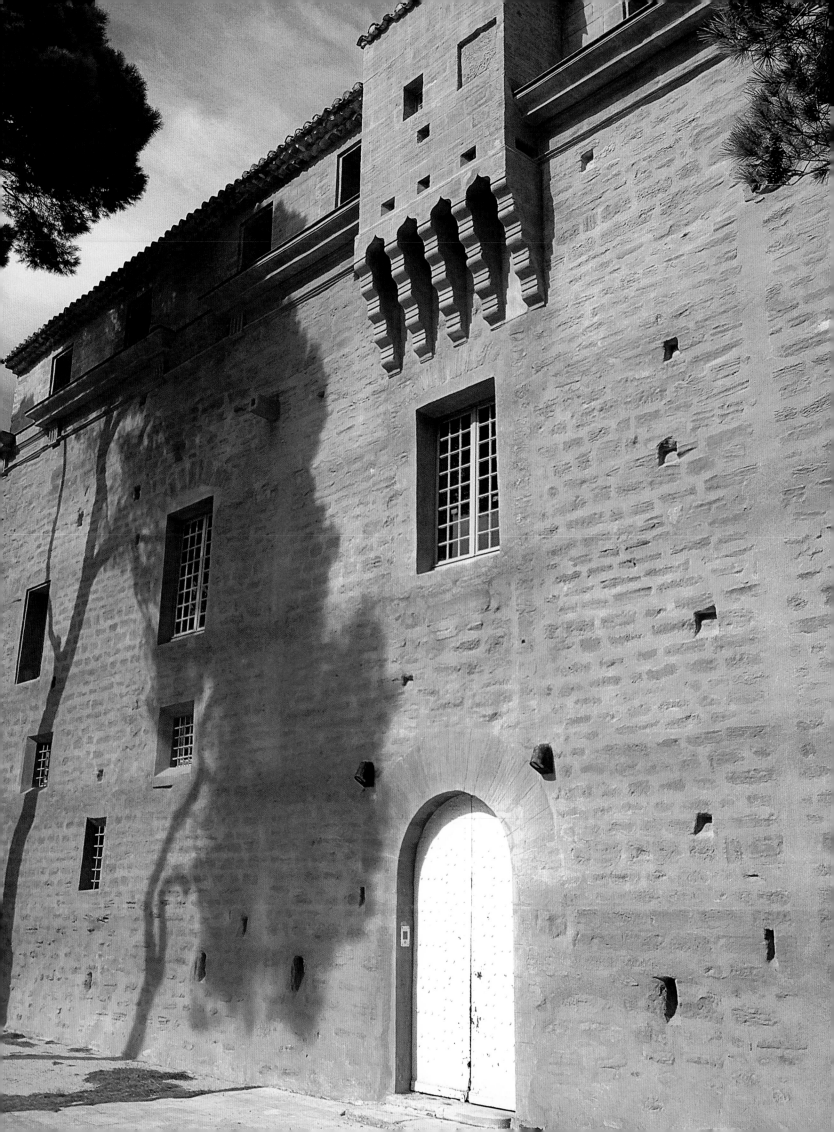

Salle Basse

Primo Six rideaux ————————— 24 tt:
Douze Chezes ———————————— 9 tt:
3. Chezes sans bras ————————— 1 tt 10:
2 bancs ——————————————— 4 tt:
Douze Caquetoires ————————— 6 tt:
Une Jante tapisserie bergame ——— 90 tt:
Un Coffre noyer —————————— 16 tt:
Une toylette velours vert ————— 5 tt:
Une Robbe de Chambre —————— 4 tt:
Un manteau de Cabelot bruxelle —— 39 tt: 15 β°

 199 tt 5 β°

Plus autre manteau Cambelot ———— 18 tt:
Un habit serge a la princesse ——— 12 tt:
2 habits drap d'Espagne —————— 24 tt:
2 juste Corps noirs ————————— 16 tt:
3 paires bas de soye ———————— 6 tt:
1 Lict de repos sans Cheuet ——— 5 tt:
1 tapis bergame demy usé ————— 1 tt: 5:
1 autre tapis fort vieux ————— 1 tt:
1 teste a perruque ————————— 1 tt:
1 malle ———————————————— 1 tt: 4:
6 Chezes peintes bois saule ——— 1 tt: 10:
1 Caisse sapin ————————————— 3 tt:

 101 tt 19 β:

Cuisine

Primo Une pastiere ———————— 3 tt:
1 tamis Et 1 Crible ———————— 0 tt: 10 β:
6 Chezes bois saule ————————— 1 tt: 10:
1 quintine siege Et fioles ——— 1 tt: 10:
2 porte assiettes ————————— 0 tt: 15:
1 hais de Cuisine ————————— 0 tt 3:

 4 tt 8 β:

308 tt 12 β 0

30 tt 8 β

Sade described his childhood thus: "Linked, through my mother, to all that was great in the kingdom; tied, through my father, to all that the province of Languedoc had to offer of highest distinction; born in Paris in the lap of luxury and abundance, I believed, as soon as I was old enough to reason, that nature and fortune united to shower me with their gifts; I believed this, because I had foolishly been told so, and this ridiculous prejudice made me haughty, despotic, and choleric; it seemed to me that everything must yield to me, that the whole universe must flatter my whims, and that it was up to me alone both to form and to satisfy them; I will describe to you just one aspect of my childhood, in order to convince you of the dangerous principles that were so ineptly permitted to sprout in me.

"Born and raised in the palace of an illustrious prince whom my mother had the honor to serve, and who was about my own age, I was urged to become friends with him, so that, having known him since my childhood, I would be able to count on his support throughout my life; but my vanity at the time was such that I as yet understood nothing of these calculations and, becoming angry one day during our childish games because he was fighting with me over something, and all the more because, with his great titles, no doubt, he thought he had the right to do so because of his rank, I took my revenge for his resistance with a great many blows, while no consideration of any kind could stop me, and nothing but force and violence could succeed in separating me from my adversary."[1]

The little boy was judged "difficult" and sent to Provence. His father hoped that, in leaving the Condé mansion, he would adopt a more realistic view of life. He arrived in Avignon on August 16, 1744. At first he was put into the care of his paternal grandmother, Louise-Aldonse d'Astouaud de Murs, who lived in the

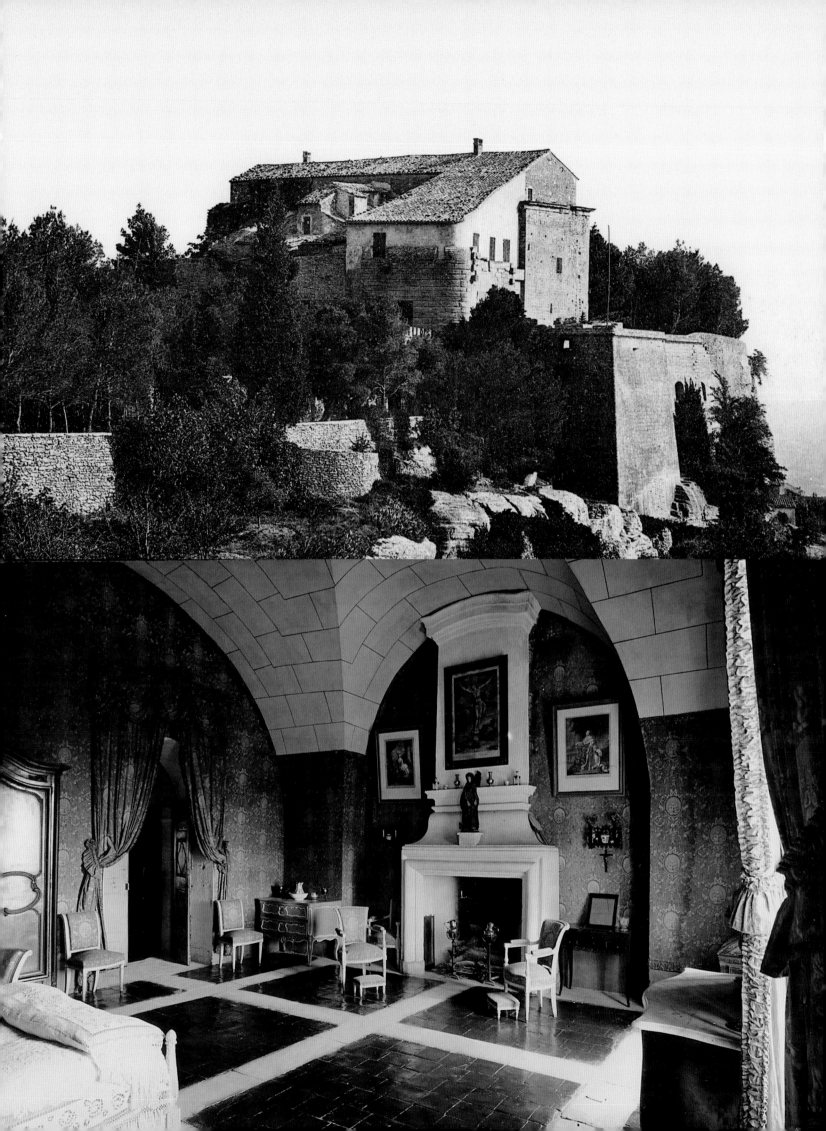

commencer par s'accabler de tristesse et d'amertume
scavés vous, qui est celuy qui joüe le plus heureusement
a la comete, c'est Rameaux, parcequ'il fait les
plus beaux opera. Scavés ce qu'on dit de trois
filles de condition qui ont epousé des gens
d'affaire, mlle de bethune a eu la peine
parcequ'elle a eu paris, mlle de la
charse a dit l'oraison de st julien, et
mlle de rochechouard s'est mariée pour
avoir du pain.
Mde la duchesse de chartres est grosse,
les bals de mr le prince de condé ont
recommencé, mde d'estain qui estoit priée
l'année passée et n'y vint pas parcequ'elle
avoit eté incomodée le tout qu'elle eut s'est de
ne s'estre pas fait excuser cette année elle
a eté invitée par mepris, s'estoit mde de massac
qu'on voulait mr le comte de charolois l'ayant
trouvée a demandé assés hault pourquoy elle s'entendu
invitée que ce n'avoit pas eté son intention et
qu'il estoit tres faché qu'il y fut elle l'a entendu
et en est sortie tout au plus vite, les comedies
de versailles vont recommencer je vous prie mon
cher frere de repondre a ces deux lettres et de
mander a ses mrs que je vous charge de tout
ce qui regarde ce pais la n'estant pas en personne
par moy meme et qu'ils s'adressent a vous.

Voltaire tient Jeudi un grand conseil a la Comédie composé de Mrs D'aumont, de Choiseuil du président Samault, de l'abbé Chauvelin, Lanoue, Grandval & Mlles Clairon et Dumeny. Il devoit leur faire la lecture de son Catilina. Après leur avoir lu le titre de Rome vangée, Il nomma les acteurs, Oreste Palamede &x, on luy demanda qués ce qu'étoit cette folie la. ah mon Dieu, dit il, Je me suis mepris Jay pris un Cayer pour l'autre, au lieu de vous porter Rome vangée, J'ai porté Electre, et puisque la faute est faite Jevais toujours lire cette piece ci. La piece lüe, et aplaudie, il leur dit, Mrs Jevais vous reveler un grand secret, que Jevous prie de me garder, mon intention est d'annoncer, et de faire afficher Catilina

mansion belonging to her daughter, Henriette-Victoire. The older woman was surrounded by four young women, all devout and noticeably "lacking a child": They all went crazy over the little boy. He was blond, blue-eyed, lively, intelligent, and already seductive. He soon had the entire household at his feet. He preferred Henriette best of all, and throughout his life would remain grateful for her kindness and cherish his memories of her. She was somewhat unpredictable, and occasionally cheated on her husband, who was mad about her. Finally, there was a sixth member of this cast of female characters, Madame de Saint-Germain, whose sole objective was to give the boy anything he wanted, to spoil him, even to spoil him rotten. In this she would largely succeed.

Donatien was next sent to live with his uncle, Abbé Jacques-François de Sade: Doubtless it was thought that the country air would calm him down. The abbé, an old, debauched socialite (though still full of sap), took his nephew with him to his châteaux in Saint-Léger d'Ébreuil and Saumane, near l'Isle-sur-la-Sorgue. Not a few have said that he corrupted his nephew, which is perhaps an exaggeration; however, the "deplorable" example he set for the boy could not help but make an impression. Donatien experienced a lofty solitude, in fantastic and mysterious settings. In 1765, upon his return to the Luberon, he did not hesitate to tell his religious aunts, as they scolded him about his conduct, that their brother Jacques, "though he might be a priest, always has a couple of girls around…. Is his château a harem? No, better still, it's a whorehouse."

Donatien learned a great deal, at will and haphazardly, from his uncle. At age ten he was enrolled in the most famous educational institution in Paris, the Jesuit Collège d'Harcourt (the future Lycée Louis-le-Grand). Life in such schools was rough. It must be remembered that at the time, the Church was in charge of the civil register (where births, marriages, and deaths were recorded), and of the care and education of those in need (the sick, the handicapped, the socially isolated). At the school, the priest-teachers had short plays performed for their students: Donatien was aflame with desire for the stage, to watch plays, to act and direct. Clearly, it was here that he discovered what would prove to be one of the most enduring preoccupations of his future life.

Previous pages: A letter from the father of the Marquis de Sade to his brother, the Abbé de Sade, c. 1749–50, sending news of Paris and the royal court.

Opposite: Courtyard and façade of the Collège d'Harcourt (engraving, Musée Carnavalet, Paris).

COUR DU COLLEGE D'HARCOURT.

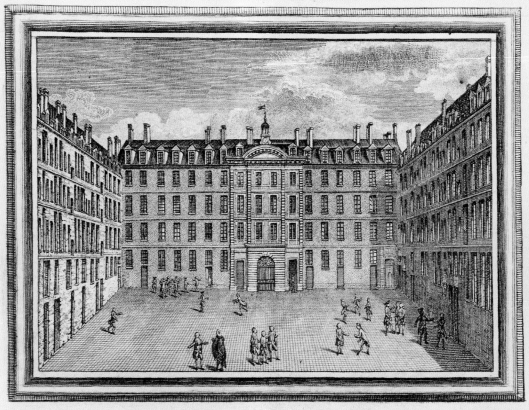

FAÇADE EXTERIEURE DU COLLEGE D'HARCOURT

Fondé en 1280. par Raoul de Harcourt, grand Archidiacre de Rouen.

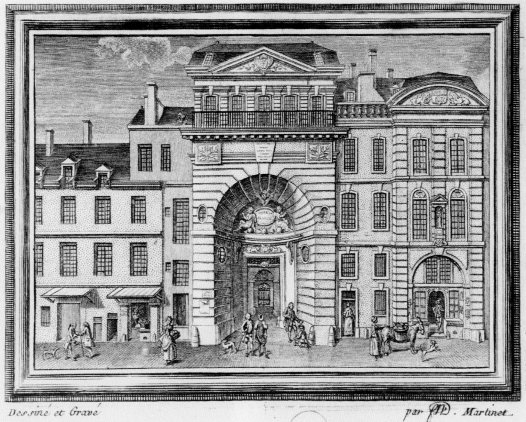

Dessiné et Gravé par AD. Martinet.

> **"For mortal man there is but one hell, and that is the folly and wickedness and spite of his fellows."**

At fourteen Donatien was accepted into the school of the light cavalry of the king's guard, in Versailles. Candidates—all young men from good families—needed the right credentials: a noble title going back several generations. Lightly armed, and therefore fast and mobile, the cavalrymen were trained to be scouts and flank guards. They wore white uniforms lined in blue and adorned with nine rose-gold ornaments and as many yellow buttons, topped with tricorne hats edged in gold. Part of the king's household guard, they never numbered more than two hundred, a close-knit unit in which each man knew every other.

Military education and regimental life thrilled Donatien. At age seventeen he obtained a commission as a cornet (color bearer) in the carabineer regiment (mounted troops armed with short muskets or "carbines") led by the Comte de Provence, the younger brother of the future King Louis XVI, better known as Louis XVIII. Donatien saw action in the Seven Years' War (1756–63), in which he served with distinction—a promising debut.

When the war broke out, he was sent first to Toulon, then to the Balearic Islands. The Duc de Richelieu (nephew of Armand Duplessis), already decorated for his service, was in charge of the campaign, whose objective was to take the port city of Mahon (capital of the island of Menorca), the second most important fort in the Mediterranean, after Gibraltar. On June 27, the French launched their assault. In the words of *La Gazette*:

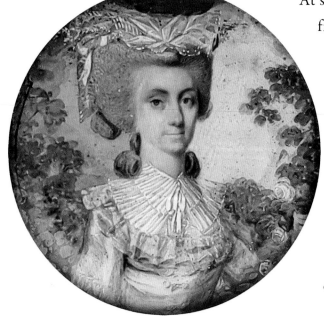

"At six o'clock in the evening, all the batteries having ceased fire, the Marquis de Monti set out at the signal of a cannon shot... while the Marquis de Brigneville and the Sieur de Sade launched a swift attack against the Queen's Redoubt and, after a very quick and quite deadly barrage, they succeeded in taking it by storming the redoubt and scaling its walls, and installed themselves within after the besieged troops had exploded four blast chambers."

The English surrendered, and the French fleet returned to its bases. The regiment in which Donatien had come of age left for the northern frontier and saw action in six

campaigns in Germany. He took part in, among others, the battle of Crevelt (June 1758), near Düsseldorf, where the Comte de Clermont ordered a retreat in great disorder, and 7,000 Frenchmen lost their lives. Donatien was promoted to the rank of cavalry captain.

After the Treaty of Paris (1763), the carabineers were divided up and sent to Angers, Chinon, La Flèche, and Saumur. It was at Saumur that the Duc de Choiseul decided in 1764 to found a cavalry school, the Cadre Noir, which remains famous. Beginning in 1774, when the Comte de Provence, upon the death of his grandfather Louis XV, assumed command of this cavalry, the troops became known as "the carabineers of Monsieur." Donatien, now nineteen, became captain of the Burgundy cavalry regiment. His superior officers said of Sade: "Both high-born and virtuous, has plenty of spirit"—a good omen. It could be said that he was a courageous officer, but he was earning a fiendish reputation as a gambler, a spendthrift, a debauched libertine. He could be found wherever flesh was for sale, in brothels, backstage at the theater, in public gardens, or in the sheds behind the barracks. "There are surely few worse schools than garrisons, few where a young man is sooner corrupted in both his speech and his morals."[2]

In 1763, Donatien was a lively young man similar to his peers; cultivated and accomplished, he was well versed in the arts—literature, theater, poetry. He was devoted to his mistress, a young actress known as La Beauvoisin, but also frequented brothels. (On the occasion of his marriage, he would even invite his mistress, escorted by his own father!) It was during his first long sojourn at Lacoste that Donatien earned the nickname *pistachié* ("pistachioed," or skirt chaser), when people realized that the young lady accompanying him was not his wife at all, but La Beauvoisin.

Barracks life and his leaves in Paris thrilled Donatien. Given to excess in everything, he burned the candle at both ends. He gambled, losing enormous sums. But, as often happened in such families, his father was determined to find him a suitable match. As an adolescent, Donatien had been promised that

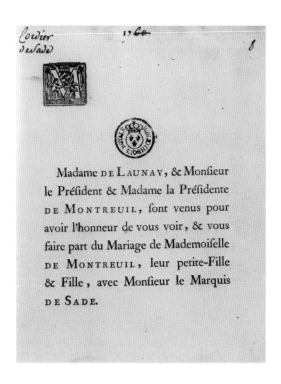

Madame DE LAUNAY, & Monsieur le Président & Madame la Présidente DE MONTREUIL, font venus pour avoir l'honneur de vous voir, & vous faire part du Mariage de Mademoiselle DE MONTREUIL, leur petite-Fille & Fille, avec Monsieur le Marquis DE SADE.

Above: Marriage announcement for the Marquis and Renée-Pélagie Cordier de Launay de Montreuil (1741–1810).

Below: Miniature on ivory sheet depicting Sade's mother-in-law, Marie-Madeleine Masson de Plissay (1721–98), known as the Présidente de Montreuil (because her husband, Claude-René Cordier de Launay de Montreuil, was the honorary president of the Cour des Aides, the customs and excise court).

Following pages: (left) Marriage certificate of Sade and Renée-Pélagie, recording their wedding on May 17, 1763, at the Church of Saint-Roch in Paris; *(right)* portrait presumed to depict Renée-Pélagie.

PRÉFECTURE DU DÉPARTEMENT DE LA SEINE.

ETAT CIVIL.

VILLE DE PARIS.

Paroisse de la madelaine ville l'evêque

EXTRAIT du Registre des Actes de Mariage de l'an 1763.

Mariage De Sade & Cordier de Montreuil

Le dix sept du mois de mai mil sept cent soixante trois fiançailles le même jour par la permission de monseigneur en l'archevêque de Paris, pour à dispense de deux bans en datte du jour d'hier, Treizième de mai de la susditte année contrôlé et insinué le même jour, en outre une dispense de domicile accordée au futur époux par sa Grandeur le même jour, publication le dit ban en cette paroisse et d'un en celles de Saint Sulpice et de St Jacques du Haut pas sans aucune opposition comme les certificats des curés ou vicaires des dittes paroisses en font foi, les Extraits Baptistaires de l'époux produits et restés en bonne forme, par moi soussigné Louis Charles Cattelier, prêtre Docteur en théologie, curé de la paroisse dite marie madelaine de la ville l'evêque à Paris a été célébré dans la ditte Eglise le mariage de haut et puissant Seigneur Donatien Alphonse François Marquis de Sade, Lieutenant Général des provinces de Bretz, Bugey, valromey Ceguy, fils mineur de haut et puissant Seigneur M^{re} Jean Baptiste François chevalier Comte de Sade, aussi Lieutenant Général des susdittes provinces, Seigneur Comte de Mazan de la coste, Saumanes et autres lieux et de haute & puissante dame madame marie eleonore

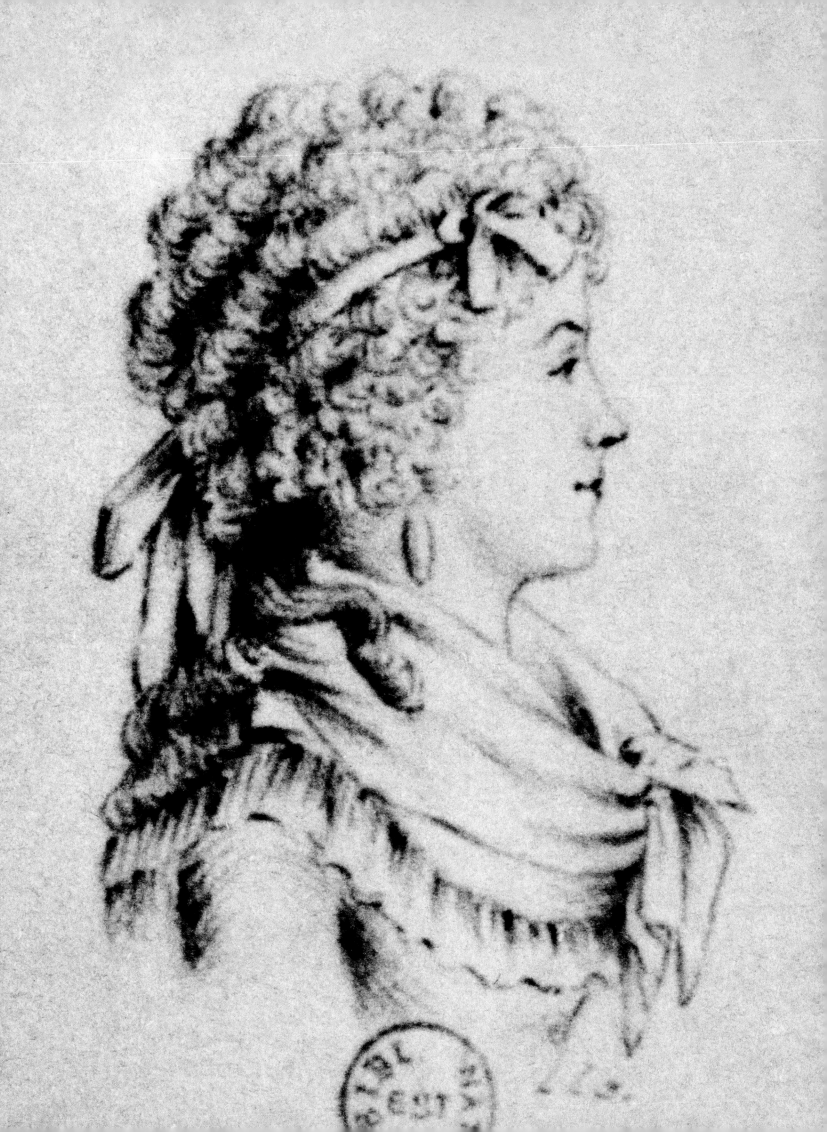

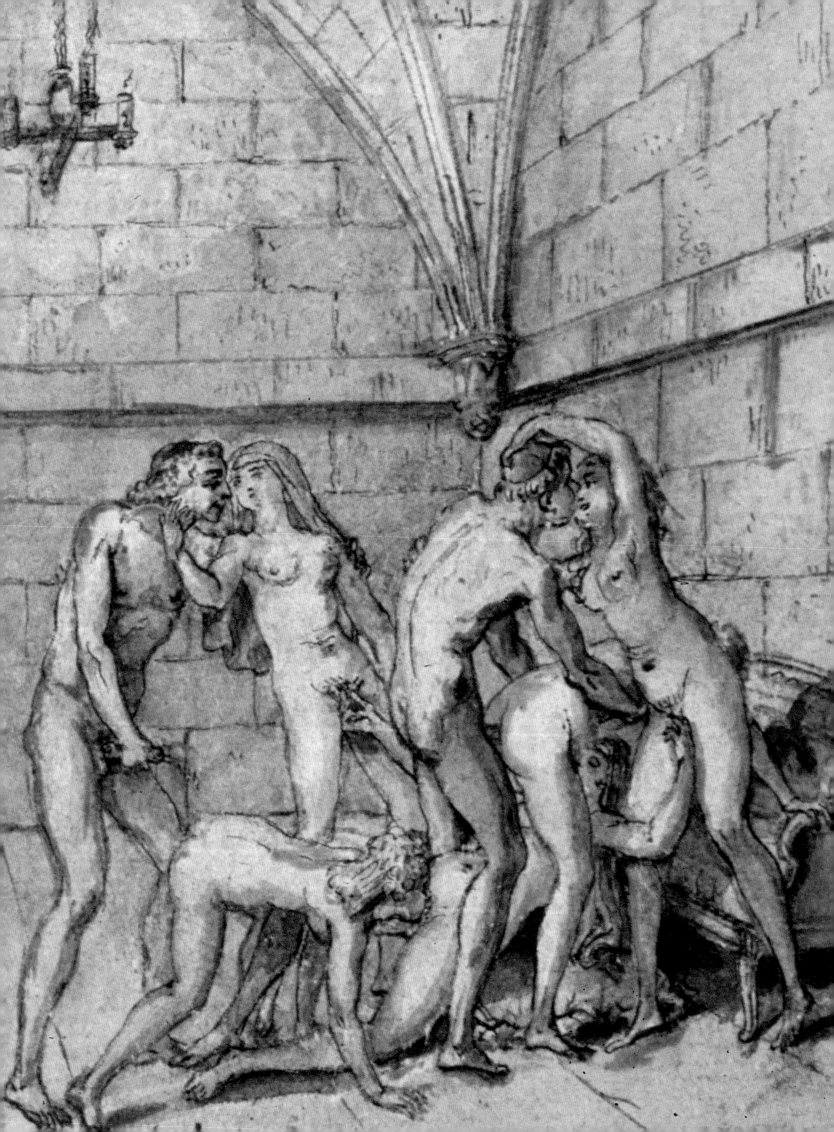

he could marry whomever he chose, but now that he had come of age it was time to get serious. He asked for advice, got information—in today's jargon, he employed his social network. Sade guessed correctly what his father was up to, writing to him thus:

"To be polite, honest, proud without giving offense, considerate without being dreary, to indulge rather often one's little whims when they harm neither ourselves, nor anyone else; to live well, to amuse oneself without ruining oneself... [to have] few friends, none even, perhaps because there is not one who is truly sincere and who will not betray you twenty times, if the most trivial of his interests should be involved....

"What reassures me most is the kindness you have had in promising me that you would never oppose me in matters of the heart...."

Donatien sensed that the "suitable matches" would soon appear. A certain Mademoiselle Cordier emerged; she came from a lower-level noble family (worse still, from the *noblesse de robe*), but she was well endowed. Also at this time Donatien expressed the desire to marry Laure de Lauris-Castellane, heiress of a very ancient Luberonnais family. He loved her, and she too was his one of his mistresses, but she was wary and dropped him. As for the Comte de Sade, he had set his sights on the Cordier family's eldest daughter, also an heiress. Somewhat against his will, Donatien obeyed his father and married Renée-Pélagie de Cordier de Montreuil, whom he found moderately pleasing. She was at least young and docile. The ceremony took place at the church of Saint-Roch on May 17, 1763. Donatien showed some affection toward her; the beginning of their life together was peaceful.

Patrick Jammes depicts Sade at the beginning of his life as a husband thus: "Extremely elegant, with a fine voice, talented, and above all well versed in philosophy.... A bit of softness in his bearing, especially around the middle, stemming no doubt from his habit of so often adopting feminine airs."[3]

He was five foot six (a decent height for the period), with light brown hair, white skin lightly scarred by pox, and blue eyes that gave him a dreamy air. He lived with his in-laws in great luxury. His mother-in-law seems to have been infatuated with him; he was protected on all sides.

Engraving by Claude Bornet for the first edition of Sade's *Juliette,* c. 1801.

49

"Benevolence is surely rather pride's vice than an authentic virtue in the soul."

Le Marquis de Sade.

Du mois d'octobre 1763 Jeanne Testard, fille galante, Declara chez un Commissaire de police que dans une orgie qu'elle avait faite le 18 du même mois avec un particulier qui lui était inconnu, ce particulier avait usé de violence pour l'obliger à commettre toute sorte d'abominations et d'impiétés.

Par les renseignements qui furent pris, on parvint à découvrir que le particulier dont la fille Testard avait à se plaindre, était le Sr Marquis de Sade, jeune homme de 23 ou 24 ans, allié à la maison de Condé.

Il fut arrêté et conduit devant Mr le Lieutenant de police, qui lui arracha l'aveu de toutes ses turpitudes. Le magistrat exigea ensuite que Mr le marquis de la Sade se transportât dans la petite maison qui avait servi de théâtre à tant d'horreurs, et qu'il remit à un Inspecteur de police qui l'accompagnait, les instruments de ses débauches, impiétés, et profanations, ce qui fut exécuté.

Il faut lire les Déclarations de la fille Testard et le rapport de l'inspecteur de police pour avoir une idée des horreurs, abominations, et sacrilèges

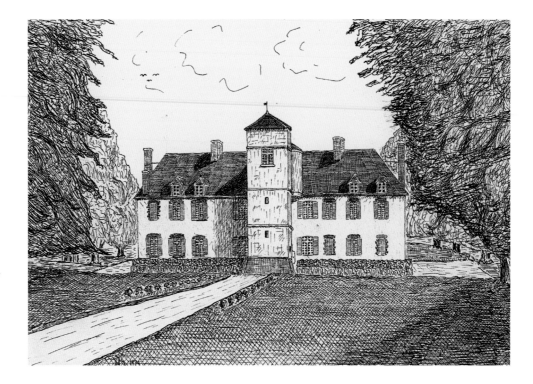

Previous pages: Detail of a love scene on wallpaper, in 18th-century style.

Right: The Château d'Échaffour (original drawing by General Pierre de Lesquen du Plessis-Casso). The seigneurial manor house at Échauffour was completed in 1740 by the general's grandfather, Claude-René Cordier de Launay, Marquis de Montreuil, Sade's father-in-law.

Opposite: Photograph of the keep of the fortress of Vincennes, where Sade was imprisoned for sixteen months in cell number eleven and for six years in cell number six, from 1777 to 1784.

Below: Jean-Charles-Pierre Lenoir, lieutenant general in the Paris police.

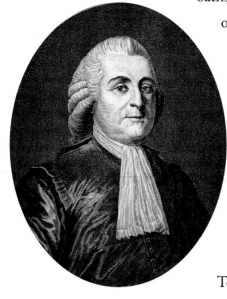

Following pages: Letter in Sade's handwriting dated January 24, 1767, addressed to his uncle, regarding the death of Sade's father. The black wax seal signifies mourning.

But the young Donatien was already preoccupied with his vices: He rented houses in Paris, Versailles, and Arcueil, where he abandoned himself to elegant and often violent orgies. He was said to enjoy sadomasochistic games and blasphemous oaths, and to like "both fur and feathers"—in other words, bisexual. He was often seen at a famous brothel run by a madam known as La Brissault, near the Barrière Blanche (one of the gates in the Wall of the Farmers-General, now demolished, today in the ninth arrondissement). He dallied with the actresses of the Royal Academy of Music, such as Mademoiselle Colet and La Beauvoisin. In the summer of 1763, he was arrested in a whorehouse for having committed very grave offenses; Jeanne Testard, a former fan maker and prostitute, lodged a complaint against him.

In her deposition, which took place before a commissioner at the Châtelet (a stronghold incorporating police, courts, and a prison), Testard said as follows:

"He asked me if I believed in God and the Virgin.... He replied to me with blasphemies.... He masturbated to climax, defiling a chalice.... He had relations with a girl, putting the Host in her private parts.... Then he took her into a room

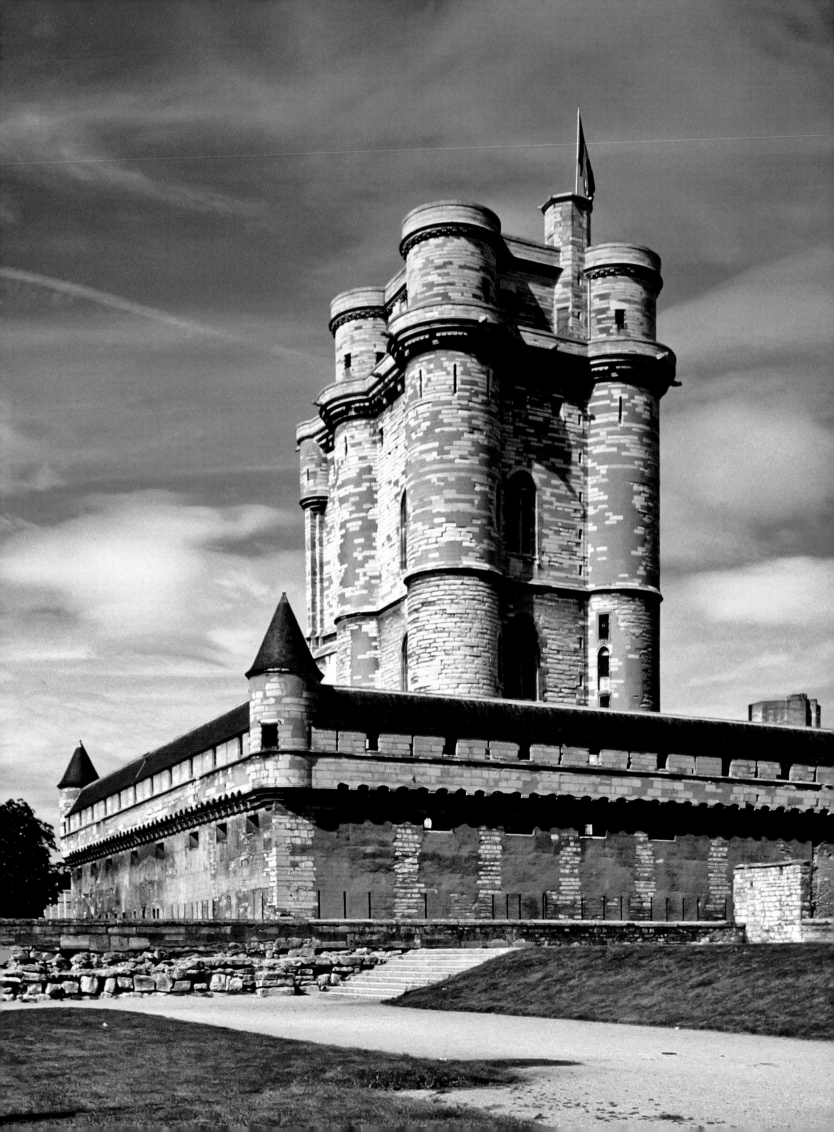

A Monsieur

Monsieur de l'abbé ...
... en son château
... par Lille
a Lille au Comtat Venaissin

Je ne sçai de quelle expression
me servir, ni comment peindre ma
douleur, elle est inexprimable
mon cher oncle, nous l'avons perdu
je n'ai pas la force de vous en
dire davantage, chargez vous je
vous prie d'instruire la famille du
malheureux evenement que nous
eprouvons. Je n'ai ni ni le courage
ni la force

Ce 24 janvier 1767 a Montreuil pres versailles a trois heures
apres midi, deux heures apres l'avoir perdu.

where pious images and nudes were mixed together.... He had himself flogged with a whip heated in the fire.... Then he masturbated to climax, defiling ivory images of Christ.... Finally, he forced her to have an enema and to expel it on an image of Christ."[4]

Sade was imprisoned in Vincennes by royal order. The Montreuils, embarrassed, got him out and kept him under house arrest at one of their properties, the Château d'Échaffour, in Normandy.

One year later, a perspicacious police inspector persuaded the madams to stop providing the marquis with young flesh, but he proved incapable of reconciling his social life and his pursuit of personal pleasures.

With information from several sources, the police decided, starting in 1764, to keep Sade under careful surveillance. Jean-Charles-Pierre Lenoir, the police lieutenant general and successor to Antoine de Sartine, ordered a certain Inspector Marais to follow Sade "closely." Marais began by searching through Madame de Montreuil's correspondence. Well-informed and energetic, he befriended La Brissault and "constrained" her to no longer provide girls to the libertine marquis. On October 16, 1767, he predicted, "It will not be long before we again hear horrible things about the Comte de Sade."

Earlier that same year, Sade's father had died. The Prince de Condé and the Princesse de Conti became godparents to Sade's first son, Louis-Marie, born on August 27, 1767. But events gathered momentum: In 1768, rumor had it that a marquis had had his way with a poor girl, one Rose Keller, widow of a young pastry chef named Valentin, who begged for alms near the Place des Victoires. Under the pretext of an offer of domestic service, the man had taken her to his country house at Arcueil. He gave her a tour of the house, where she encountered drunken prostitutes. She was led to the attic, stripped, shackled, and whipped. Her assailant reached orgasm; she wailed; more blows rained

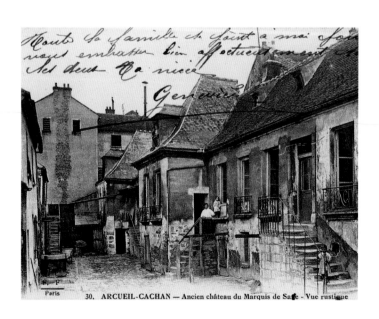

Below: Postcard depicting the house in Arcueil called the Aumonerie (private chapel), where Sade held Rose Keller hostage on Easter Sunday, April 3, 1768.

down. Exhausted, she was next forced to utter blasphemies—all the worse because it was Easter Sunday. The girl was bleeding; Sade applied an ointment, then left her upstairs while he went down to join revelers at dinner. Rose succeeded in escaping through a window, naked and still bleeding. She roused the village of Arcueil; passersby gathered round her; horrified, they decided to break down Sade's door. Once inside, they found a heap of tangled bodies, the Marquis de Sade and his partners in debauchery.

The Sades and the Montreuils did all they could to protect Donatien from being treated like a commoner. He was a nobleman; he had a right to certain considerations. He was imprisoned first in the Château de Saumur for seven months, then in the Château de Pierre Encise in Lyon. The case went to trial in June, and the Comtesse de Sade, his mother, appealed to the king to have him released. Louis XV, persuaded, had Sade set free. He was immediately sent to his country estate. As for Rose Keller, newly enriched by the Sade family to the tune of a hundred louis d'or, she withdrew her accusations and married a month later. In 1769, Sade was leading a merry life at his château in Lacoste, in Provence,

Above: Drawing of the Château de Mazan, attributed to Sade.

Following pages: Overview of Lacoste, with Sade's château overlooking the village from the top of the hill. Built in the 11th century, the estate was left to Gaspard-François de Sade in 1716 by his cousin Isabelle de Simiane, Marquise de Crillon, including forty-two hectares of land.

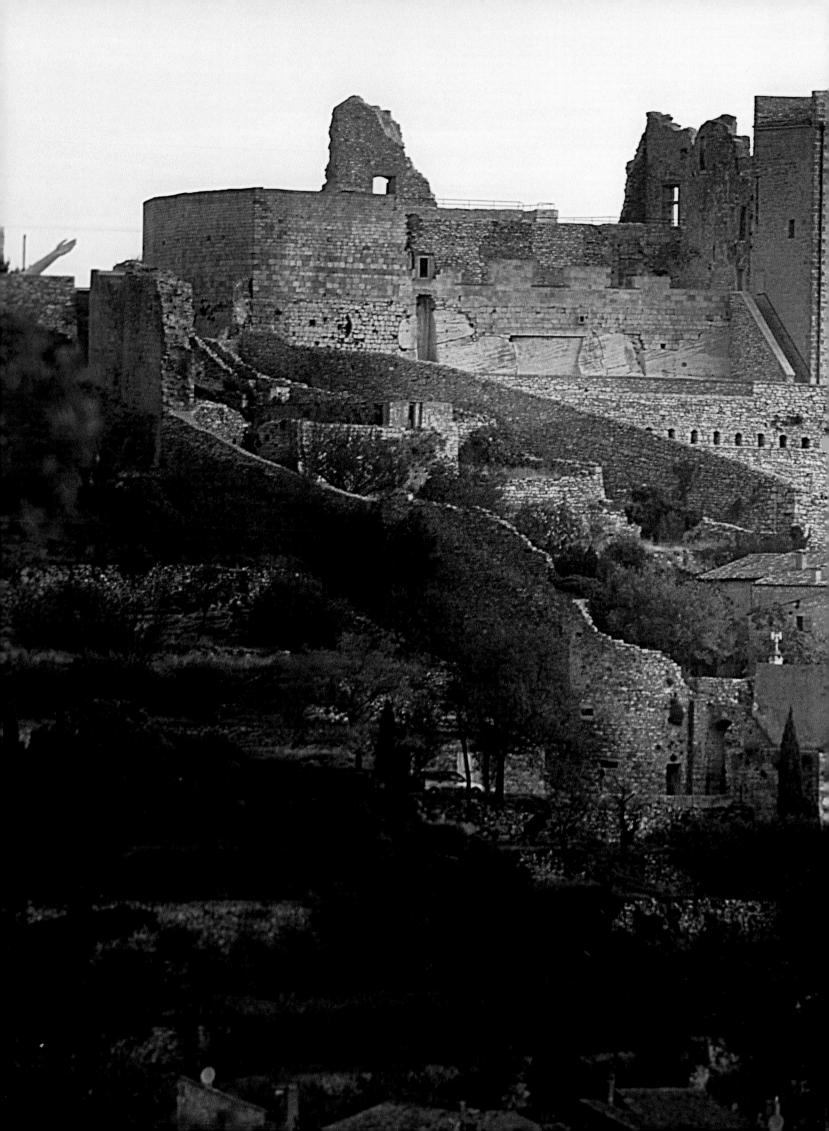

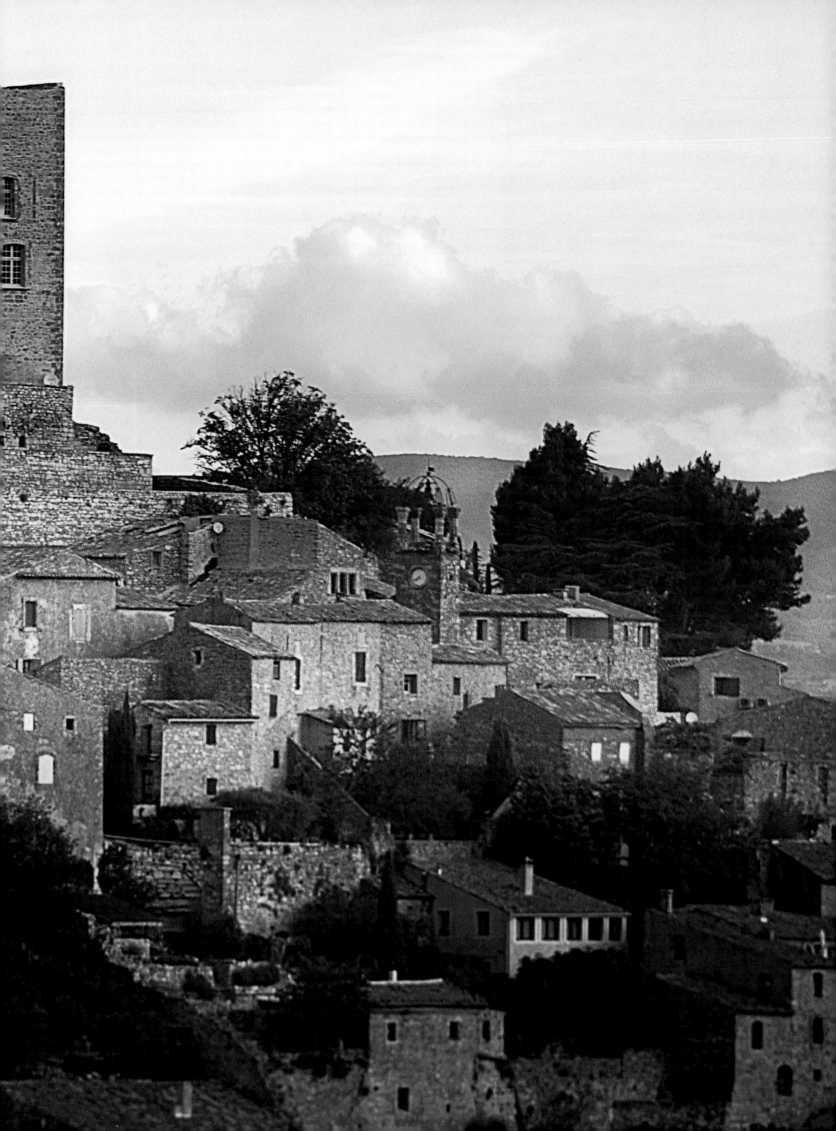

Livre

De Dépense pour

L'année

1777

~~facon~~ façon du chausson	3	
port de lettre	1 . 1	
10 2 peaux de confiture	3	
fiacre	4	
a Mde robine	12	
13 une voie de boye	24	3
fiacre	9	
16 port de lettre et chaise	2	10
une bouteil d'encre		10
une livre de chocolat	6	
17 a quelle agathe ses étrenne	24	
sur ces gage	6	
une demi livre de laine	4	6
a la fena d'chai		3
19 une poiel a feux	1	8
21 ser a proter eaux des		
corne et petite porte	5	8
24 a la jeune ne a compte de ces gage	6	
une voye de boi	23	13
un fiacre	2	14
	141	13

when his second son, Donatien-Claude-Armand, was born in Paris. As a younger son, he was merely a chevalier. That same year, Sade also spent two months traveling through the provinces of the Dutch Republic, visiting Brussels, The Hague, Amsterdam, and so on. He had pretensions of picking up where Pietro Aretino had left off; while there, Sade sold some erotic texts—a genre in which he excelled.

New problems arose in 1770, just as Sade wished to be restored to his post as a captain in the Burgundy cavalry. The general in charge opposed his return. A year later, while a decision was still pending, Sade gave up hope and sold his officer's commission. In September 1771, his debts sent him to prison, at For-l'Évêque in Paris. Accordingly, he missed the birth of his daughter, Madeleine-Laure. In early November he returned to Lacoste, accompanied not only by his wife and children, but he also persuaded everyone that the presence of his wife's twenty-year-old sister, Anne-Prospère de Launay—a Benedictine secular canoness of great beauty and cunning, with whom Sade would share a torrid passion—was "necessary." In the village of Lacoste, the houses had been beautifully restored, arrayed around the old village square and along the sides of the lanes, some earthen, others paved. Sade rediscovered the region—Eyguières with its springs, and Bonnieux, opposite Lacoste.

Just turned thirty, Sade was now a man in his prime. He lived hard and fast, as he had dreamed as a child. He soon exhausted his wife's dowry and his own revenues in repairing a large part of the Château de Lacoste—with forty-six rooms, it was one of the province's most impressive buildings. Sade also had a theater built at Mazan and renovated the theater at Lacoste. He founded a troupe of actors to stage all sorts of entertainments, plays, and spectacles; they performed Voltaire, Chamfort, Diderot, Regnard, and Sedaine. Sade was lavishly praised, but he was going deep into debt, and at high rates of interest. However, intoxicated by the endless revelry, Sade cared little; he was at his zenith.

His wife and children returned to stay with Madame de Montreuil before the end of November, leaving Sade alone with Anne-Prospère.

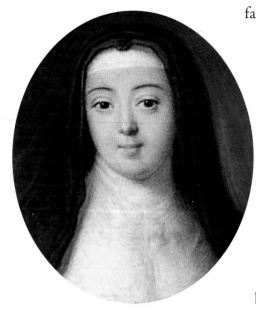

Previous pages: An accounts book belonging to Sade discovered at Lacoste.

Opposite: A poem in Provençal written by the inhabitants of Lacoste and performed as a song for the Marquis de Sade: "Our handsome Marquis,/ Who could believe it?/ Is here in the countryside/ At last, he has come to see us./ Ah, let's all sing together/ Long life, long life!/ Ah, let's all sing together/ May he live long."

Below: Portrait of Anne-Prospère de Launay (1751–81) by Maurice Lever. A secular Benedictine canoness, and the marquis's sister-in-law, her scandalous liaison with Sade began in Lacoste in 1771.

Canssoun
su l'aribado de moussu Lou marquis de sado
et su Lou restabissamen de la santa de
moussu Lou Conté

nouoste beou marquis,
qu pourié Lou créire?
es din Lou pais
enfin nous ven veiré.
ah
Canten tous enssen
que vive que vive
ah
Canten tous enssen
que vive Lon tem

sias Lou ben vengu
nouoste futur mestre
erias attendu
tan que se poa estre
ah
Canten ben —

de soun Cher papa
eou suivè La traço
et sigur fara
pa menti la raço
ah
Canten tous enssen
que vive ben

Lou pere es gari
l'enfan nous lassuro
que double plesi
qhurouso avanturo
ah
Canten tous enssen
qu'aven nouoste Conté
ah
Canten tous enssen
que se pouorto ben

disien qu'ero mouor
crian din Lalarmo
planian nouoste sor
verssavian de Larmo
may
Rejouissen nous
reprenen Leis armo
mai
rijouissen nous
d'un sor tan hurous

sabian que la mouor
n'esparnio perssouno
que n'a gis de Couor
et que tou meissouno
mai

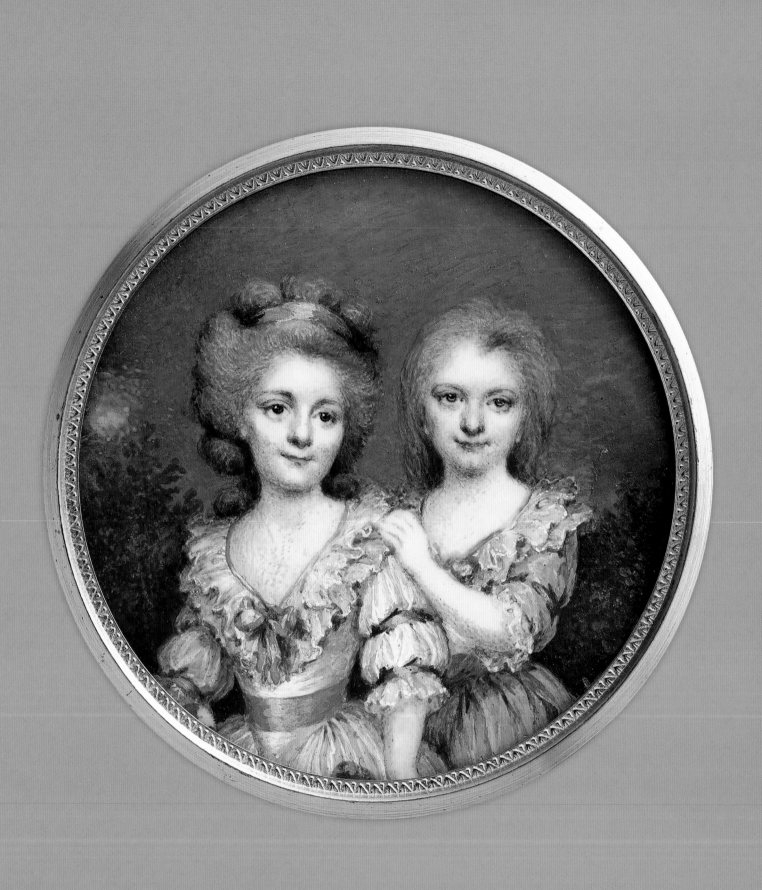

Above: Miniature on ivory sheet, discovered in 2013 in the Château d'Echauffour, depicting *(left)* Renée-Pélagie Cordier de Launay de Montreuil, the Marquise de Sade, and *(right)* her sister Anne-Prospère, one of the marquis's lovers.

Opposite: Letter sent by Sade from prison to Anne-Prospère, with her reply.

Following pages: (left) A copy of the appeal in cassation (that is, to France's highest court of appeal) requesting annulment of the sentence in the Marseilles affair; *(right)* testimony in the case.

Je vous l'ai dit cent fois et Je vous le
Rappelle vous etes le plus mauvais econome
que Je connoisse. Combien y a t'il que Je vous
recrecate pour me faire du marché de
foin. Mais vous attendez que la saison soit
passée affin de me le faire payer le double
N'est ce pas? ô l'excellent econome et en
attendant J'en manque, et en attendant Je
le paye cinquante Soli. ô mon de Dieu du
foin du foin et Manque moi decidement
quelque chose d'apposition sur cela

il faut que vous ayez la bonté d'envoyer de la
bougie car nous en manquons, et M.d Bourdet vous
prie de luy faire avoir douze pans de blonde
pareille à l'echantillon. voudrez vous bien mettre cette
lettre à la poste et faire tenir l'autre à M.lle Solier
Envoyé aussy Six cannes de gaze pareille à l'echantillon
pour la glace du Salon

Extrait d'arret
de Cassation du Décret
de Soit informé et de
toute la procédure
pour le S.r Marq. de Sade
C.
M.re le P. G. D. Roy
30 juin 1778.

Copie d'un extrait dressé sur beau
parchemin et en expedition timbrée —

——————

Extrait des registres du parlement.
Entre Messire Louis Aldonse Donatien
marquis de Sade, demandeur en requête
du vingt six juin mil sept cent soixante
dix huit, tendante en cassation du décret
de soit informé rendu par le lieutenant
au siège de la ville de Marseille le
trente juin mil sept cent soixante et douze
et de tout ce qui s'en est ensuivi d'une
part et M.re le procureur général du Roy
defendeur d'autre — la cour faisant droit à la
requête de Louis Aldonse Donatien de Sade
du vingt six du présent mois a déclaré
le décret de soit informé du trente juin mil
sept cent soixante douze rendu par le —
lieutenant criminel au siège de Marseille
l'information et la requisition faite par
le procureur du Roy au dit siège le 1.er
juillet suivant ensemble ce qui s'en est
ensuivi, nuls par deffaut absolu d'existance
du délit présuposé d'empoisonnement,
et comme tels les a cassés et lussé, et
en concedant acte au procureur général

demeurant Rue daubagne mai 5 de nicolas

a dit que setant trouvée samedy matin sur les —
dix heures chés la nommée mariette au loin de la —
Rue des Capulins avec Les nommées marianne et
marianette, elle y vit deux hommes l'un desquels de
haute taille vetu en matelotte Rayée, l'autre plus petit
d'une jolie figure, visage Rempli, vetu d'un frac gris
portant epée, et ayant une Canne, Lequel Leur dit
qu'il vouloit s'amuser avec elles, et Leur fit voir quantité
d'ecus qu'il tira de sa poche, il dit Ensuite que celle
qui devineroit le nombre d'ecus qu'il tenoit dans la —
main passeroit Lapremière, Lesort tomba sur La —
nommée marianne qui fut Enfermée avec Led. homme
et l'autre habillé a la matelotte que Lad. deposante
a apris etre Le domestique du premier, marianne étant
sortie se plaignit d'avoir mal d'esthomach, but une
Ecuelle d'eau, vint Ensuite Letour de mariette, et —
après elle, celuy de La deposante que Led. homme
a frac mit sur Le lit Et fouetta avec un balay de
Brus tandis que sondomestique l'embrassoit, et comme
d'une main il fouettoit Ladeposante, de l'autre il —
excitoit son domestique qui etoit etandu du dos sur Le
lit, il voulut Ensuite que La deposante Lefouettat —
Luy avec le meme balay de Brus, et elle vit sur La
Cheminée un fouet de parchemin garni d'epingles, qui —
etoit Ensanglanté, Led. homme proposa a La deposante
depermettre Et que son domestique La connut par —
derriere et Luy promit un Louis, mais elle Le Refusa —
elle sortit vint Ensuite Letour de marianette, et peu
après il Rapella marianne avec Lesquelles ils Resterent
Enfermés, après quoy il donna a chacune six Livres —
nous observant que dudepuis Lad. marianne setrouve
incomodée et plus n'a dit &c.

Du 5. jour
Constitué francoise garagnon Epouse de jean baptiste —
virolet menager native d'arles agée devingt neuf ans
demeurant Rue de S.t ferreol Le vieux a la maison du S.r
Rou

8témoin

Les soussignés Consultés sur le
point de savoir s'il résulte note
d'infamie d'un arrêt qui ordonne pour
les coups résultants de la procédure que
l'accusé sera admonété derrière le
bureau présent le Procureur Général de
mettre à l'avenir plus de décence dans
sa conduite, qui lui inhibe de fréquenter
la ville de Marseille pendant le terme
de trois années, et le condamne à une
aumône de cinquante livres applicable
à l'œuvre des prisons.

Estiment que l'infamie des peines
qui ne sont pas corporelles résultant
seulement de l'idée que le législateur
y a attachée, il faudrait que l'admonition
fut mise par les ordonnances au rang
des peines infamantes pour qu'elle put
déshonorer Celui qui la subit. Loin
que l'admonition soit rangée dans
la classe des peines infamantes elle
n'auroit plu l'être par sa nature
puisqu'elle ne consiste qu'en un
avertissement donné par le juge, il est
même deffendu en prononçant
l'admonition d'y joindre une amend
crainte que la condamnation à l'amend
n'emportat une fletrissure que la

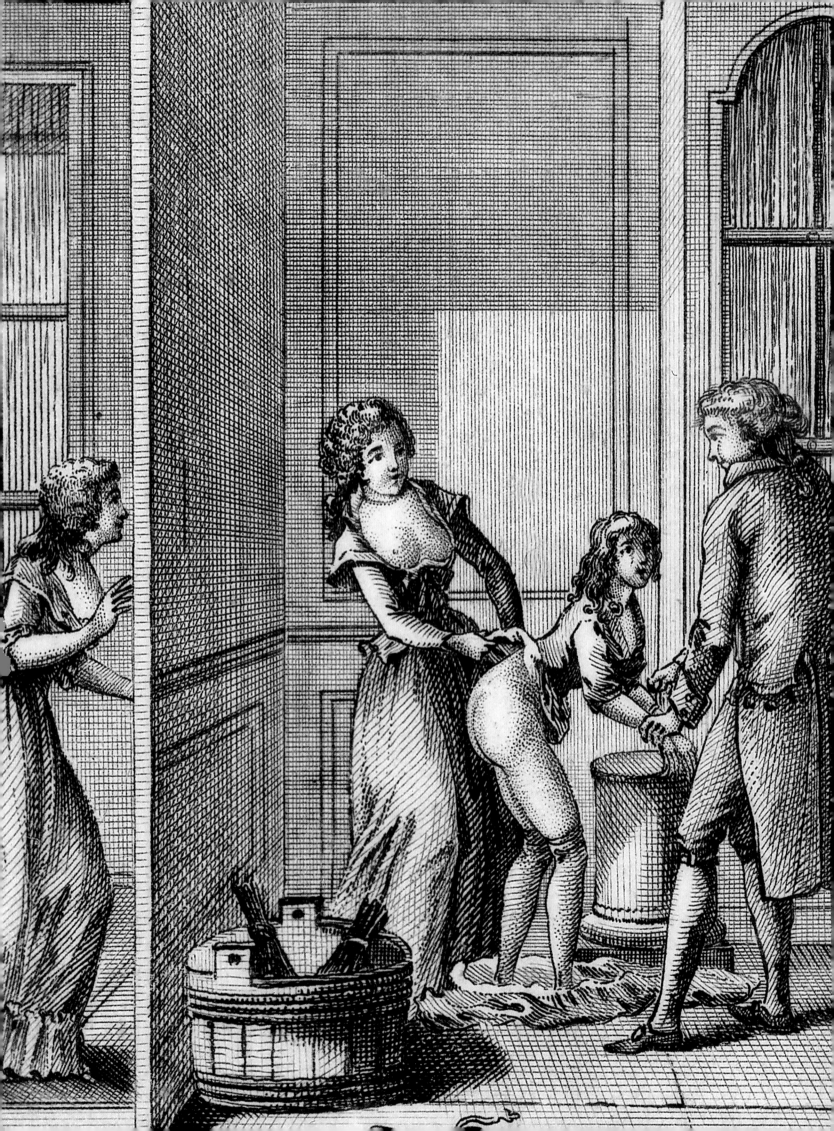

Ostensibly restoring her "fragile" state of health in the clean air of Provence, Anne-Prospère was overcome with agitation in the remote surroundings. She went on a spending spree, buying shoes, pralines, writing materials, a bathtub. Sade's uncle the Abbé was "moved" by such youth and beauty. At Mazan, Sade had just finished outfitting a second theater, and hired new actors, stage machinists and technicians, and so forth. At Lacoste, in May 1772 alone, he presented *Le glorieux* by Philippe Néricault Destouches, *Les Mœurs du temps* by Bernard-Joseph Saurin, *Le retour imprévu* by Jean-François Regnard, *Le père de famille* by Diderot, and *Adélaïde du Guesclin* by Voltaire. Life was a nonstop party. Sometimes a creditor would appear, only to be turned away: "A commoner—really!" The money flowed freely. Anne-Prospère played the part of "official mistress."

In June 1772, as the reign of Louis XV was drawing to a close, new scandals erupted: In Arcueil, there was a girl involved; in Marseilles, four more. On June 23, 1772, Sade, now thirty-two, headed for Marseilles with his valet, Latour, in search of funds. They made inquiries here and there. At the end of the day, they arrived at the Hôtel des Treize-Cantons and checked in. Straight away they got to work to find a brothel and some girls.

Near the old harbor, on a grimy back street, at 15 bis, rue d'Aubagne, they found what they were looking for. One night, the two men entertained four young prostitutes in a "lively" manner, with much toasting. To arouse their senses, they offered their companions anise-flavored candy made with Spanish fly, an aphrodisiac widely used at the time and made fashionable by Marshal Richelieu (great-nephew of Cardinal Richelieu), a specialist in such sensory experiences; the substance could be found in every house of ill repute. Unbridled lust held sway, with spanking, whipping, and other corporal punishments, and well as sodomy—in that era a highly reprehensible act and a criminal offense. Afterward, each girl was given the six livres promised her. The two fellows took their time before leaving town and heading back to Lacoste.

A few hours later one of the girls fell ill, perhaps with gastritis; another thought she had been poisoned. Gossip spread. One of the whores, angry at having been "abused," lodged a complaint against the marquis. Someone said that two of

the girls had died. The authorities, only too happy to have at last a "confirmed" plaintiff, quickly leaped into action.

By July 10, Sade's wife, Renée-Pélagie, was in Marseilles, bringing with her a large sum of money (4,000 *livres*) to "calm down" everyone. On the eleventh, a hussar and men-at-arms came to Lacoste, searching the premises, confiscating papers and notes, seeking the "accused." He had slipped away with Anne-Prospère, to seek la dolce vita in Italy, where they arrived at the end of the month.

Meanwhile, Renée-Pélagie's father came to Lacoste in August. His political connections were of no avail; the machine of justice was in motion. The authorities were angry, the press and public opinion—this period witnessed the beginning of their power in its modern form—were enraged. Some wanted not merely to arrest Sade, but to kill him. On September 3, 1772, Sade and his accomplice were sentenced in absentia to death by burning at the stake for sodomy and poisoning. On September 12, their effigies were burned on the Place des Prêcheurs in Aix-

Copie prise sur l'original
sur parchemin — feuille double grand
in folio, écrit en ronde — signé du Roi
Louis 16 et scellé de son sceau
(Il n'en reste qu'un fragment.)

Lettres d'Ester à Droit pour
le Marquis de Sade.

Louis par la grâce de dieu, Roy
de France et de Navarre, Comte de
Provence Forcalquier et terres adjacentes,
à nos aînés et féaux Conseillers les gens
tenant la grand Chambre de Notre Cour
de Parlement d'Aix, Salut; Notre cher
et bien aimé Louis aldonse Donatien
Marquis de Sade, nous a fait exposer
que par arrêt rendu en la chambre
des Vacations à Aix le onze Septembre
mil sept cent soixante douze, la dite chamb.
des Vacations auroit ordonné l'exécution
d'une sentence rendue par Contumace le
trois du même mois par le Lieutenant
général Criminel en la Senechaussée de
Marseille, qui l'a condamné à mort
pour Crimes prétendus de Poison et de
Sodomastie, qu'il ne peut pas y avoir
de preuves et encore moins de preuves
légales de ces deux Crimes, inexistants

en-Provence. It was not until six years later that the Provence parliament would reverse the judgment "at first instance," or the case's first hearing in court.

Renée-Pélagie tried to stop the flight of the two lovebirds by taking control of her husband's finances, which was not easy. By August they were in Venice. In September Sade gave in to the advances of a pretty young girl; devastated, Anne-Prospère returned hastily to France. She had been madly in love with Sade since 1769, and she could not accept his infidelity. Sadly, abandoned by everyone, the canoness entered a grimly strict order of nuns, where would end her days.

Sade, accompanied by Latour, someone named Quarteron, and an Italian woman, returned to Marseilles by sea. He decided to settle at Chambéry, in Savoie, which was an independent duchy, not yet part of France. In November, the "pretty stranger" left them. Sade was distraught, and asked his wife and mother-in-law for help. They replied that they would stand by him, since they wanted to protect the family name and recover the correspondence of Anne-Prospère, who was having difficulties with her religious order. (There were rumors of a mysterious red casket containing compromising letters.) But in December, the king of Savoie, Charles Emmanuel III, sent the Comte de Chavanne to arrest Sade. He was taken to the Château de Miolans, in Saint-Pierre d'Albigny, with Latour, his partner in crime. Sade's stay was comfortable enough: He had a big room in an imposing tower, a chimney well stocked with wood, Latour by his side, dogs for company. He made friends with another powerful nobleman, the Baron de l'Allée, a big-time gambler. They lived it up for a while, but fell out over a game of cards.

Renée-Pélagie was spending money hand over fist. Accompanied by a trusted confidant named Albaret, she showed up in Savoie, where the guards were easily bribed. Sade escaped and returned to Lacoste. For a few months he played hide-and-seek with the police. Cunning as a fox, he stayed one step ahead and always slipped away before they arrived. The high-level authorities were growing "impatient." In March 1774, feeling the net tightening, Sade departed again for Italy. Shameless as ever, he even disguised himself as a priest. While he was in hiding, his mother and his wife pressed his cause everywhere to have the sentence passed in Aix revoked.

Opposite: Copy of a letter from Louis XV permitting Sade to go to court to defend himself against the sentence handed down in Marseilles on September 11, 1772.

Following pages: The closing pages of a letter written at Lacoste on June 27, 1778, by Gothon Duffé, a Swiss female servant, to the Marquis de Sade.

quil seul deja écoulé un siecle depuis votre
depart votre absence votre eloignement et lincertitude
ou me laisse vos affaires me jettent dans le plus
grand abattement je vous asure monsieur que je
suis bien triste et que je pleure tres souvent
en pensant a votre situation daignié donc
monsieur mhonnorer de vos nouvelle si je suivoit
mon inclination jabandonnerois a ce moment votre
maison pour voler ou vous etes afin du voir le plaisir
de vous voir je natten sur cela que votre permision
pour mexecuter si deja quelque chose monsieur
dans le pais qui puisse vous faire plaisir vous
navez qua ordonner de jour et de nuit vous pour-
ves disposer de moi a tout ce dont je puis etre -
capable
mr lavocal sest charger avec plaisir de vous re mettre
quelque fleur da cru de votre terrasse quelque a
bricots et deux pots de confiture de votre cru quoisque

vous soyez dans un païs ou il y en a de plus beaux
et de meilleurs peut etre j'ai crus que vous trouve-
riez les votre et plus beaux et plus exquis
quoi qu'il ne soient pas encore parvenu a leur
maturite parfaite j'en fis passer la semaine
derniere a madame par charvain quatre douze
nes vous en aurez bien eu sens doute la moitier
si j'avois pu prevoir d'avoir le plaisir de vous
d'avoir si jours d'ici veuillie bien monsieur
m'honnoree tous jour de votre protetion et de votre
bienveillances et etre convaincue que j'e
serai tous jour avec le plus respetueux a-
tachement

monsieur

de lacorette 27 juin 1778 votre trehumble tres
 obeissantte Serventte

But the Devil looks after his own. Sade's docile and submissive wife sought compliant servants willing to endure the master's whims, such as Anne-Marguerite Maillefert (aka Gothon Duffé), as well as several very young "maids of all work." We do not know the exact role played by a youth named André, hired as Sade's "secretary," we know only that he was illiterate. This group did not entirely please Sade, who sent for some "famous locals," from Marseilles and Montpellier. All this he did quite openly: The Reverend Father Durand, from the Convent of the Récollets, furnished still more prey, to Sade's delight.

The marquis lived in grand style, to such an extent that after a few weeks the families of the young servants were concerned enough to lodge a complaint for "kidnapping without their knowledge and by seduction." Once again, the indulgent Sade family stifled the affair, making all the evidence disappear.

In 1929, Paul Bourdin, one of Sade's biographers, unearthed the correspondence between Gaspard-François-Xavier Gaufridy, notary to Sade and many members

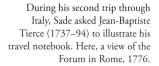

During his second trip through Italy, Sade asked Jean-Baptiste Tierce (1737–94) to illustrate his travel notebook. Here, a view of the Forum in Rome, 1776.

of his family. Reading the letters, we learn that the "scandals" that brought about the downfall of the Divine Marquis were not so much the Arcueil or Marseilles affairs but rather this terrible story of Sade's young victims, and we understand how, in this case, Sade's relationships grew strained and attitudes toward him hardened.

The consequences of this affair would weigh heavily, leading to fourteen years in prison, while the justice system and his family's money were erasing the older scandals. Beyond the "standard" abuses suffered by the victims, one of the young girls had been cut with a penknife. She was taken in secret to the Abbé de Sade's home in Saumane, where she appeared to be deeply distressed, and confirmed growing suspicions: The marquis showed a taste for blood and leaving marks.

Marie Tussin, another young girl who had been in Sade's "service," also accused him of abuse. Accusations are easily made, but the bodies of his victims bore traces of violence. The young Marie was then sent to a convent in Caderousse, near Orange, but rumors only grew louder. In this story, we see elements that would become premises of *The 120 Days of Sodom*.

In July 1775, not long after the young Louis XVI, grandson of Louis XV, had ascended the throne, more police officers, seemingly almost comically helpless, came seeking the "fugitive" but came up empty-handed, as Sade was again forced to flee. Under the pseudonym of the Comte de Mazan, he returned to Italy, reaching first Florence, then Rome. The following year, he stayed in Naples, where he met the young French painter Jean-Baptiste Tierce (1737–94), who would illustrate Sade's *Voyage d'Italie*.

All this came to an end with Sade's arrest in 1777, accused of sodomy and sentenced in Aix, a conservative jurisdiction. Condemned to imprisonment in the Bastille, he cunningly succeeded in slipping through his captors' fingers and reached the foothills of the Luberon. Back on friendly

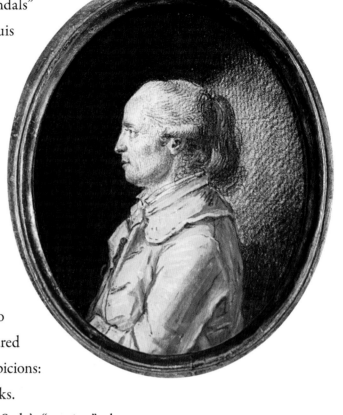

Above: Portrait of Gaspard-François-Xavier Gaufridy, Sade's notary and agent, based in Apt (about forty miles east of Avignon), who remained loyal to the marquis for twenty-six years.

Following pages: (left) Allégorie: La Chasteté de Cécile, (Allegory: The Chastity of Cécile), color lithograph by Salvador Dalí, from a portfolio by the artist entitled *Le Marquis de Sade* (New York: Shorewood, 1969) illustrating three plays by Sade. This image illustrates *L'erreur de l'infortune*—presumably the play included in the complete works as *L'égarement de l'infortune* (Fortune Misplaced). The twenty-five prints in the set, all signed and numbered by the artist, were made from a series of original gouaches commissioned in 1969 by the Sade family (Goldenberg Collection). *(right)* Memorandum concerning Sade, with testimony in a morals case in Montpellier.

9/J

Memoire

Concernant M. le marquis de Sade

Les deux filles du nommé Besson
Jardinier de la Ville de Montpellier dirent
vers la Toussaint dernier a la nommée
Catherine Trillet agée d'environ 22. ans
et fort jolie fille d'un tisseur de Couvertes
de la ville de montpellier rue Ste ursule
qu'elles etoient Chargées de la part du pere
durant Religieux revolé de ladite ville de
Chercher une Cuisiniere pour un Seigneur
qui etoit alors dans Montpelier et elle si
qui se retiroit dans son chateau eloigné
d'environ 15. lieues de montpelier et elles
proposerent a ladite Trillet agée d'environ
22. ans d'aller servir ce Seigneur, elle y
Consentit et furent toutes trois au logis
du Chapeau rouge se presenter a ce
Seigneur qui etoit m. le marquis de Sade
la Trillet qui gagnoit 40. écus a
montpelier en demanda 50. a m. de Sades
qui les lui promit et meme de la paier
selon qu'elle le serviroit.

"There is no more selfish passion than lust."

Detail of *Justine* by Camille Clovis Trouille (1889–1975).

turf, he hid at the home of the priest in the village of Oppède, who welcomed him most warmly, even going so far as to offer Sade his housekeeper, who was also his mistress.

As Sade took refuge in Lacoste once more, his relations with the locals were as tense as ever. The peace-loving villagers viewed with fear and annoyance the policemen's clumsy investigations and were horrified that the number of "nice girls" in the area appeared to be plummeting. Sade barely escaped when the enraged father of Catherine—nicknamed "Justine" by Sade—who worked in the château's kitchen, went so far as to discharge his pistol at the marquis one night, but it misfired. Of the irate father Sade later wrote, "He said that he had been told that he could kill me safely and that nothing would happen to him."

Sade sensed an ill wind blowing, so in late January 1777 he set out for Paris, but on February 13 his luck ran out: He was imprisoned by *lettre de cachet,* a secret royal order imposing punishment without trial, at the request of his mother-in-law, Madame de Montreuil, who was willing to spend whatever it took to end the scandal. Sade remained in jail in Aix for twenty-three days. His trial began on June 22; early on July 14, the parliament of Provence announced, "The court has received only complaints of libertinism and debauchery." Sade was punished only with an admonition from the royal prosecutor.

In the early morning hours of July 15 the marquis left Aix by carriage: Although he had believed himself free, Sade had just learned that he was to be locked up in Vincennes. On the night of July 16, at Valence, the marquis disappointed his would-be captors and escaped into the countryside. He reached Montélimar, Avignon, and at last, Lacoste. In his château of choice there now lived a new housekeeper, Marie-Dorothée de Rousset, daughter of a notable in Saint-Saturnin-lès-Apt. As a girl, she would have joined in the marquis's childhood games. Her figure was judged by her peers to be "middling," but her face was said to be moderately attractive, while her mind was lively, sharp, and subtle. She gave the impression of liking to banter at every opportunity. Changing his spots in a trice, Sade made himself all sweetness and light; he liked to talk with her, to be near her, to share a smile or take in the view. For her part, she encouraged this sort of courtly love and delighted in this relationship. Milli, as Sade called

Opposite: Engraving from *Thérèse philosophe* (Theresa the Philosopher), a famous pornographic text published anonymously in 1748, much admired by Sade.

Following pages: (left) Letter in the handwriting of Marie-Dorothée de Rousset (1744–84), addressed to Gaufridy, Sade's notary; *(right)* view of the church at Lacoste, dedicated to Saint Trophime, and founded in 1123.

J'ay reçû votre lettre par mlle Souton Monsieur Savorat, j'y repondrai dans un moment ou ma digestion sera faite, il est d'ailleurs fort tard, j'ay donné un rendé vous pour une promenade de nuit. Savon vouleur partir grand matin il me tourmante pour luy donner un billet afin de vous rendre favorable et propice dans ses interests. je luy ay rendu exactement la Reponce que vous m'aviés faite il est enchanté de finir il assure avoir un besoin extreme de son argent vous faires un heureux.

Le garde n'etoit point ivre c'est un insolent de toute façon, dans ses plaintes de hier se croyant seul avec sa maitresse, et ne se doutant pas que je parle devant eux pour luy repondre de la maniere qu'il convenoit, il sembloit qu'il y avoit des grands arrerages, Cet homme est un chien de politique et de fourbe pour vous et pour moy. j'aurais l'honneur de vous en dire plus long au premier moment, D'Elsine tout de suite aprés mes repas cela me fait tousser, et les quaintes me provoquent le crachement de sang. ainsi donc j'ay l'honneur de vous souhaiter le Bon Soir, et de me dire bien sincerement votre amie et servante Rousset

je vous felicite de la definition de votre Rapport, une autre fois vous choisiriés mieux le sujet, vous ne me marqués quand vous voulés que j'aille à apt, me bouderiés vous? il ne faut pas laisser partir mr de fontienne sans me faire finir avec mr Duclos, Cela est essenciel, sans quoi je mets à sec votre Bourse, et qui Scait Ce qui arriveroit en sus.

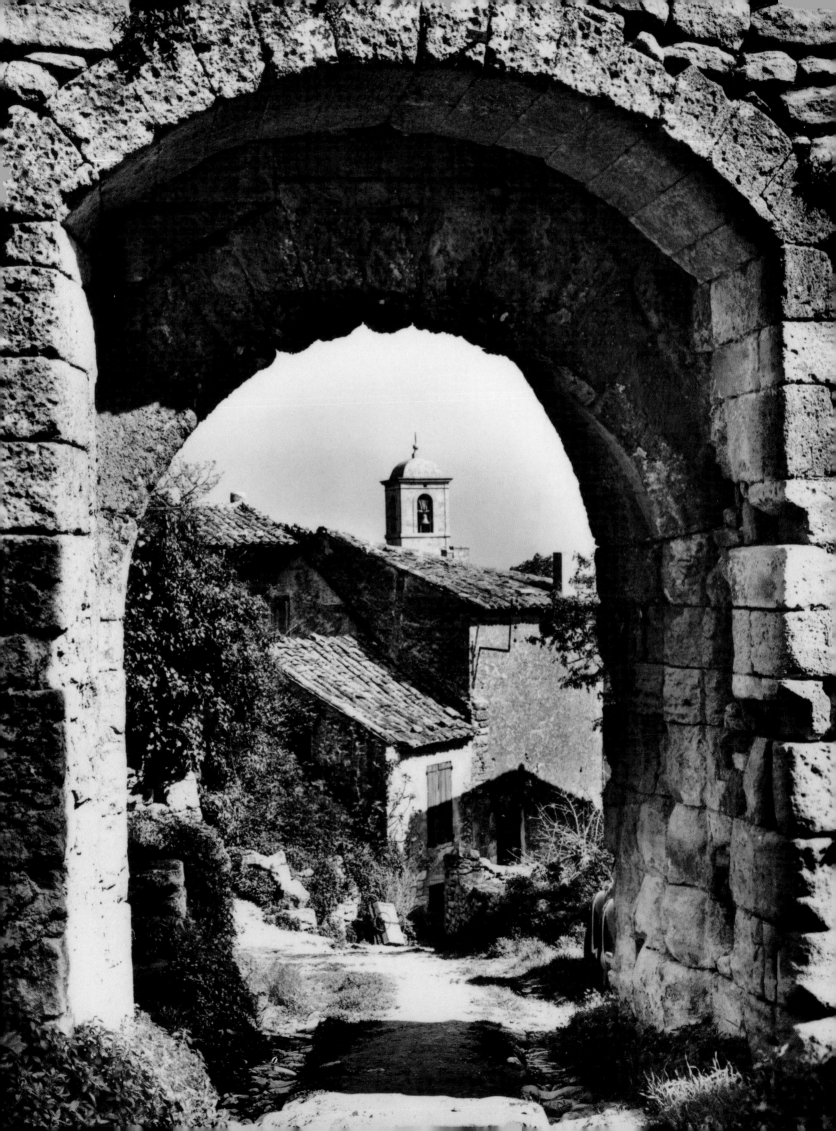

her, had set his senses on fire. All of his mistresses hitherto had been nothing but prey, but with Milli he seemed to have become respectful and charming.

It was in this sweet and gentle period that vicious rumors began to circulate about Gaufridy, Sade's notary, who was also his confidant, stockbroker, banker, etc. It was said that he had a penchant for Milli. Perhaps someone wanted to discredit him and force his withdrawal from the marquis's affairs. In this turmoil swirling around a moment of calm, Madame de Montreuil learned of her son-in-law's presence in Lacoste. Her fury redoubled when her daughter, Sade's wife, announced her intention to return to Provence to rejoin her husband. However, Renée-Pélagie remained in Paris, in the Carmelite convent on the rue d'Enfer (Hell Street), near the eponymous city gate, today the Place Denfert-Rochereau. In August 1777 grim letters informed Sade that his situation was becoming dangerous. On the evening of August 19, a local inn filled with "pale faces" of those bent on revenge. Alarmed, Sade decided to spend the night in Oppède, then to remain in hiding, while Milli kept him informed by secret messages. Not long after, gnawed with anxiety, Sade hid in an isolated barn not far away.

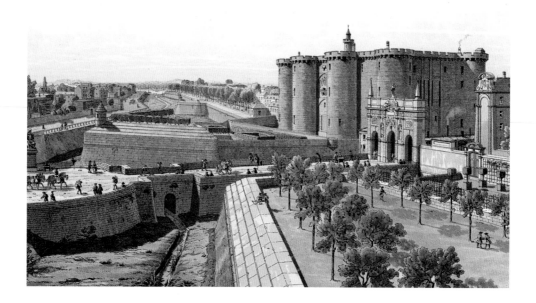

Engraving of the fortress of the Bastille (formally the Bastille Saint-Antoine) in Paris c. 1740. Sade was incarcerated there for more than five years beginning in February 1784.

But, not knowing what to believe, and disdaining all caution, he returned to Lacoste. On the evening of August 26, he heard shouts and cries as his door was broken in; he had to quit his bed and hide in a tiny side room. Sade was forced to surrender to Inspector Marais, accompanied by police agents from Paris and local men-at-arms, bristling with weapons: He was well and truly caught. He was bound and thrown into a carriage. Drama contending now with farce, it took them thirteen days to reach the capital, as Sade had become something of a celebrity and curious onlookers thronged the vehicle along the way.

Sade was able to send word to his notary, urging him to take several practical measures regarding Lacoste and some of his farms. Accustomed to issuing orders and organizing matters, Sade did not hesitate to entrust Milli with a number of tasks—to keep certain papers and documents hidden—and to give the keys to their hiding places to his wife upon her arrival. After putting everything in order according to Sade's wishes, Milli joined Renée-Pélagie in Paris later in the autumn, staying in the same convent as Sade's lawful wife. She put all her savoir faire to work in an effort to have her lover freed, including making overtures to his aunts.

On September 7, 1778, at 8:30 p.m., the gates of the fortress of Vincennes slammed shut behind the ardent libertine and brilliant writer. He became the prisoner in cell number six. During his time in prison, Sade shed his guise as a fiendish libertine nobleman, becoming simply Donatien-Alphonse, still a young man, and an author—if not wise, at least profound and penetrating.

Sade served out his sentence for twelve years, at Vincennes until 1784, then in the Bastille. By sheer luck he escaped the death penalty to which he had been sentenced. Yet those close to him feared both for him and for his wife. Sade's daily routine in Vincennes, a former royal castle most closely associated with Louis IX, was hard. He was shut up in a tower, with twenty-odd locked doors between him and freedom. Daylight entered his cell stingily through two little barred windows. He was called "Monsieur Number Six," according to prison tradition, after his cell number. Privileges were few; the prison was infested with rats and other vermin; Sade felt himself banished from the world as time seemed to come to a halt.

À Madame

Madame de Sade

à Paris

Letter in Sade's handwriting to his wife dated October 3, 1779. In order to evade the censor, Sade wrote a second letter in invisible ink between the lines of the first.

Ce 3 9bre 1777 ou coin de mon feu (encor qui m'eut dit que j'en
allumerois ici) ou plustot de mon poële car il n'y a que cela dans cette
maudite maison. ce qui joint a une année si exacte qu'il
que tu m'envoies elle me devient une preuve plus que
suffisante du temps enorme que j'ai sans douter a rester ici
de la prison No 4: ...

je vois bien que vous vous accoutumez a mon sort ma chere
amie, et que ce sera jusqu'au bout que vous ferez durer votre chagrin
j'aime mieux que vous travailliez comme cela et l'avance a le
petit persiflage aussi deplacé que ridicule et qui veut
detruire que de le laisser subsister jusqu'au dernier moment
reellement pas fait pour vous attirer des sentiments bien
comme vous faisiez cet été ce qui me plongeoit apres au
chauds de ma part. souvenez vous bien que quelque chose que
desespoir quand ce fatal instant arrivait ceci est beaucoup
vous puissiez dire et faire il ne me sera jamais possible de
moins cruel. vous repondes a la lettre ou je vous demandois
vous pardonner votre acharnement a faire une chose que
un bonet et ou je vous parlois des manches de ma veste verte
tout prouve que vous sçavez mais vous me le dites par votre
et vous dites que dans cette lettre il n'y avait point d'amitié pour
jargon inintelligible vous? peutetre a la bonne heure mais je
vous. Cela m'etonne. ou plutot me paroit tout simple bon
y vous entends pas et mon malheur en devient que plus affreux
bien qu'il faut que l'inconsequence et la deraison deviennent
que je le garde ou secaux veille une prison soit, mais
les bases de notre commerce. avant peu la contagion me
que vous vouliez me persuader qu'il y joint la barbarie d'un
gagnera et comme elle tient un peu a la folie, l'air de ce
pardonne que je sois ainsi... de voila ce qui
sejour est tres propre a la determiner.

je ne ferai point mettre de manche a cette verte j'ai
autre chose a mettre et j'ai la manie de vouloir la garder
pour le beaufour. vous sçavez lequel? Dieu veuille que ne soi

In September 1783, Sade described himself in a letter to his wife: "As for my vices: imperious, angry, quick-tempered, extreme in everything, subject to a disturbance of the moral imagination never equaled in any other, atheist to the point of fanaticism.... In a word, there I am, and what is more, either kill me or take me as I am, for I will not change."

During Sade's detention, Milli Rousset, whom Sade also called Milli Printemps ("Springtime") or Fanny, was ever at his side. A pure and simple soul, she remained close to Renée-Pélagie and helped both spouses—Sade with his material needs, his wife with her need for comfort and affection. Moreover, Milli was always vigilant in keeping Sade's mind open and active: She teased him, pestered him, titillated him, always trying to enliven a mind she judged superior to many others. In tender moments she also liked to speak Provençal, that language redolent of cicadas and sunshine. But the wearing effects of time or the lack of sexual contact slowly extinguished the flame the two lovers had shared in Lacoste. Their ties grew strained, there were cutting remarks, harsh words, less physical affection. They scratched and stung and hurt each other. On January 25, 1784, Milli died alone in Lacoste. She had been spitting up blood and growing weaker for a long time. Sade suffered in her absence.

A few days later, the authorities decided to close the fortress of Vincennes. There were only three prisoners left: Comte Hubert de Solages, Comte de Whyte de Malleville, and Sade—fashionable noblemen all. On February 29, 1784, they were transferred to the Bastille, a new symbol of cruelty and, soon, of liberty. Sade was now housed within the infamous walls first built by Charles V in 1370, the very symbol of arbitrary royal power.

It was here that Sade, profiting from his imprisonment as much as he could, wrote *The 120 Days of Sodom*. This extraordinary manuscript is a scroll comprising thirty-three little attached sheets, 12 meters long by 11 centimeters wide (40 feet by 4⅓ inches), covered in a tiny hand. According to one story, upon his release from prison in 1789, Sade took the manuscript—a veritable work of art, this scroll of fine paper—with him (possibly *on his person*), hidden inside a hollow dildo. Already Sade was achieving mythic status.

Death certificate for Marie-Dorothée de Rousset, childhood friend of Sade's and grand-niece of Joseph-François de Rémerville, a historian and Provençal poet who resided in Apt.

Extrait des registres de
l'état civil de la commune
de Lacoste (Vaucluse)

1784

Mademoiselle Marie Dorothée de
Rousset agée d'environ quarante années
est morte dans la communion de l'Eglise
après avoir reçu les sacrements avec édification
le vingt cinq janvier et a été ensevelie le
vingt sept janvier de la présente année
mil sept cent quatre vingt quatre
dans le cimetière de cette paroisse
présents Antoine Terenc et Jacques
Clot, lesquels requis de signer ont déclaré
ne savoir

Signé Testaniere pr Curé

Sade was first put on the second floor of the ironically named Liberty Tower, where he was called "Liberty Number Two"; later he was moved to a sixth-floor cell. He was depicted by his jailers thus: "A full, handsome face; of medium height." He wore a gray tailcoat and marigold silk breeches, with a feather in his hat, a sword at his side, and a cane in his hand. Madame de Montreuil once more opened her purse so that Sade's detention might be as comfortable as possible. In this period, incarceration was not necessarily synonymous with being endlessly degraded and humiliated, but simply with deprivation of liberty. Prisoners could have furniture, food, personal effects, candles, and so on delivered. People hoped that Sade had become mild and repentant, and imagined him so. Quite the contrary: He was annoyed and raged against the world. His fellow prisoners, unknown or famous, such as Henri-Gabriel Riqueti, the Comte de Mirabeau, all had to put up with his ire and his moods. Sade was entitled to two hours of exercise per day: One in the morning, to take the air atop the prison's ramparts, and one after lunch, in the courtyard. His solitude weighed upon him more and more. He gained weight, he lost his good looks. Once, while in one of the Bastille's dungeons, he described himself thus: "I have become, for lack of exercise, so corpulent that I can hardly move." His eyes began to trouble him, and in June 1787 he was examined by oculists, but with inconclusive results. The marquise visited often, bringing comfort and, above all, reading and writing materials.

The manuscript scroll of *The 120 Days of Sodom,* written in the Bastille, three hours a day, from October 22 to November 28, 1785. The 11 cm–wide pages were assembled into this scroll, 12 meters long (40 feet by 4⅓ inches) (Martin Bodmer Foundation, Cologny, Switzerland).

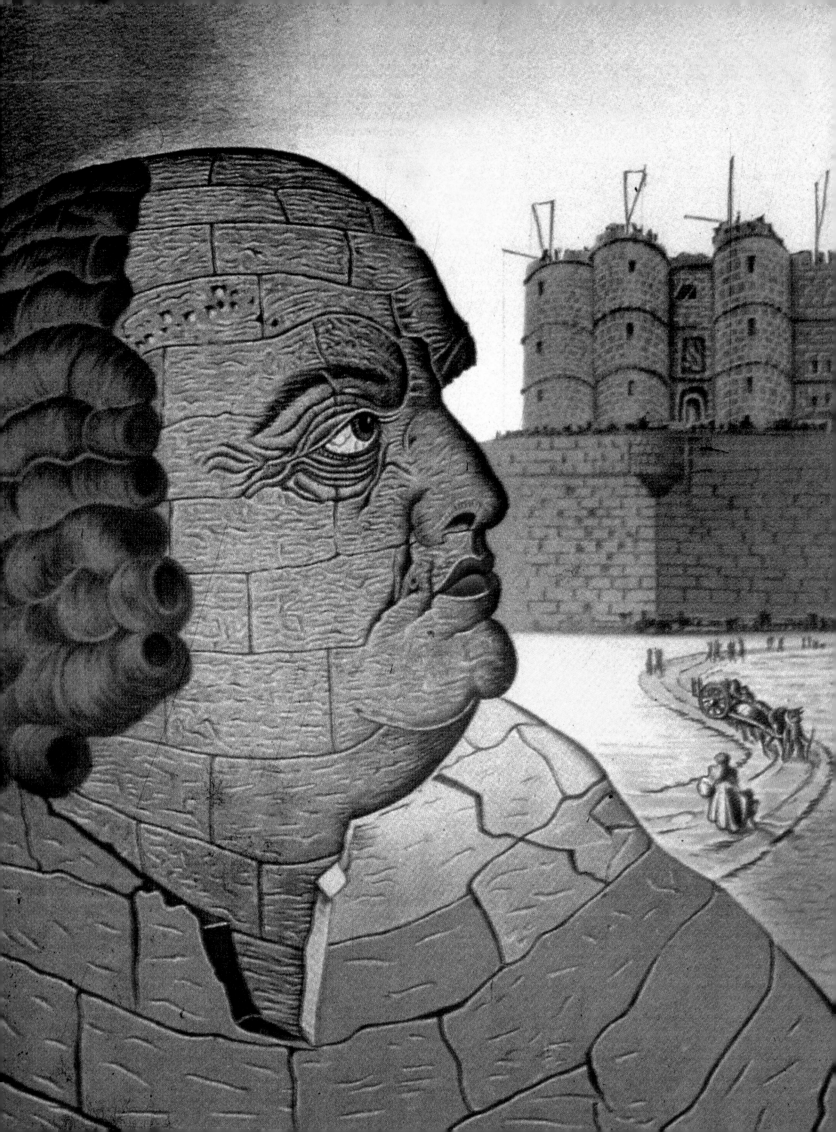

66 It is not my mode of thought that has caused my misfortunes, but the mode of thought of others. 99

Imaginary portrait of Sade by Man Ray, 1938. The artist depicts the marquis as obese, gazing upon the Bastille. Sade here is himself made of stone—perhaps the artist's way of representing the stultifying effects of long-term imprisonment.

A token of the "section des Piques" dated 1793; the reverse shows the Revolutionary Phrygian cap ringed by the motto "Liberty or death" (Musée Carnavalet, Paris). The marquis joined this radical Jacobin revolutionary faction, originally the "section de la Place Vendôme") in July 1790 and was named its secretary in September 1792.

The tone of Sade's correspondence with the outside world, including those close to him, grew stiff. Sade wrote to his wife in 1783: "Since being no longer able to read or write, here is the hundred and eleventh torture I have invented for her [his mother-in-law]. This morning, I pictured her flayed alive, dragged over thistles, and then thrown in a vat of vinegar. I said to her, 'Execrable creature, take that for selling your son-in-law to the executioner! Take that for ruining and dishonoring your son-in-law! Take that for making him lose the best years of his life, when he counted on you alone to save him after his sentence!'" And furthermore: "It is not at all my way of thinking that has caused my misfortune, but that of others." And: "You stirred up my brain, you made me imagine phantoms[5] that I had to make real."

Sade was a man living (or surviving) in a state of absolute frustration. Yet as Simone de Beauvoir says so rightly, "He entered prison as a man, and left as a writer."[6] Overall, Sade's literary production in this period, with numerous novels and plays, is abundant, and frankly obscene. In those early days of the Revolution, Sade's relationship with Bernard-René-Jourdan, Marquis de Launay, governor of the Bastille, deteriorated and, whether motivated by weariness or anxiety, De Launay had Sade sent off to Charenton, an insane asylum.

Released in March 1790 by the Constituent Assembly, after its abolition of *lettres de cachet,* Sade was torn between the revolutionary fervor all around him and his legitimate desire to protect his most precious possession, his estate at Lacoste. Moreover, his wife, who had retired to live in a convent, refused to see him, and even obtained a legal separation.

In Paris, Sade was an agitator within the radical Jacobin Section des Piques (which included Robespierre) while advocating for hospital reform. To raise funds, he endeavored in these years to have several of his plays produced, winning some critical successes and sometimes playing to good houses. In 1791, Sade's anonymous *Justine, ou Les malheurs de la vertu* (first published in English as *Justine, or Good Conduct Well-Chastised*) was published collaboratively in Holland by Paris and Girouard, and soon after, his *Adresse*

d'un citoyen de Paris au roi des Français (Address of a Citizen of Paris to the King of the French), by Girouard alone.

From 1792 to 1794, Sade was in and out of prison several times, on various charges. The Legislative Assembly, like the Convention before it, proved little inclined to liberty of morals. Sade got himself elected secretary of the Piques in August 1792. He used his influence to protect his in-laws from arrest, but on December 8, 1793, Sade himself was arrested by order of the Committee of General Security as "suspect," in the house he had shared since January 1791 with his mistress, actress Marie-Constance Quesnet, at 20, rue de la Neuve-des-Mathurins, in the Chaussée d'Antin quarter. Now fifty-three, Sade remained in prison until October 15, 1794. His "certificate of residency" described him thus: "Height: five feet, two inches, hair almost white, round face, high forehead, blue eyes, ordinary nose, round chin." Paradoxically, he was found to be rather mild and full of humanity.

Madelonnettes Prison, a former convent, at 12, rue des Fontaines-du-Temple, was the first of the "four prisons" named in Sade's letters. Twelve years of incarceration at Vincennes and the Bastille had surely made him familiar with the experience of imprisonment: guards bribable (or not), rules bendable (or not), invisible cracks in the system. And he knew well his own capacity for resistance; three years of freedom had left it dormant, but he would reawaken it. The only question was, how long would he be there? The Revolution was no clearer about the length of prison sentences than the monarchy had been; moreover, it released very few and guillotined many. One of Sade's first letters urged his colleagues among the Piques to intervene in his favor. But Sade's situation—as a former noble and victim of a *lettre de cachet,* as well as an "active" citizen who had published minor political works but who was also a libertine writer known to have written *Justine*—made them cautious. They waited to see which way the revolutionary wind would blow.

The grave of Sade's wife and their daughter, Madeleine-Laure (Cimetière Communal d'Échauffour).

Les Jumelles
ou Le Choix difficile.

Comédie

en deux Actes et en Vers.

Similima Proles

indiscreta Suis gratusque Parentibus Amor.

Virgille.

One month after his release, he would write in a letter to Gaufridy, dated November 19, 1794: "I have been in four prisons in the last ten months; in the first, I slept for six weeks in the latrines." On January 13, 1794, he was transferred to Carmes, at the corner of rue d'Assas and rue de Vaugirard: "In the second, eight days with six people stricken with a virulent fever, two of whom died in front of me." On January 22, he was moved to Saint-Lazare, at 107, rue du Faubourg-Saint-Denis, where the painter Hubert Robert was imprisoned; there Sade wrote an appeal describing his political conduct addressed to the members of the Committee of General Security: "In the third, in the middle of the counterrevolution of Saint-Lazare, a prison where I protected myself from infection only by incredible caution." On March 27, he was finally transferred to Picpus: "My fourth and last was heaven on earth: a beautiful house, a superb garden, select company, agreeable women, when, all of a sudden, the execution site was set up just below our windows and the graveyard for the guillotined right in the middle of our garden. We saw buried, my dear, eighteen hundred, in thirty-five days, including a third of our unhappy household. Finally my name was put on the list, where it remained through the eleventh, when the sword of justice had fallen heavily the day before on the new Sulla of France [Robespierre, guillotined on 10 Thermidor]. From that moment on, everything calmed down and, through the efforts, as prompt as they were zealous, of the admirable companion who has shared my heart and my life for five years, I was at last liberated on the twenty-fourth last Vendémiaire [October 15]."

Transferred in this way from prison to prison, Sade escaped the scaffold before the events of 9 Thermidor (July 27, 1794), which culminated with the Montagnard faction's coup d'état against Robespierre and their subsequent dissolution. Sade had indeed been on "the list," but the authorities did not look for him in the right place. For seven years, from October 1794 to March 1801, the Thermidorian Reaction left Sade free to enjoy his liberty, until he was arrested once again under the Consulate, on March 6.

In 1795, Girouard published Sade's *Aline et Valcour, ou, Le roman philosophique,* which he had written in the Bastille in the 1780s (with a subtitle falsely claiming that the book was written a year before the Revolution). Next came *Philosophy*

Opposite: Les Jumelles, ou le Choix difficile, a comedy by Sade found in the library of the Château de Condé-en-Brie by his descendents.

Following pages: Certificate testifying to the Marquis de Sade's good moral character issued by the city of Clichy, 14 Thermidor, Year VII (August 1, 1799).

Clichy, le an
la République Française, une et indivisible.

DÉPARTEMENT
DE LA SEINE.

CANTON
DE CLYCHY.

Nous membres de

L'Administration Municipale du Canton de Clichy, Département
de Seine, certifions a qui il appartiendra que le cen
Sade (Donatien alphonse françois) domicilié Commune
de St ouen de cet arrondissement, a obtenu à la ditte
administration, Séance du quatorze thermidor an Sept,
un certificat à neuf temoins attestant Sa résidence,
Scavoir 1° en la Commune de Clichy, depuis le trente
vendemiaire an Cinq jusqu'au premier floréal meme
année et depuis le dit premier floréal jusqu'a ce jour
en celle ditte de St ouen.

Certifions en outre qu'il est a notre Connoissance
que Depuis que le dit Sade est dans notre arrondissement
il n'a jamais manifesté d'opinion Contraire au vrai
républicanisme et que nous avons toujours remarqué

en lui des qualités civiques qui caractérisent le bon citoyen.

En administration le dix huit thermidor an sept de la république française une et indivisible.

Janvier& Muelle

Pouvier Port-Poirié

Boucry

Je, Commissaire du Directoire Exécutif près l'admon Susdite, atteste qu'il est à ma Connoissance que Depuis le Commencement de la révolution Jusquez à ce jour le Citoyen Sade a Constament manifesté les principes d'un bon et Sincère patriote, et d'un excelent Républicain depuis l'Epoque de 1792 (v.s.) en un mot, qu'il a toujours été d'une opinion prononcée pour la Révolution et la liberté.

Sarade

in the Bedroom (whose subtitle called the book "the posthumous work of the author of *Justine*"), published "at the publisher's expense" (an indirect reference to the author's pretended decease). The post-Thermidorian period provided a healing respite after the Terror, and morals followed suit, becoming once more as depraved as they had been during the monarchy. In 1797, keeping up with the times, Sade began to publish a new, deluxe edition of *Justine* (written in 1787 and published in 1791), as *La nouvelle Justine,* much expanded and illustrated with some one hundred engravings on vellum. Sade took the opportunity to send a copy to each member of the Directory. *Justine* was augmented by a sequel, *Juliette, or Vice Amply Rewarded,* about Justine's sister. Printing of the novels' ten-volume set was completed by 1801. A play, *Oxtiern, The Misfortunes of Libertinage,* which had been staged at the Théâtre Molière in 1791, was published in 1800.

Thinking nothing of it, in 1798 Sade sent a copy of *La nouvelle Justine* to Napoleon, who threw it in the fire—an ill omen. The future emperor said later, "It is the most abominable book ever engendered by the most depraved imagination."[7]

Portrait of François Simonet de Coulmiers, the director of the Charenton asylum.

In the spring of 1798 the financial situation of Sade and his mistress Marie-Constance deteriorated. The revenues from his farms in Beauce were seized; Sade sold numerous objects and pieces of furniture. Desperate, the couple was forced to separate. At his wits' end, Sade found a job as a prompter at the theater in Versailles, enough to make ends meet. In 1799 *The Crimes of Love* appeared, prefaced with an essay on the nature of fiction. The end of the year found Sade alone and destitute, and he was taken in by the hospice in Versailles. He rubbed elbows with the sick, the homeless, beggars. He presented himself as untouchable. But Sade was having trouble getting *Justine* accepted. In response to journalist Alexandre-Louis de Villeterque, who had attacked him violently in the *Journal des Arts, des Sciences et de la Littérature,* Sade would publish a

short work entitled "The Author of *The Crimes of Love* to Villeterque, Hack Writer." By spring 1800, however, Sade was able to move back into his house in Saint-Ouen: his books sold, he received royalties, and he was restored to life.

By January 1801, the Consulate's restoration of domestic peace in France led to the reintroduction of a rigid morality. Arbitrary power was ascendant once more, and the police impounded *Justine* and *Juliette*. On March 6, Sade was arrested as a libertine author and incarcerated in the Saint-Pélagie prison, without sentence; a few days later he was branded "an incurable and dangerous madman. In 1803, with the Constitution of the Year 10 now in effect, making Napoleon First Consul for Life, the authorities took a hard line. On March 14, Sade was moved to the Bicêtre prison, but his family, shocked by the degrading way prisoners were treated there, was able to get him transferred to the Charenton asylum. On April 27, Sade reached what would be his last home on earth.

Charenton was a mental asylum, but it was plain that Sade was not insane. As often happens in dictatorial or totalitarian regimes, Sade was diagnosed as a sexual obsessive. The prefect, Louis-Nicolas Dubois, a by-the-book man, wrote, "This incorrigible man is in a perpetual state of libertine madness." One of Sade's contemporaries wrote, "There, the marquis maintained, until his death, his sordid tastes and habits. When he walked in the courtyard, he would scratch obscene drawings in the sand. When you visited him, his first utterance would be something filthy, and all this with his very soft voice, with his very handsome white hair, with the friendliest air, with admirable politeness. He was a robust old man and without infirmities."

At Charenton, Sade enjoyed a few privileges. His "room," off a library, overlooked the Marne; he was allowed to go for walks as much as he liked, to have guests at meals—yet he was always under surveillance. In particular, his space was

Above: Imaginary portrait of Sade in prison (French school, 19th century).

Following pages: Engraving by Godefroy Engelmann depicting the asylum of Charenton-Saint-Maurice c. 1830. Founded in 1641, Charenton housed the insane and a few inmates sent there by *lettres de cachet,* secret royal orders. Sade was imprisoned there twice: first in 1789, and then from 1803 until his death in 1814.

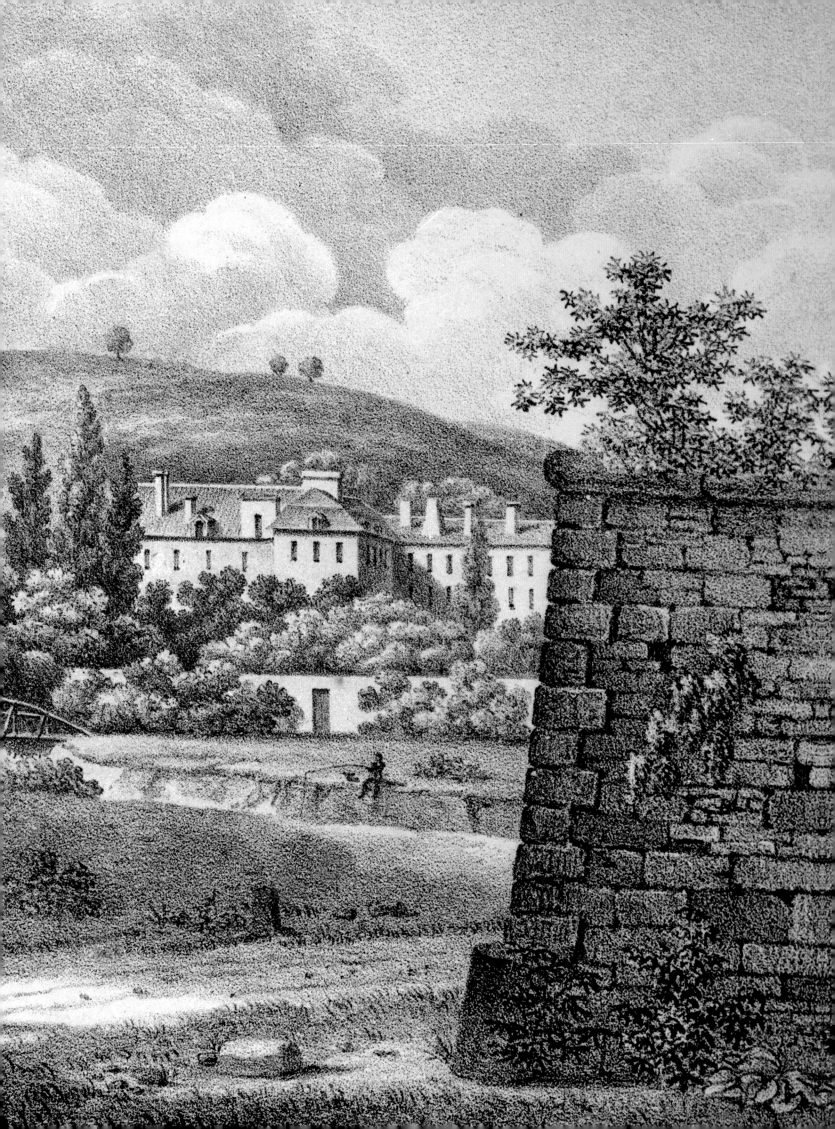

a Sa majesté

L'empereur et roi, protecteur de
la confederation du Rhin en sa commission
des petitions au conseil D'etat

Sire

le Sieur de Sade pere de famille dans le Sein
De laquelle il voit pour sa consolation un fils qui se
distingue aux armées, traine depuis près de neuf
ans dans trois differentes prisons consecutives, la
vie du monde la plus malheureuse. il est Septuagenaire,
presqu'aveugle, accablé de goute, et de rhumatismes
dans la poitrine et dans l'estomac qui lui font souffrir
D'horribles douleurs. Des certificats des medecins de la
maison de charenton ou il est maintenant attestent
la verité de ces faits et l'authorisent a réclamer
enfin Sa liberté en protestant qu'on n'aura jamais
lieu de Se repentir de la lui avoir Donnée

il ose Se Dire de votre majesté

Sire, avec le plus profond
respect,

Le tres humble
tres obeissant Serviteur
et Sujet

De Sade

Charenton Ce 17 juin 1809

regularly searched for licentious texts. On June 5, 1807, prison authorities found Sade's manuscript of *Les journées de Florbelle, ou La nature dévoilée* (The Days of Florbelle, or Nature Unveiled).

Sade got on well with the Charenton's director, François Simonet de Coulmier, a churchman who had been a legislative deputy representing the clergy during the Revolution and a member of the legislature under the Empire, known for his kindness and benevolence. Following in the footsteps of the "alienist" (psychiatrist) Philippe Pinel, he made conditions for the inmates less harsh, and put an end to practices he regarded as barbaric: No more caging or straitjackets, recognition of a right to clothing, an end to cold baths. Although he kept his distance from the police under Napoleon and Joseph Fouché, the emperor's minister of police, he was dismissed following the Bourbon Restoration for being too humane.

Regarding his famous inmate, Coulmier was conciliatory, procuring him paper, pens, ink, and books, and allowing Marie-Constance to live with him once again. Coulmier also believed in the therapeutic value of theater on mental illness, and Sade staged plays in the asylum, including some of his own. It was a fertile literary period for him. Coulmier had a real theater built, with raked seating, that could fit some forty inmates and almost two hundred guests. The venue quickly became popular among fashionable society as crowds rushed to the "Coulmier-Sade" performances. The casts mingled inmates with professional actors or top-notch amateurs. Sade wrote the plays, directed the performances, designed the sets. If he closed his eyes, he could believe he was at Lacoste, under the southern sun, with the cicadas and the wild winds.

Even at Charenton, the police, with the force of Napoleon and the Empire behind them, dogged Sade, canceling his performances, destroying his manuscripts, driving a sword through the heart of a man on the decline, without the least respect for his immense literary talent. As an author, Sade would long remain the paradigm of a monstrous imagination, representing madness, vice, debauchery, and crime. As the nineteenth-century critic Jules Janin once wrote in *La Revue de Paris:* "Do you want me to analyze one of the Marquis de Sade's books for you? They are nothing but bloody corpses, children torn from the arms of their

mothers, young women with their throats cut at the end of an orgy, goblets full of blood and wine, unheard-of tortures. The fire is lit beneath the cauldron, the rack is set up, skulls are split, men and women are flayed of their burning skin, there are cries, oaths, blasphemy, they bite one another, tear the hearts from their breasts, and this on each page, on each line, always."

But the chief physician at Charenton, like Coulmier, thought Sade was out of place in this institution for the insane. He leaned toward moving Sade to a fortified prison; at Charenton Sade enjoyed too much freedom. Since he was not mad, he could not be treated, so he should be elsewhere. The servile Prefect Dubois recommended the Château de Ham, a castle in the Somme (where the future Napoleon III would be imprisoned from 1841 to 1846). In April 1809, Fouché initially decided to follow Dubois' recommendation, but in the end decided to leave Sade at Charenton, at the request of his family, for life.

At age sixty-six, the licentious author still inspired fear. The Empire stiffened its resolve; Fouché left office, to be replaced by Jean-Pierre Bachasson, Comte de Montalivet, more loyal and obedient than Fouché. His command: "Considering that the Sieur de Sade is afflicted by the most dangerous kind of madness, that his communications with the other inhabitants of the house risk incalculable danger, that his writings are no less insane than his speech or his conduct, he will be placed in an entirely separate place, in such a way that all communication with him will be forbidden under any pretext whatsoever. The greatest care will be taken to forbid him any use of pencils, ink, pens, and paper." Effectively, Sade was suffocated.

May 31, 1814: Exit Director Coulmier, enter Martin Grégoire du Roulhac de Maupas, a rather closed-minded lawyer, son-in-law of the famous professor of forensic medicine Antoine-Athanase Royer-Collard. As soon as he was in charge, Roulhac de Maupas attacked Sade with everything he had, even as the old man declined. Unable to expel him, he considered having Sade locked up in the *"quartier des furieux,"* the ward for the violently insane. The new minister of the interior, François-Xavier-Marc-Antoine de Montesquiou-Fézensac, more open-minded and benevolent, hesitated to do so. In November, Sade's health declined suddenly; he had pain in his lower abdomen and his testicles.

Following pages: (left) Report from the doctor at Charenton on Sade's last days, in 1814; *(right)* Sade's last will and testament, in his hand, written by Sade at Charenton in the presence of his companion, Marie-Constance Quesnet (signed and dated January 30, 1806).

Notes sur Monsieur de Sade

Entré à la maison royale de Charenton le 11 novembre 1814, je n'ai eu aucun rapport, ni aucun entretien avec le M. de Sade qui a succombé le 2 décembre suivant à une maladie que je n'ai pu étudier que pendant quelques heures et qui ne m'a laissé d'autre impression que celle d'un engouement pulmonaire accompagné peut-être d'épanchement séreux dans la poitrine avec respiration difficile et sifflante comme il arrive dans les accès d'asthme.

Je ne connaissais M. de Sade que parce que on me l'avait signalé; je le rencontrais fréquemment se promenant seul d'un pas lourd et traînant, mis d'une manière fort négligée dans le corridor avoisinant l'appartement qu'il habitait; je ne l'ai jamais surpris causant avec personne — passant à côté de lui je le saluais, et il répondait à mon salut avec cette politesse froide qui éloigne toute idée d'entrer en conversation.

M. de Sade était peut-être un des personnages curieux de l'époque et de la dernière moitié du 18e siècle; curieux, par ce que j'en avais entendu dire; car je n'avais pas encore lu ses livres, et bien que je les connusse fort imparfaitement il est vrai par tradition; mais lecteur, je dois le dire, rien n'a pu pourrait me faire soupçonner en lui l'auteur de Justine et de Juliette; il ne produisait sur moi d'autre effet que celui d'un vieux gentilhomme altier et morose.

Le 1er décembre 1814, l'état de M. de Sade s'aggravant, on le transporta dans un autre appartement composé de deux pièces où il fut confié à la garde d'un domestique.

Dans l'après-midi, un de ses fils vint le voir; c'était un homme d'un âge au moins mûr, ayant servi pendant l'émigration en Russie, soit dans l'armée de terre soit (ce que je crois) dans la marine; le M. me pria de veiller d'un père; ce à quoi mon fonction de jour; ma fonction de borner à lui faire prendre quelques gorgées de tisane et d'une potion qui avaient été prescrites, la respiration qui était bruyante et laborieuse — s'embarrassa de plus en plus vers le milieu de la nuit, et peu de temps après avoir fait taire vers les plus aucun bruit, et surpris de ce calme, j'approchai de son lit et je pus constater qu'il était mort.

Avant de prendre mon service, j'avais rencontré, sortant de chez M. de Sade qu'il visitait d'ailleurs depuis plusieurs jours, l'Abbé Geoffroy, aumônier de la maison de Charenton, ecclésiastique éclairé qui en

Testament

de Donatien alphonse François Sade

je m'en remets de l'execution des
clauses mentionnées ci-dessous a les
piété filiale de mes enfans, Desirant
que les leurs agissent envers eux Comme
ils auront agi envers moi.

1er voulant temoigner a Demoiselle marie
Constance renelle femme ~~veuve~~ veuve de
~~feu~~ monsieur balthazar quesnet. autant
que mes faibles pouvoirs me le permettent mon
extreme reconnaissance ~~et~~ des Soins et
pour moi depuis le vingt cinq ~~du~~ avril mil
de la pure et sincere amitié qu'elle a eu
Sept cent quatre vingt dix, jusquau jour de
mes deces Sentiments temoignés par elle
ma mem...eux en m'enlevant Sous le regime
avec delicatesse et Desinteressement
de la terreur a les fours revolutionaire
trop constamment Suspendu Sur ma tete
et que chacun S'est efficée detourné avec
autant de Zele que d'adresse et de bienfaisance
je Donne et legue a la ditte Dame ~~quesnet~~ ~~Constan~~
marie Constance renelle femme quesnet. La Somme

de vingt-quatre mille livres tournois
en espèces monnaie&c et ayant cours
en France à l'époque de mon décès
voulant et entendant que cette somme
soit prélevée sur le plus libre et le
plus clair partie des biens que je laisse
chargeant mon enfant de le lui ~~compter~~ déposer
dans l'espace d'un mois à compter de ~~jour~~
un de cés chez le Sieur Finot notaire
à Charenton St Maurice que je nomme
aldt Sld mon exécuteur testamentaire
que par lui [soit] employé de le dite Somme
de le manière énoncée ci après C'est à dire
que le Sieur placera le dite Somme de
manière la plus sûre et la plus avantageuse
à Hugues quenel et susceptible de lui [procurer]
un [e] ~~~~ subsiste revenu suffisant à Son
aliment et à Son entretien [revenu] exactement
payé de trois en trois mois inaliénable et
insaisissable par qui que ce puisse être
voulant en outre que le fond et la rente
de ladit Sous soit reversible à Charles
quenel fils de ledit Dame quenel
lequel deviendra aux même qualité
[possesseur] dudit dat même Seulement à l'époque
de décès de Sa ~~~~ respectable mère
et cette volonté que j'exprime ici de le legs
faite par moi à Hugues quenel dans le cas
imprésumable où mon enfant chercheraient à

Se souvenir qu'il aura pris le … souvenir
que donne … que …
en connaissance de … … sur les …
et que cet acte ci en … qu'il accorde
à … leur … intention le doute
… ne peut même agiter un instant
mon esprit et surtout quand j'y réfléchis
au vertu morale qui nous … jamais …
de les distinguer et de les mériter avec élévation
… sensibilité et amour fraternel

2° Je donne et legue en outre à ladite
Dame … toute … meubles, effets, linges
habits, livres et papiers qui se … trouver
… à l'époque de mon décès, à l'exception
… des papiers de mon père et désigner
lesquels … venir … un an —

3° Il est également dans mon intention et
volonté dernière que les … leçit ne
… … madame … tout au
… … de tous les droits réclamations
ou créances qu'elle peut avoir à … sur
ma succession … qu'elle … être

… dans la marge gauche:
Je donne
et legue
à … mon
mon exécuteur
testamentaire
un …
… de douze
cent livres pour
… …
… donne
le … dont
il veut bien se
charger pour moi

… bas:
Je … que mon corps soit ouvert et qu'on qu'il
soit gardé quarante huit heures dans la chambre
où je décéderai placé dans un cercueil de bois
non cloué, … … quarante huit heures
tout le cours de ce

Extrait du régistre des actes de décès de la commune de Charenton St maurice, arrondissement de Sceaux, département de la Seine.

L'an mil huit cent quatorze, le trois Décembre heure de midy

Pardevant nous maire de la commune de Charenton Saint maurice, officier de l'état civil, sont comparus. M.rs Jean pierre Dumoustier âgé de cinquante cinq ans et et marie victoire françois Dubuisson, âgé de cinquante sept ans, tous deux domiciliés audit Charenton St maurice, desquels nous ont déclaré que le jour d'hier, deux du présent mois de décembre, est décédé en cette commune sur les dix heures du soir M. Donatien alphonse françois, Comte, Desade, homme de lettres, âgé de soixante quatorze ans, demeurant audit Charenton St maurice et ont les déclarants signé avec nous le présent acte de décès, après lecture faitte, ainsy signé, Dumoustier, Dubuisson et finot maire

Pour Extrait conforme audit régistre délivré par nous maire de la Commune de charenton St maurice, ce jourd'huy. Seize Janvier, mil huit cent quinze.

Now quite ill, in 1814 Sade requested release, in vain. But death soon freed him. On Friday, December 2, 1814, Sade died of acute pulmonary edema. He had asked to be buried on one of his estates, at Malmaison, near Épernon. He wanted the earth that covered him to be sown with seeds to give birth to new life. But his property, sold in 1810, no longer belonged to the family. His son Claude-Armand did all he could to save Sade the humiliation of an autopsy, and prevailed. Sade was buried at Charenton, beneath a mute slab, without inscription. He remained there until the cemetery was moved, when his body was exhumed.

After the exhumation, one Dr. L.-J. Ramon laid hands on Sade's skull in order to study it. Dr. Johann Spurzheim, an early popularizer of phrenology, had a cast made, which he kept for years. This relic traveled farther than Sade could ever have imagined, as Spurzheim embarked on lecture tours of England and the United States. At his death, Sade's skull disappeared—yet another mystery. 8 All that survives today is the cast, preserved in Paris's anthropology museum, the Musée de l'Homme. An honorable end to a paradoxical life.

Above: Plaster cast of Sade's skull, preserved in the Musée de l'Homme in Paris.

Opposite: Death certificate of the Marquis de Sade, who died on December 2, 1814, at six o'clock in the evening.

1. *Aline et Valcour* (1795). Sade wrote this text while imprisoned in the Bastille in the 1780s; it was the first of his books to be published under his real name.
2. Sade, ibid.
3. Patrick Jammes, *Le Brave Marquis de Sade*.
4. The Jeanne Testard affair left one the earliest dossiers involving Sade in a morals case, including the manuscript police report and letters from Inspector Marais to Lieutenant-general Antoine de Sartine of the Paris police.
5. This phrase would be reprised by Hervé Guibert in the title of his novel *Vous m'avez fait former des fantômes* (Paris: Gallimard, 1987), which concerns the training of children for combat and includes scenes of a pedophilic character.
6. Simone de Beauvoir, *Faut-il brûler Sade?*
7. Emmanuel de Las Cases, *Le Mémorial de Sainte-Hélène* (Paris: Gallimard, Bibliothèque de La Pléiade, 1956–57).
8. Jacques Chessex, *Le Dernier Crâne de M. de Sade.*

II

AN EXEMPLARY OEUVRE
From *The Crimes of Love* to *The 120 Days of Sodom*

*S*ade left behind a considerable oeuvre, yet his infamy was such that his descendents did everything possible to erase his dreams. For a long time they shut the doors on his memory, just as they shut up his châteaux. But Sade has never gone away. After a life in which trials and judges played a larger part than libertinism, Sade left more than a hundred works of several kinds—an impressive number.

—:•:—

Although he spent nearly half his life (twenty-eight of his seventy-four years) behind bars, condemned by society and the law, he never accepted the extraordinary constraints imposed upon him. His rebelliousness, his taste for life, his limitless appetite—all this he poured into the thousands of pages he covered with his feverish hand. Was he not perhaps slave to another law entirely? At the end of *The 120 Days of Sodom,* the tormentors become slaves of their passions; it is their young victims who dominate them and make them perish from their own tortures. In the course of a life during which he defied three political regimes, Sade's apologias for crimes that undermine politically motivated laws, and a flamboyant imagination that corrupted the laws of humanity's political nature, ensured that he would be hunted and censored. In 1788, Sade decided to assemble some twenty or thirty texts under the title *Contes et fabliaux du XVIII° siècle, par un trouvère provençal* (Tales and Fables of the 18th Century, by a Provençal Troubadour), thinking they might be

Daniel Auteuil in the role of the Marquis de Sade in the film *Sade,* directed by Benoît Jacquot and released in 2000. The film won two Prix Lumière in 2001, among France's highest awards for cinema.

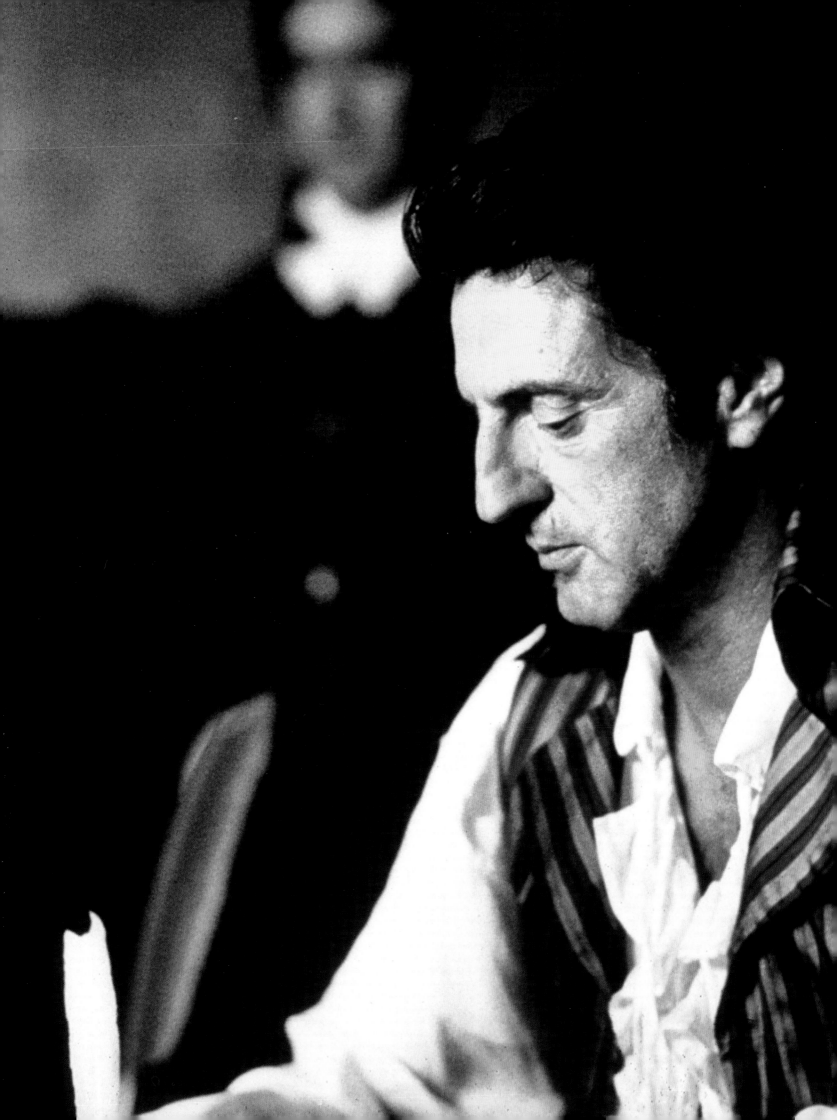

published in four volumes. In addition, he planned to integrate his *Historiettes* (Stories) into a collection of essays under the title *Le portefeuille d'un homme de lettres* (The Portfolio of a Man of Letters),[1] while *Justine, ou Les infortunes de la vertu* (that book's first version) would become a separate novel.

This massive amount of writing resulted from the time made available to Sade for such work by his imprisonment. In effect, writing became his life's passion, his engine. On March 1, 1788, he began work on *Eugénie de Franval,*[2] and made rapid progress. Beginning in October of the same year, he began to keep a catalogue raisonné of his works. At this point, his writings would have filled fifteen octavo volumes. Sade ceased work on the *Contes et fabliaux* but, remaining true to his principles, tried to maintain a unity of tone and submitted to the self-imposed discipline of a certain—as we might put it today—*decent* vocabulary.

In the year VIII (1799–1800), Sade completed a collection of eleven novellas, arranged in four volumes, entitled *Les crimes de l'amour, Nouvelles héroïques et tragiques* (The Crimes of Love: Tales Heroic and Tragic), published in Paris by Massé in 1800.[3] The collection is prefaced by a very important essay, "Une idée sur les romans" (Thoughts on the Novel), which outlines Sade's fictional aesthetic.

Sade returned to *The Crimes of Love* in 1803–04. He wished to explore the idea of alternating sad and cheerful stories by adding ten light tales to the collection, which he spoke of as a sort of French version of Boccaccio's *Decameron*. Also dating from this period are notes outlining such diverse projects as *Madame de Thélème* and *La cruauté fraternelle* (Fraternal Cruelty, presumably related to *Émilie de Tourville, ou La cruauté fraternelle,* one of the *Contes et fabliaux,* written in 1788), *Les inconvénients de la pitié* (The Inconveniences of Pity; lost or destroyed), *Aveuglement vaut mieux que lumière* (Blindness Is Worth More Than Light), and *L'âne sacristain, ou Le nouveau Salomon* (The Ass Sexton, or The New Solomon). Whether Sade lacked enough time or sufficient focus, many of these remained only drafts and sketches.

In focusing on writing novellas, while the novel as a genre was still in search of its proper form and idiom, Sade joined a long tradition of European fabulists, with such predecessors as Boccaccio, Marguerite de Navarre, Madame de Villedieu, Pierre Bayle, Jean de Segrais, and above all Madame de La Fayette, author of *La princesse de Montpensier*. Sade paid tribute to her in "Une idée sur les romans," his introduction to *Les crimes de l'amour:* "[There is] nothing so nicely written as *La Princess de Clèves*.[4] Kind and charming lady, if the three Graces held your brush, yet was love not permitted to direct it sometimes?"

If *Les crimes de l'amour* remains Sade's most exemplary text, this is in part because it is a powerfully psychological work. It includes very little physical violence, little eroticism, few bawdy allusions, but is infused with tragic passion. Sade's true cruelty is expressed through torments of the soul much more than of the body. In *Ernestine* (the collection's "Swedish tale"), we see the suffering of the heroine who witnesses the death of her lover, not of the condemned man himself. Sade paints scenes of violence by creating truly torturous situations. Together with Sade and his protagonists, we as readers are in a realm of absolute honor.

It is possible to find in Sade's oeuvre sentiments that anticipate Romanticism, especially its interest in the medieval or gothic, with such motifs as corpses, daggers, and gloomy tapestries. Dreams in his fictions are almost always premonitory; reading the stories, our emotions are stirred as we unfold a kind of story within the story. The device of premonition allows Sade to transfer to readers a feeling of prescience. Yet all this takes place within a structure, and by means of a literary style, of extreme simplicity. Sade loved history instinctively, and took advantage of it to paint broad canvases. His plots progress step by step, involving some sort of ordeal that allows the reader to discover the various devices Sade uses. The victim is innocent. Sade permanently postpones any explication and narrative resolution, leaving the reader disturbed, even irritated. For Sade, this is the most important effect, the object of all his care.

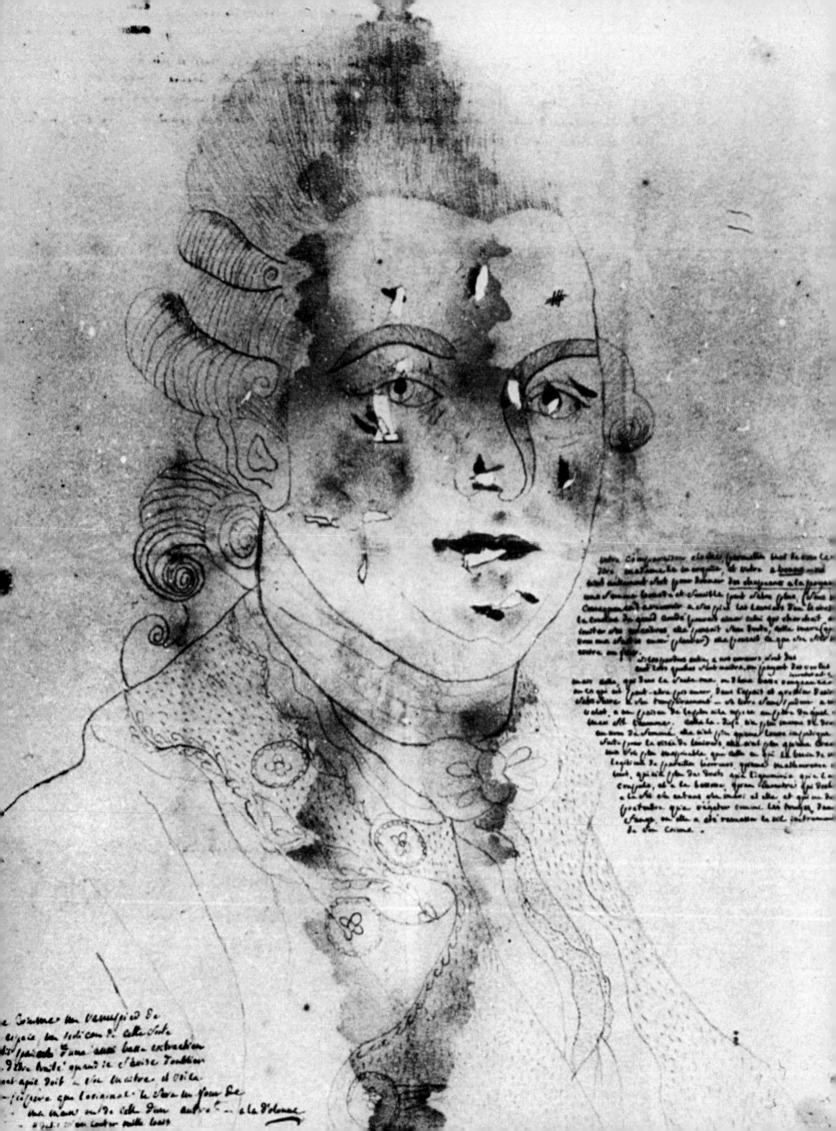

Beyond doubt, the work that best symbolizes, summarizes, and represents Sade is *The 120 Days of Sodom*. Perverse (and perverted) to some, sublime to others, reading it leaves no one indifferent. The book hooks you, marks you, clasps you tight, and leaves you speechless.

After all his various travels, Sade arrived in a singular place in his imagination, as his every voyage led to prison—an ultimate, essential place, a kind of nonplace, embodiment of an absolute condition. In *The 120 Days of Sodom*, this place is called the Château de Silling, a mountaintop medieval castle deep in the Black Forest, where four aging wealthy libertines isolate themselves with four veteran madams and forty-six young male and female victims who they intend to rape and torture to death. The castle can be reached only after passing through trials and over obstacles right out of fairy tales: a village of dwarves or elves, a thick forest, high mountains, a dizzying precipice, a bridge (which the libertines cut behind them), high walls, a deep moat, a heavy wooden door. After all this, once the libertines have locked themselves inside, heavy snow falls to muffle both the torturers' moans and their victims' cries. It is more than likely that Sade had read Charles Perrault's pioneering classic collection of fairy tales (first published in 1697), and worth recalling that Perrault's stories "for children" are by no means his only works, and that we often read them in expurgated versions, purged of all that the nineteenth century's prudish moralism condemned. As for the Brothers Grimm, they came after Sade, but the spirit of their work is nonetheless the same.

Libertinism is a kind of voluptuous pleasure in being alive, a systematic search for the absolute satisfaction of the desire for pleasure. Within the hidden castle cut off from the world, the libertine, in order to penetrate the secret of life, must descend still further, into an underground realm of deep grottos and secret dungeons accessed only by ceiling trapdoors, a little bit like Robinson Crusoe in Michel Tournier's retelling of Defoe's tale, in which the hero, naked and alone, curls up deep within a hollow on his island, seeking to turn day into night.[5] Sade's heroes likewise isolate themselves, but they create a complete microsociety in which it is the act of enclosure itself that creates the system, by enforcing the norm of inclusion and exclusion. The

Portrait of Lefèvre, Sade's former secretary—and allegedly his wife's lover—torn and bloodstained by the Marquis, with insulting captions written by his hand, July 13, 1781, while he was imprisoned at Vincennes (illustration appeared in *Vie du marquis de Sade* [Life of the Marquis de Sade] by Gilbert Lely, Éditions Jean-Jacques Pauvert, 1982).

Sade the Outcast, by Delphine Lebourgeois, 2010.

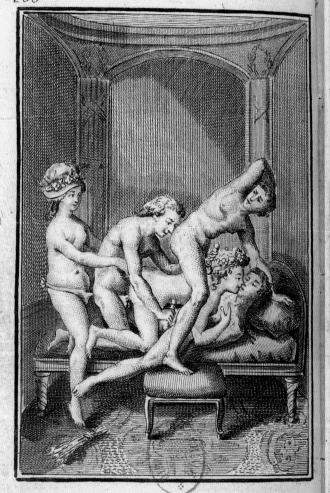

LA

PHILOSOPHIE

DANS

LE BOUDOIR,

Ouvrage posthume de l'Auteur de
JUSTINE.

TOME SECOND.

La mère en prescrira la lecture à sa fille.

A LONDRES,
Aux dépens de la Compagnie.

M. DCC. XCXV.

Scene douzieme et derniere

St Fal adelaide Florival

L'emissaire des valets ensuite poutac
Darneuil

le Comte et adelaide commencent a se perdre
dans l'obscurite du fond, lorsque florival precedé de
quatre valets et de l'emissaire entre brusquement et
dit a l'emissaire et aux valets

Ô mes amis Sauves adelaide

a l'instant trois des valets saisissent le fond, le quatrieme
et l'emissaire saissent la jeune personne et la rameinent
en scene, elle est evanouie dans leurs bras, florival
poursuivant dit au Comte qui fuit, a

et vous sortes homme traitre et perfide
ou cette main que Conduit la fureur
va dans l'instant vous arracher le Coeur

adelaide revenue a elle, et tachant
d'echaper a ceux qui la tiennent

idea is comparable to Fourier's utopian socialist Phalanstery (an independent community holding property in common)—but, clearly, with entirely different aims.

In this self-contained place, food becomes particularly important, revealing the characters' social origins and their place within the group's hierarchy, as do their clothes and furniture: With Sade, everything is a sign. Food nourishes but also poisons, becoming emblematic of a range of practices and behaviors, all of which signify otherness, within a realm of inversion (or perversion). A source of comfort may also signify death. In the case of clothing, Sade's symbolism is simpler still: Nudity becomes itself a kind of garment, symbolic of humiliation, the "clothing" that marks the submissive victim as a form of property and again indicates his or her function within the group. The libertine is revealed as a set and costume designer, a stage director.

In contrast to *Les crimes de l'amour,* in *The 120 Days of Sodom* Sade seeks to tell the whole story in minute detail. Speech is destructive insofar as it trespasses the limits of the unsayable. There is in Sade the kind of transgression through writing that is dear to Louis-Ferdinand Céline. Many less insightful readers have noted a repetitive aspect of the narration of suffering in *The 120 Days of Sodom,* yet they fail to perceive that its purpose is precisely to exhaust the reader. Sade was truly a man of his time, standing between Neoclassicism and Romanticism, between rigor and a taste for the baroque. Each of Sade's novels is an accumulation of murders, crimes, incestuous acts, atrocities. Yet it is difficult to make those readers understand that the fact of dreaming up certain situations is much more beautiful than living them out.

Sade is typical of his era in his taste and feeling for travel. Voltaire, Swift, Montesquieu all carry us, long before the revolution in transportation, "somewhere else." The eighteenth century was a time of voyages and discoveries. Knowledge advanced as the realm of terra incognita shrank. Sade leads us to Italy, to Constantinople; at sea, travel recovers its initiatory dimension.

Written in only thirty-seven days in 1785, Sade initially hid the scathingly transgressive text within one of the walls of his cell in the Bastille; according to some, he took it with him to Charenton. Eventually, it passed from hand to

Photograph of Marie-Laure de Noailles, née Bischoffsheim (1902–70). A descendant of Sade by her mother, Marie-Thérèse de Chevigné, she bought back the manuscript of *The 120 Days of Sodom* in 1929 for the family.

hand before coming to the Vicomtesse Marie-Laure de Noailles, one of Sade's descendents, in 1929. Simone de Beauvoir defended the work in her 1955 work *Faut-il brûler Sade?*, and in 1975 Pier Paolo Pasolini based his last film on the novel. By 1982 the manuscript had found its way to Gérard Nordmann, a Swiss collector of erotic texts. Today, the president of the Bibliothèque Nationale de France, Bruno Racine, with the help of rare book collector Pierre Leroy, is working to convince the state to acquire the manuscript in order to celebrate the bicentennial of Sade's death, in 2014.

Among Sade's numerous works that remained unpublished in his lifetime are many plays. His comedies include two five-act verse plays, *Le misanthrope par amour, ou Sophie et Desfrancs* (The Misanthrope by Love), accepted by

"Nature has created men so that they might amuse themselves with everything on earth."

Illustration by Guido Crepax, from his graphic novel *Justine ou...* (Justine or...) (Éditions Delcourt).

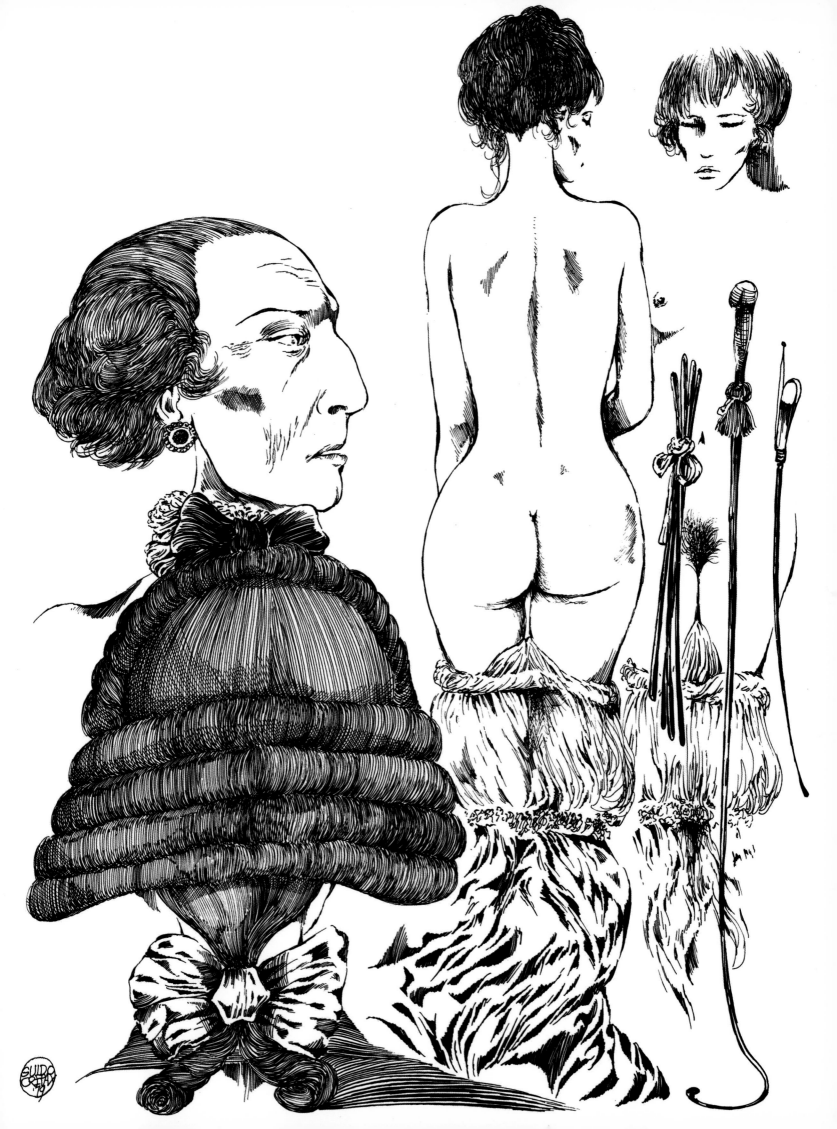

L'ÉGAREMENT

DE

L'INFORTUNÉ,

DRAME

En trois Actes et en Prose.

Malheur aux cœurs ingrats et nés pour les forfaits,
Que les douleurs d'autrui n'ont attendris jamais

Alzire, Act. 2. Sc. 2.

~~Xxxxxxxxxxxxxxxxxxx~~

il est donc des forfaits qu'on ne peut condamner !

Présentée le 30 8bre 1790
Cette pièce a été corrigée par le théâtre
de palais royal, d'après les indications
données par ce théâtre

et elle y est reçue

relivée bon de mon brouillerie avec gaillard
et donnée au théâtre de molière où elle
est reçue

the Théâtre Français in 1790, but not staged there, and *Le prévaricateur, ou Le magistrat du temps passé* (The Prevaricator, or The Magistrate of Time Past); *Le Capricieux, ou L'homme inégal* (The Capricious One, or The Unequal Man); *Les jumelles* (The Female Twins), in two acts; and three one-act comedies, *L'homme dangereux, ou Le suborneur* (The Dangerous Man, or The Suborner), *Les antiquaires* (The Antique Dealers), and *Azélie, ou La coquette punie* (Azélie, or The Coquette Punished), the last in free verse.

Sade's unpublished dramatic works also include two tragedies, the five-act *Jeannne Laisné, ou Le siège de Beauvais* (The Siege of Beauvais) and the one-act *Euphémie de Melun.* His other dramas include *Henriette et Sinclair, ou La force du sang* (The Power of Blood), *L'égarement de la fortune* (Fortune Mislaid), *Fanny, ou Les fêtes du désespoir* (Fanny, or The Feasts of Despair), and *Franchise et trahison* (Candor and Betrayal). Sade also wrote a one-act comic opera, *La tour mystérieuse* (The Mysterious Tower), and a one-act farcical light comedy, *L'hommage de la reconnaissance* (The Gift of Gratitude).

Among Sade's numerous unpublished works of fiction are two historical novels: *Histoire secrète d'Isabelle de Bavière, reine de France* (The Secret History of Isabelle of Bavaria, Queen of France), written in 1813 but not published until 1953; and *Adélaïde de Brunswick, princesse de Saxe,* written in 1813 and published in 1964.

Sade also kept a journal, the sum of everything he did, said, heard, and thought from 1770 to 1790, during his imprisonment, as well as several notebooks, his *cahiers de notes et pensées,* notes and thoughts set down during his final years at Charenton. The justice system and the police burned and otherwise destroyed a great many of Sade's manuscripts of all kinds, in a furious rage to obliterate the bulk of his works forever.

—:·:—

Even today, finding Sade's writings online is not easy. Alone among the great classical French writers, he is represented only in fragments. His works are not found in all bookstores, and when they are, a kind of censorship always seems to be in force, as is true online. Nonetheless, by virtue of his struggle

for liberty, as a man and as a writer, and of his courage—without parallel elsewhere in literature—Sade belongs in the pantheon of the greatest writers. As Béatrice Didier writes in her introduction to *Les crimes de l'amour,* "Sade's style is always that of the aristocracy in which, strangely, and to different degrees depending upon the work, the technical vocabulary and the flowery graces of the eighteenth century are conjoined. The combination is unforgettable, unique. Here, the beauty of the unadorned linear narrative is due to a fantastic violence of language, completely contained, but which we feel always ready to explode; thus executions, passion, intrigues retain the dark fire of a black diamond."[6]

1. The texts were mostly written in 1787–88 while Sade was in the Bastille; they remained unpublished until 1926, when they were issued as *Historiettes, contes et fabliaux* (Stories, Tales, and Fables), edited by Maurice Heine. That collection also includes *Dialogue entre un prêtre et un moribund* (Dialogue Between a Priest and a Dying Man), composed in 1782, while Sade was in Vincennes.
2. Recently translated for the first time into English by Andrew Brown, Jr., as *Incest* (London: Hesperus Classics, 2003).
3. Except for *Incest*, the collection has not been translated into English. While the eleven novellas of the Year VIII have been published since 1800 under the title *Les Crimes de l'amour* (an arrangement maintained, for example, in Pauvert's 1968 edition of the complete works), this has more to do with the vagaries of publishing than with Sade's artistic intentions. As discussed later in this chapter, he wanted the collection to have many more stories.
4. *La Princess de Clèves,* published anonymously in 1678 but credited to Madame de La Fayette, is regarded as the progenitor of the modern psychological novel.
5. Michel Tournier's first novel, *Vendredi, ou Les limbes du Pacifique* (Paris: Gallimard, 1967), won the Académie Française's Grand Prix du Roman. It was translated into English by Norman Denny as *Friday, or The Other Island* (London: Collins, 1969).
6. Béatrice Didier, ed., *Les crimes de l'amour.*

revû et corrigé en dernière analize, en avril 1808.
elle est bien maintenant, et l'enfant est en action
mais les deux Cahiers sont pré censeives en Cupille
attendu que le denouement tel qu'il doit etre ne se
trouve qu'au Cahier broché en papier de fleurs. page cornée.

Bon brouillon

1

L'egarement de l'infortune
drame en trois actes et en prose

66 Seeing is believing, but to feel is to be sure. 99

66 All men are fools;
to escape seeing one,
one should shut himself
in his room,
and break his mirror. 99

Still life in homage to the Marquis de Sade. The bronze cast of Sade's skull was made from the original plaster cast
in December 2011 by master founder Jean-Marc Avanzini.

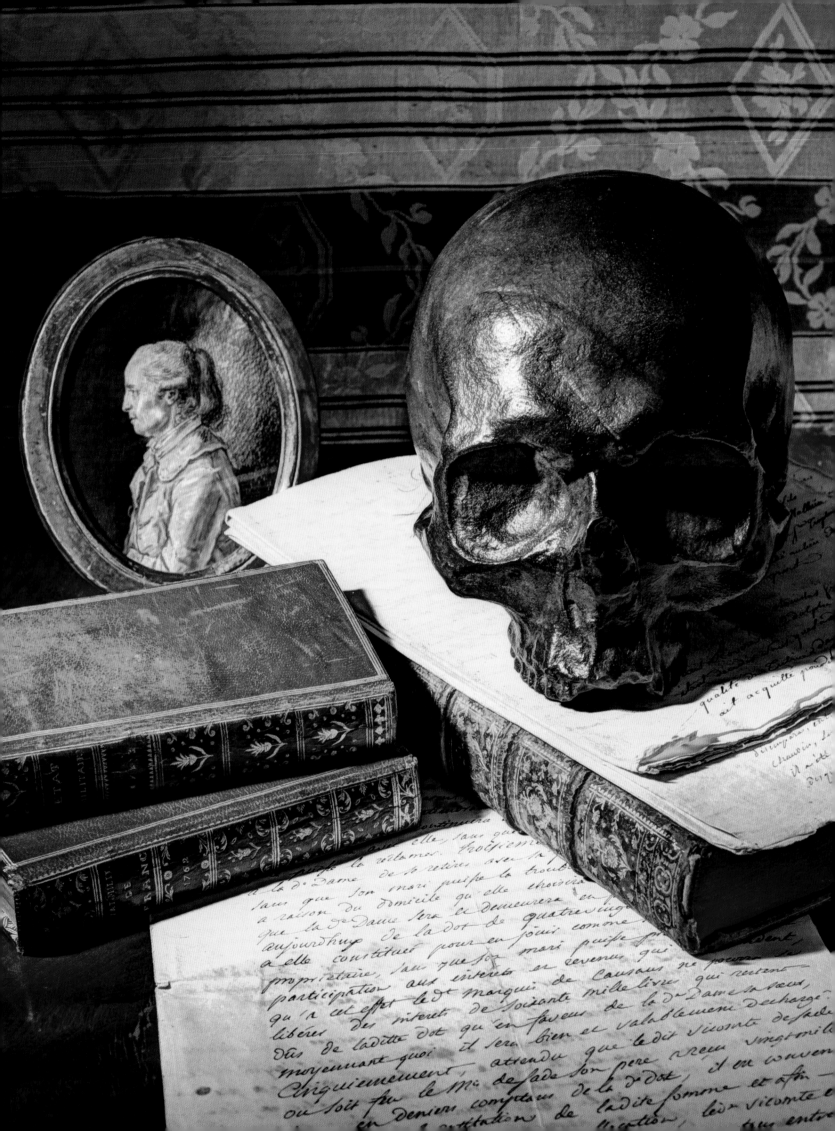

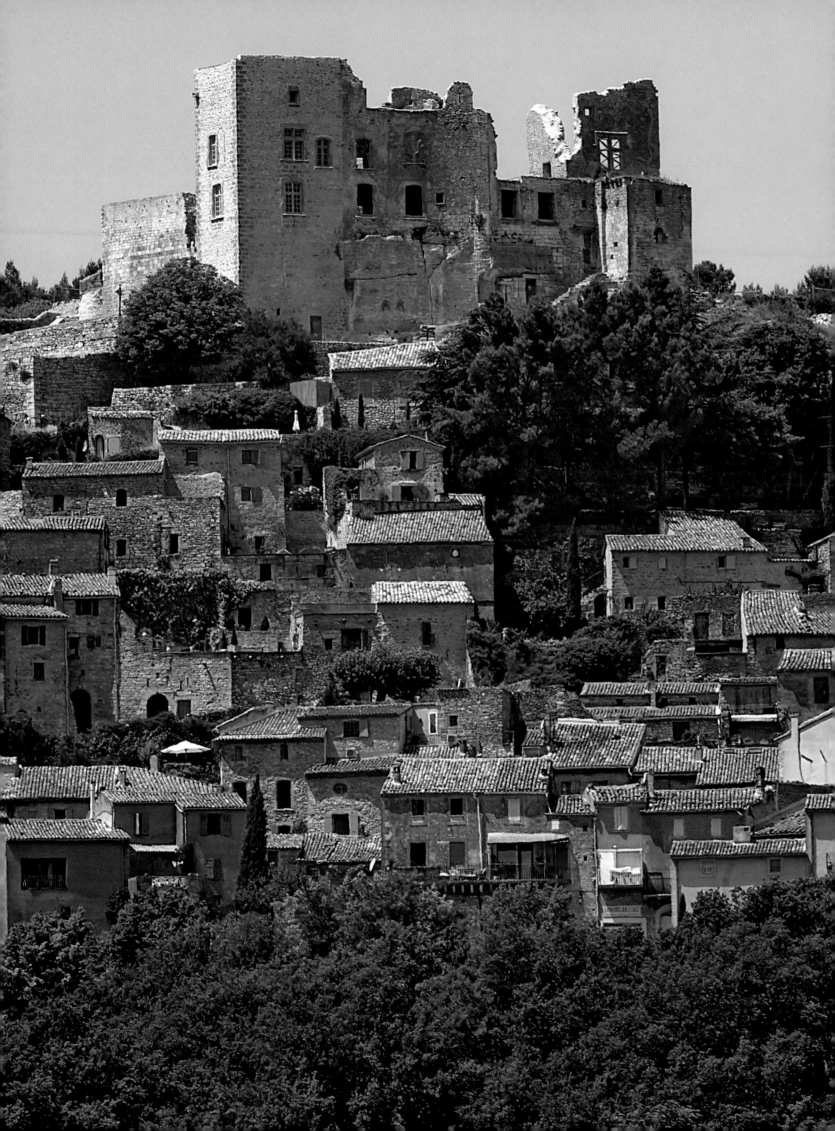

III

THE CHÂTEAU DE LACOSTE
From the Edelbert Family to Pierre Cardin

*F*or Sade, the Luberon always remained the place that had formed him and from which he drew sustenance, a kind of Eden where he was fond of seeking refuge, as much in his memory as by returning there in person. Not many years after moving into the vast forty-six–room castle at Lacoste with his young wife, Sade was sent to prison for the first time for holding orgiastic fancy-dress balls; his second, five years later, for kidnapping and torture; then later again for distributing drugs, writing libertine novels, pornography, political intrigue, and so on. Each time, Lacoste provided Sade a respite, a pause, a way station in his endless travels.

In the ninth century, the fiefdom of Lacoste was the property of the Varac-Farald family. From the thirteenth century on, it became part of the seigneury of the powerful Agoult family, which later became the seigneury of the Simianes. Situated about three miles from Fontaine-la-Vaucluse, the castle dates from the eleventh century. In this period the place belonged to the Edelberts, close relatives of the Saint-Mayeul family, who furnished the monastery of Cluny with many of its abbots. The proprietors settled in Castellane after repulsing a Saracen incursion, pushing them back as far as the medieval mountain village of La Garde-Freinet. Later, they left their holdings to their cousins, the Simianes. Throughout this period, the château dominated the village of Lacoste below and indeed the entire surrounding area. The castle stands on a crag at the

Opposite: View of the village of Lacoste and the south facade of the château during its restoration in 2005.

Following pages: Aerial view of the Château de Lacoste at sunset.

141

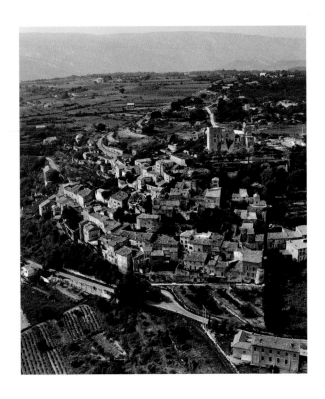

Above: Aerial view of Lacoste with, at upper right, the ruins of the château.

Opposite: View of the tower and the restored east facade of the château in 2012.

confluence of two valleys, and this rock was the true architect of the fortress, giving it its peculiar form—an irregular polygon of seventeen sides. The predominant local landmark on account of its height, its primary purpose was defense; its three-story facade afforded an exceptional panoramic view of the environs, and its size, fifty meters long and forty feet wide, guaranteed the castle a dominant position in the Luberon countryside. These geographical constraints forced the various successive lords to find creative solutions to live there comfortably.

Dating back to the twelfth century, the Sade family is without doubt one of the oldest in Provence. The name is generally considered to come from the village of Saze on the Rhône, close to Avignon. Within the enclave of the Comtat Venaissin, which surrounded Avignon, and was controlled directly by the pope from 1274 to 1791, a simple papal bull was all it took to ennoble a rich merchant or entrepreneur. In this way the Sade family entered the ranks of the nobility in the thirteenth century, rising in very little time to join its most respected order, the *noblesse d'épée,* the "nobility of the sword."

In 1545, the royal militia breached the castle's fortifications in order to extract some Waldensians (a heretical sect dating back to the 1170s, later absorbed into Protestantism, known as the Vaudois in French) who were hiding there. In 1562, it was the Simiane family who were threatened by Protestants. The period was violent, and many faced a dire fate. Lacoste lay between two parishes, Bonnieux and Menerbes, both papal possessions, where trade in silks and tobacco flourished, while Protestant communities grew and thrived nearby. In 1590, the great-grandson of Barthélémy de Simiane made the fortress his seigneurial residence. In 1627, Diane de Simiane married Jean-Baptiste de Sade, bringing the Sade family closer to this exceptional property. It was in 1716 that the Sades became, through inheritance, the château's proprietors, when Isabelle Simiane bequeathed it to her cousin, the writer

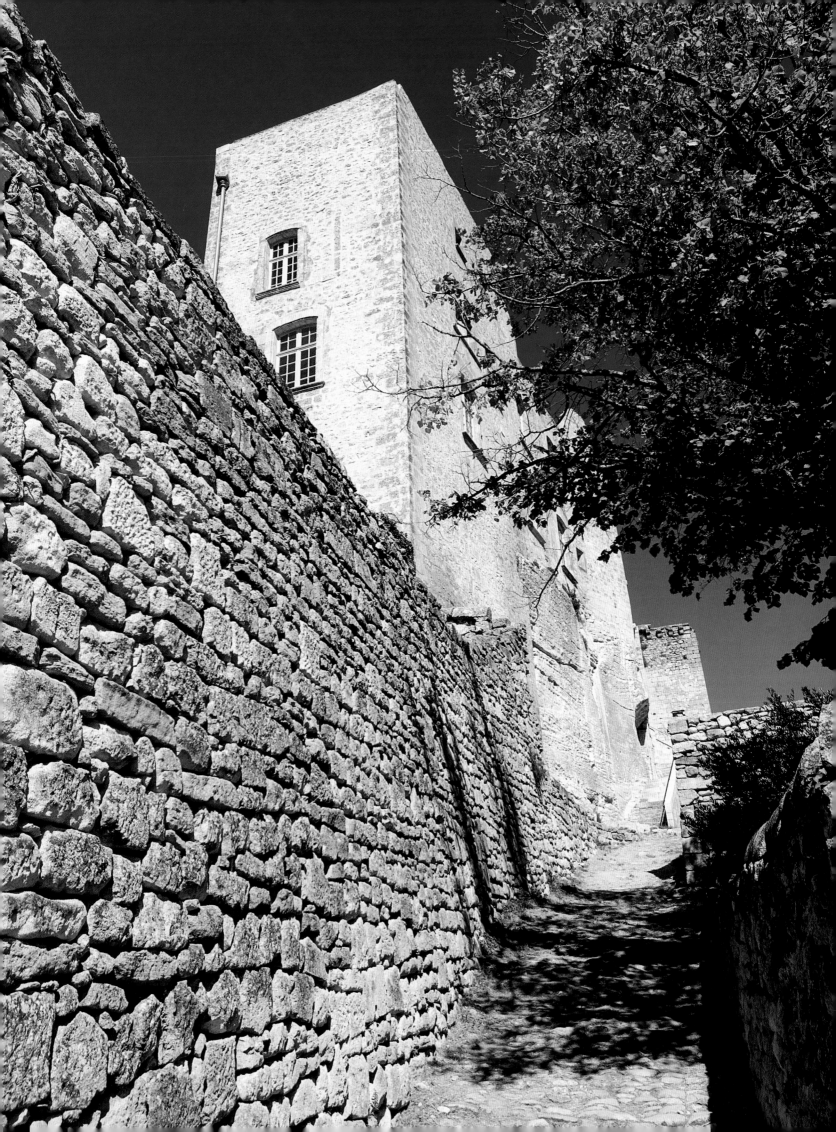

Doit monsieur le marquis de Jude au s. Sambue pour
pour les fourniture En batisse quil a fait faire au
chapteau sellon lordre a luy donne par mr le marquis
par le compte par luy tenu des matiere anploye
Et loyer des ouvrier comance le 9 aoust 1765 ce
monte la somme de — — — — — 1639# 9s
à reçu a compte de la ditte somme 410# 0s Deduit
 1229# 9

Le 30 7br 1765 pour reste dune
rescrition a luy anvoye par mr
le marquis sur les gabelle peyé
a aix par mr bougard — — — 60#

plus à Joseph rouber de
menerbe Enfante a la
chace — — — — — 38#

plus pour rescrition du
26 novambre 1766 peyé
par mr de saye directeur
du controlle a aix — — — 200#

plus reçu par un manda
de mr labbe de Jas sur le
fermier la cotte pour le
compte du guitz arrondaiçi
quil ma peyé a sovet
vitrie à apt — — — — 72#
 410#

Debution faite de quatre cens dix lives veste que jay
fourni pour mr le marquis la somme de — 1229# 9s
me doit pour le change de cette somme pour
trois annee ne doutan pas un momant Et
mr Et trop equitable pour ne m'indaniffe
Et soufrir En mon propre pour luy des
interee que je peye a cette occasion Es — 184# 7s
 1419# 16

Gaspard-François de Sade, seigneur of Saumane and Mazan, and Donatien's grandfather. His wife, Louise-Aldonse d'Astouaud de Murs, gave birth to nine surviving children; the eldest son was Jean-Baptiste, Donatien's father. Gaspard was the first in the family to use the title of marquis. He also liked to style himself "hereditary captain of the town and château of Vaison, colonel in the artillery of the pope of the Comtat Venaissin."

Around 1740, Gaspard, as the new owner of the Château de Lacoste, undertook a number of renovations, including construction of an arcade, demolition of the old kitchens, installation of new bedrooms, and remodeling of the windows according to prevailing tastes. He had the cistern enlarged, and a private chapel built.

—◆—

In May 1763, Donatien got married. His father offered him the château as a wedding present, to be his home. Donatien furnished it with ostentatious good taste. The young man knew the area well, since Lacoste is close to the storied home in Saumane rich in history where Donatien had lived with his uncle, the Abbé de Sade. To this day, it is said that the cellars and dungeons of his château witnessed scenes of wild indulgence.

From May to August 1765, Sade resided in Lacoste with his mistress, La Beauvoisin. It was at this time that he began to spend money heedlessly on his numerous theatrical productions, as well as a slew of important renovations to restore and embellish the château. Yet already in this period, Sade made only brief visits to Lacoste.

In 1767, Sade's father, the titular marquis, died, leaving his son as heir. Sade inherited properties at Lacoste, Saumane, and Mazan, but also very serious debts that would great trouble in future years. Sade stayed in Lacoste from 1769 to 1772, between the Arcueil and Marseilles scandals. It was in 1772 that Sade made his longest stay, during which he had a theater built that could accommodate 120 spectators. Then, after his escape to Italy, he hid out in the château until his incarceration in Vincennes, in 1777. After escaping from custody during his transfer to Aix, he took refuge there one

ON fait sçavoir à toutes person-
nes qu'il y aura Foire à la Coste
le jour de St. Thomas 29. Decembre,
où il y aura des joyes tant à la course
qu'au sault pour les hommes, demy
hommes, vieillards, filles, petits gar-
çons, comme aussi pour les chevaux,
mulets & bourriques.

Liberté *Égalité*

République française

Département de Vaucluse, District d'Apt

Municipalité de la Coste

Laisser passer le Citoyen Daniel David, Cultivateur
natif de cette commune de la Coste, District d'Apt
Département de Vaucluse, y domicilié, agé de trente deux
ans, taille de cinq pied, deux pouces, Cheveux grisaillé, sourcils
Chatains, yeux roux, nez pointu et mediocre, Bouche allié,
grande, menton rond, front petit, visage Long et marqué
de petite verole; et prété lui aide et assistance en cas de
Besoin.

Delivré à la Coste le present passeport, auquel a été
apposé le Sceau de cette municipté, à la Coste le vingt six
messidor, L'an second de la République française une et
indivisible

Daniel David qui a signé avec nous Chauvin maire

j. Beridon off.ₘ mpal

Payan, Secret.ᵉ Greff.

last time, from July 16 to September 1778, before being taken back to Vincennes.

Throughout the summer of 1789, during the Terror, the Château de Lacoste, unlike other structures symbolic of the Ancien Régime, remained intact. However, the situation deteriorated rapidly during the last months of 1792. It must be recalled that the monarchy effectively fell on August 10, with the storming of the Tuileries palace (where the royal family was under house arrest) by the sans-culottes, the Paris republican mob. The royal family took shelter with the Legislative Assembly while their Swiss Guards were gruesomely massacred amid exceptionally violent fighting, but they were officially arrested three days later. After a thousand years, the French monarchy was finished; the Republic's birth was rapidly becoming inevitable.

The original doors of Sade's château, today installed at the Maison Appy, on Rue Basse in Lacoste, 2013.

On September 7, the administrators of the Apt district, concerned, wrote to the municipality to recommend that they "take great care that the house of the Sieur de Sade, who has never emigrated, not be violated," for they had received word that "some citizens plan to carry off at first light whatever furniture might be there and make a bonfire with it."[1]

A little while later, a certain Gebellin, in an inn in the village below the château, tried to whip up the Costain brothers. What were they waiting for to pull down the symbol of their oppression? On Sunday, September 16, the looting to come was on every tongue. Roux and Ange Raspail, cooks by trade, prepared for an assault the following day. At the château, the marquis's terrified staff made haste to pack their trunks. Time was running out; everyone knew how such things turned out for those who were "caught." During the daytime on Monday, a small "official" group of about a dozen men climbed the slopes to the château, where they found perhaps a hundred locals. Everyone began looting, breaking and destroying things, throwing furniture out the windows. But the forces of reason and order soon arrived on the scene as the municipal authorities, conscious of the uniqueness of the place and its proprietor, decided to put an end to the looting—only the château's doors

were already gone. An incredible mad ballet ensued as revolutionaries—many, mere hooligans—contended with national guardsmen, municipal councilors, and envoys sent by Minister of the Interior Jean-Marie Rolland de la Platière, the former smashing and stealing while the latter tried to protect and save whatever they could. It was one step forward, two steps back, as some pieces of furniture were confiscated to protect them, while others quite suddenly vanished.

In late 1792, the municipal authorities in Lacoste expressed concern over what had occurred; Minister Roland launched an inquiry; and two police superintendents named Jouvenne and Laurent were appointed to conduct a long and patient judicial inquiry, which they completed in January 1793. Their conclusions are heartbreaking: "In less than an hour, the Revolution reduced this seigneurial manor to a dilapidated hovel."

Below: The Château de Condé-en-Brie is the cradle of the Condé dynasty; the Sade family inherited the estate in 1814 and owned it until 1983.

Following pages: (left) A document of the Lacoste municipal council dated September 28, 1792, reporting on the pillaging of the château; *(right)* inventory of the books remaining at the château following its ransacking.

———◆———

Looted and devastated during the feverish excesses of the Revolution, the estate was ceded to the Marquis de Rovère, a native of Bonnieux, the deputy representing the Vaucluse in the national legislature. Arrested after

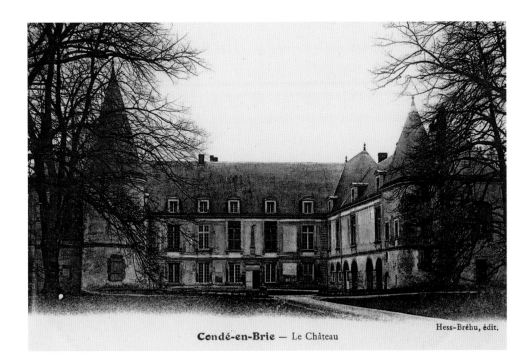

Condé-en-Brie — Le Château

Hess-Bréhu, édit.

Extrait des Régistres de la
municipalité de la Coste, District
D'apt, Département des Bouches du Rhône

Ce jour d'hui vingt huit septembre mil sept cens
quatre vingt douze, L'an 4.me de la Liberté et
le 1.er de l'égalité, le conseil Général de la
Commune de la Coste assemblé, Présens, M. M.
Daniel Bar, officier M.pal, Simon aggry, Daniel
David, Charles mille, et Jacques aggry, Procureur de
la Commune.

Se sont présentés, M. M. Raspaud et Laurent fils,
Citoyens de la ville D'apt, se disant Commissaires
du Département.

D'après l'injonction à eux faite d'exiber leurs ordres,
il nous ont produit leur commission conçüe en ces
termes: "nous Commissaires du Département des
"Bouches du Rhône, D'après les ordres ultérieur, que
"nous avons donné, soit au District d'apt, et aux
"municipalités de St. Saturnin et la la Coste &c.
"Donnons pouvoir aux S.rs Louis honoré Raspaud
"et Laurent fils, de se transporter en qualité de
"nos Commissaires à St. Saturnin, La Coste et
"Goult, à l'effet de faire transporter à apt
"Draps, Linges, Couvertures, &c, qui se trouvent

D'après un inventaire fait
le 2 janvier 1793 des livres
du Chateau de la Coste (après
le pillage) placés par les soins de
la municipalité dans l'hospice —
(Etat des livres trouvés dans l'auspice (sic) des
cy devant freres Minimes du 2 jan. 1793)

envoyé l'original
à Mr Begis
avril 1874

Il résulte qu'il y avait encore
1448 Volumes — dont 58 ouvrages
in folio formant 169 Vol. —

quelques livres gothiques — et sur la
Provence et Petrarque les Ouvrages Suivants:

Statuts de Provence — 1 v. in 4°
Rimes del Petrarca 2 v. in 4°
histoire de Provence 2 v. in folio (Bouche!)
nobiliaire de Provence 2 v. in 4 —
memoires de Petrarque T. 2. 2.3 — in 4°
Memoires de Petrarque 5 v. incomplets
petrarca Con d.. commenti Sopra — 1 v. in fol. parch.
petrarcha — opera latina 1 v. in fol. parch.
histoire Générale de Provence Tom. 1er in 4°

nota Presque tous les ouvrages in 8 et in 12 ne sont désignés
qu'en nombre sans titres de l'ouvrage

Le Conseil Soussigné

qui a pris lecture du Contrat de Vente de la Terre de la Coste, souscrit par M. Louis aldonze Donatien De Sade, homme de lettres, au profit du S. Rovere et de la D.e Vachon Belmont son épouse, devant Deloche et son Confrère Notaires à Paris le 22. Vendémiaire an Cinq.

D'un Contrat d'acquisition fait par mondit S.r De Sade de la ferme de la Malmaison passé devant Morisseau et son Confrère Notaires à Paris le 13. Pluviose an 5.

D'un autre Contrat d'acquisition de la terre de Grand-villiers, passé devant les mêmes Notaires les mêmes jour et an.

De la Copie du jugement d'ordre prononcé au Tribunal Civil d'apt le 16 X.bre 1806, relativement à la distribution du prix de la Vente faite par la V.e Rovere comme tutrice et autorisée par justice, de ses enfans mineurs, aux S.rs Matthieu et Jardiol, d'une partie du prix de la terre de la Coste montant à 53,800 francs

D'un jugement rendu au Tribunal Civil de première instance du Département de la Seine le 4. juillet 1806.

D'un arrêt de la Cour d'appel de Paris du 11. mars 1809.

De la Copie du Contrat de Mariage de M. De Sade passé devant les Notaires de Paris le 15. mai 1763.

De la grosse d'un acte passé devant Gibert et son Confrère Notaires à Paris le 23. 7.bre 1790.

D'une liasse d'inscriptions et de bordereaux de Livée

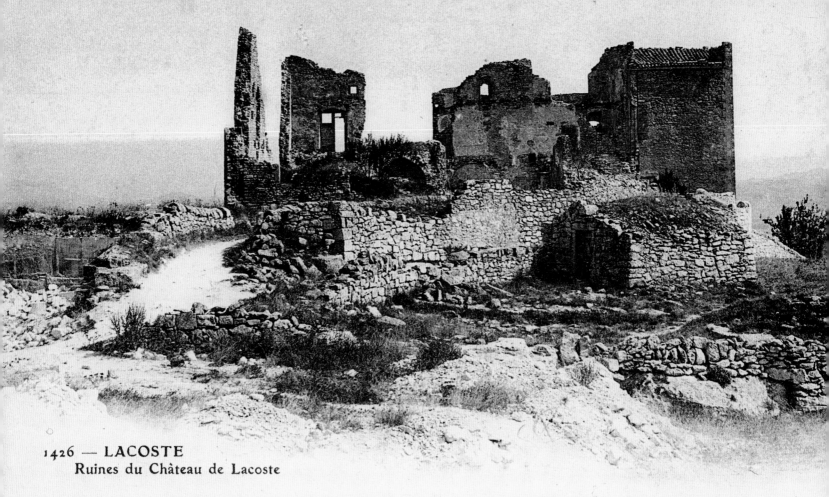

1426 — LACOSTE
Ruines du Château de Lacoste

Editions J. Brun & Cie, Carpentras

2 LACOSTE - Ruines de l'ancien Château

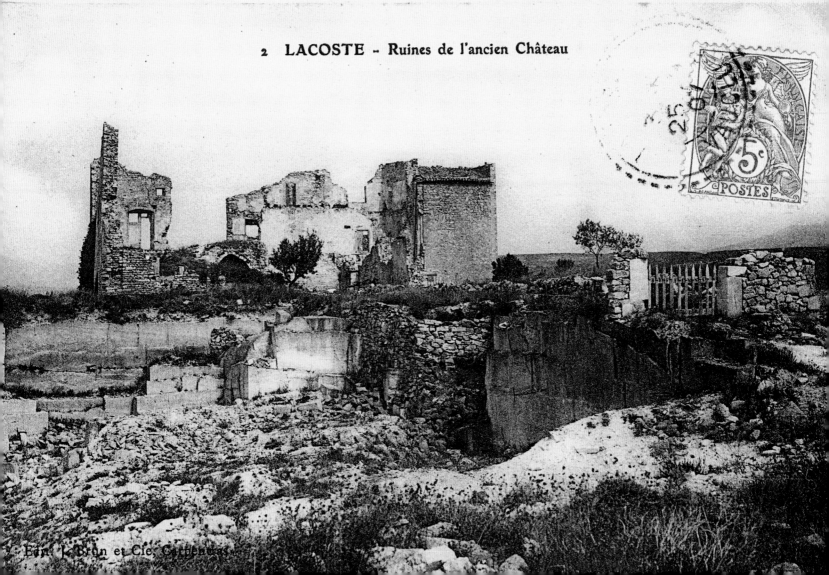

Edit. J. Brun et Cie, Carpentras

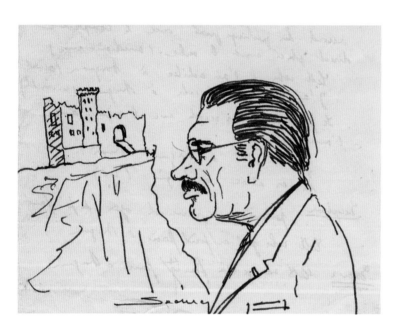

the Directory's coup d'état of 18 Fructidor, Year IV (September 4, 1796), Rovère was deported, along with many other deputies, to a penal colony on the island of Cayenne in French Guiana, where he died. In 1816, at the height of the Restoration, his widow sold off what was left of the château—a mere shell, without exterior doors or windows, its roofs collapsed—to Pierre Grégoire, a farmer, for 1,200 francs. Next, the estate fell in to the hands of Cyprien Jean, a mason, who used the ruins of the buildings to build or restore a number of houses in the village, stripping the mansion of interior doors, entablatures, woodwork. Many other such proud and ancient residences suffered the same fate.

It was in 1946 that the Comte and Comtesse de Sade arrived at Lacoste, while on their honeymoon. They discovered a château in ruins, now owned by another mason. Since the end of the Empire, the Sades had lived in Condé-en-Brie, in the Aisne. This return to their roots was, for them, the beginning of a new adventure. Xavier de Sade was a descendent, four generations removed, of the Divine Marquis. All his life, the Comte de Sade fought to have Donatien known and recognized for who he truly was. His wife, Rose-Marie (née Meslay), shared her husband's feelings, and his determination to restore his family's heritage. In order to be closer to Lacoste, the couple acquired a house in the south of the Vaucluse, than moved a little further north, to Venasque.

Upon the death of the marquis, his youngest son, Claude-Armand, had stored a trunk containing his papers in the library of the Château de Condé. During World War II, afraid that they would be robbed or looted, the family decided to conceal the marquis's legacy in a tiny room in the château's attic. But the Germans, always on the hunt for books, discovered the hiding place. In their

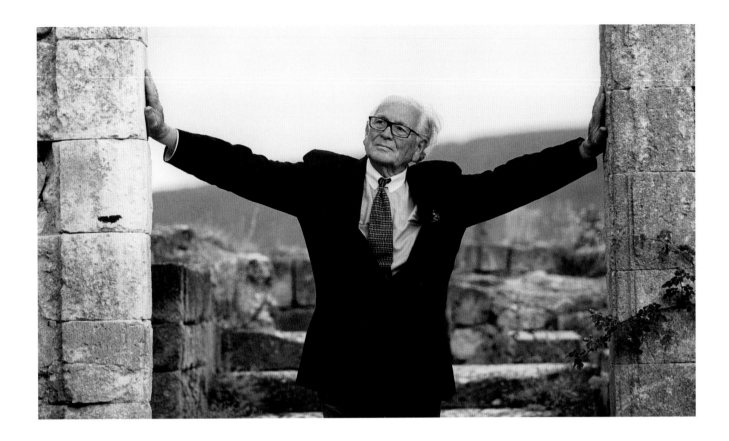

boundless fury, they destroyed the relics, throwing many of the texts out into the main courtyard, even going so far as to soil these collector's items with their own excrement.

◆

From 1952 to 2001, André and Nora Bouër were the owners of the estate. Bouër, a professor of English, was originally from Lacoste and devoted his life to restoring the château as much as he could, having acquired the property in order to save it from ruin. The building was added to the French national registry of historic monuments in 1992. After the death of her husband, Nora Bouër, overwhelmed by the enormousness of the task, sought someone to pick up where he had left off, declaring, "I am concerned to respect my husband's wishes and to continue his work." She approached in succession the Fondation de France (a government agency that fosters private philanthropy), the Institut de France (a learned society that manages many museums and châteaux), the Parc du Luberon (a vast public nature reserve that encompasses many architectural monuments), and the Syndicat des Vignerons du Luberon, the regional winegrowers' association. The Syndicat, which was interested only in the château's outdoor theater, not the building itself, contacted the

66 In less than an hour, the Revolution reduced this seigneurial manor to a dilapidated hovel. 99

ANDRÉ BOUËR

The main gate to the château, with a view of its curtain walls in 2011.

Parc du Luberon, proposing that it take charge of restoring the château. With the enthusiastic endorsement of the mayor of Lacoste, the Syndicat reached an agreement in principle with the park's administration and secured its support for the project. However, Bouër and the winegrowers ultimately failed to reach an agreement, and the partnership fell apart. Not long after, however, Nora Bouër succeeded in finding an ideal ally: the famous couturier Pierre Cardin.

Previous pages: (left) The restored main courtyard of the château in 2013, including the above-ground portion of the cistern and the frame of a door that formerly led to staircases; *(right)* detail of the great reception hall, with doorways leading further into the interior.

Above: American soprano Renée Fleming in recital in the quarry theater at Lacoste, July 23, 2003.

Opposite: Performance of *Un amour de Sade* (One of Sade's Love Affairs) conceived and directed by Ève Ruggieri, incorporating arias from the Mozart–Da Ponte operas. The work was staged in the main courtyard of the château during the Festival de Lacoste, on July 12, 2013, with soprano Pauline Courtin as Anne-Prospère de Launay and baritone Christian Helmer as the marquis.

Following pages: The château was the site of an exhibition of animal-themed sculptures entitled *La sauvage compagnie* (Wild Company) in July 2012.

In 1995, conductor Marius Constant had staged a contemporary opera at the château. Constant, who knew Cardin, showed him the site and all its features. Cardin had much to offer: his success on the cultural scene in France and abroad; his financial means; and his success in the realm of fashion. Cardin scented a good deal: As a cultural entrepreneur, he could create a new arts venue in the Luberon, a region known and recognized for its cultural wealth. It was in 2001 that Pierre Cardin, in his capacity as a patron of the arts, became proprietor of the Château de Lacoste and undertook the gigantic project of consolidating and securing its structures. All the same, the deal came with a codicil: upon the death of its new owner, the château would revert to the Institut de France. The estate had already been supposed to go to the Institut upon the death of André Bouër, but the directors, intimidated by the restoration required, had backed away.

At the time of the sale, Nora Bouër declared, "Pierre Cardin is the only man worthy of such a place." Knowing that the great couturier wanted to bring the estate back to life before leaving it to the Institut, Bouër did not hesitate for a second, eager as she was to see her husband's work continue—even though the necessary formalities dragged on for an entire year.

Initially, Cardin hesitated, as he told Nedjma Van Egmond of *La Provence* on April 24, 2001: "At first, I said to myself that it was too much to manage since

"I will hold no orgies there, only libertine arts festivals."

PIERRE CARDIN,
in *La Provence* April 24, 2001

Soprano Michelle Canniccioni in the role of Madame du Barry in an adaptation of the novel *Le rêve de Zamor* (Zamor's Dream) by Ève Ruggieri, during the Festival de Lacoste in 2005.

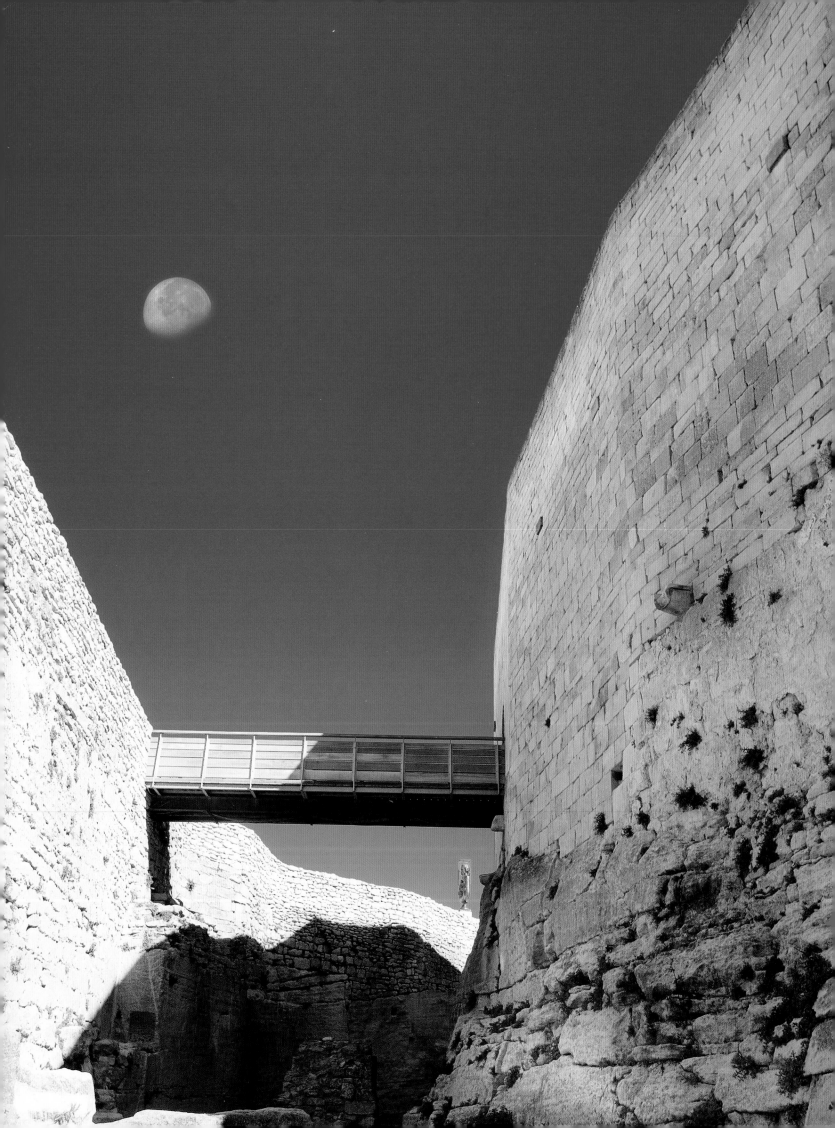

I already had a theater in Paris and two in the Midi. Then, after insistent appeals from Madame Bouër and composer Marius Constant, who knew the place very well, I came back, and it was truly love at first sight." The site's impressive dimensions—covering some 4.5 hectares (11 acres)—surely played a role in convincing the couturier to surrender to its charms. Even if for Cardin Lacoste is not "about the money," the cost of the transaction has nonetheless remained secret. It was in fact the Fondation Cardin that acquired the castle and its outbuildings, including the famed outdoor theater, a converted former rock quarry (the local stone is a kind of molasse, a mix of sandstone and limestone). Experts estimate a price in the neighborhood of a million francs (or 150,000 euros), which seems low. However, Cardin committed to investing ten times that amount to restore and develop the property.

Cardin knew the region—his sister lived in Avignon—but not the village of Lacoste and its environs, which he had never seen. Yet, at age sixty-eight, he had become the château's seigneur: the next move was up to him. With the help of the journalist and musician Ève Ruggiéri, Cardin decided to found a summer cultural festival to showcase young talent every July and August, with attractive evening music and theater performances that would appeal to a cultivated audience and bring together locals and vacationers. In order to be able stay comfortably while at Lacoste, Cardin bought a house for his personal use in the village and also rented two properties nearby to house the festival's artists and technicians.

Looking over the jagged ruins of the castle, shattered by men and crumbled by the passage of time, Cardin could hardly avoid being reminded of the fiendish reputation that enveloped the Marquis de Sade throughout his life. Lacoste had served as the model for Silling: that was how Sade chose to present the château to posterity. The tumbled stones might be mute, but the walls seemed to remember.

Previous pages: Le Rêve de Zamor with Michelle Carniccioni, Patricia Fernandez, Nigel Smith, and François Lis, during the Festival de Lacoste 2005.

Save The Date

Le 13 juillet 2001

en présence de S.A.R. le Prince Emanuele-Filiberto di Savoia

Soirée Libertine

en souvenir du "divin" Marquis de Sade

présidée par Pierre Cardin

au Château de Lacoste (Luberon)

Pierre Pelegry - Jean-Pascal Hesse
7, rue Royale, 75008 Paris

Tél.: 01 47 42 75 82 - 01 42 66 95 53

Above: Invitation to a "Soirée Libertine" in memory of the Marquis de Sade, July 13, 2001.

Opposite: View from the moat of the bridge linking the esplanade to the château.

Following pages: View of the main terrace and the restored main courtyard.

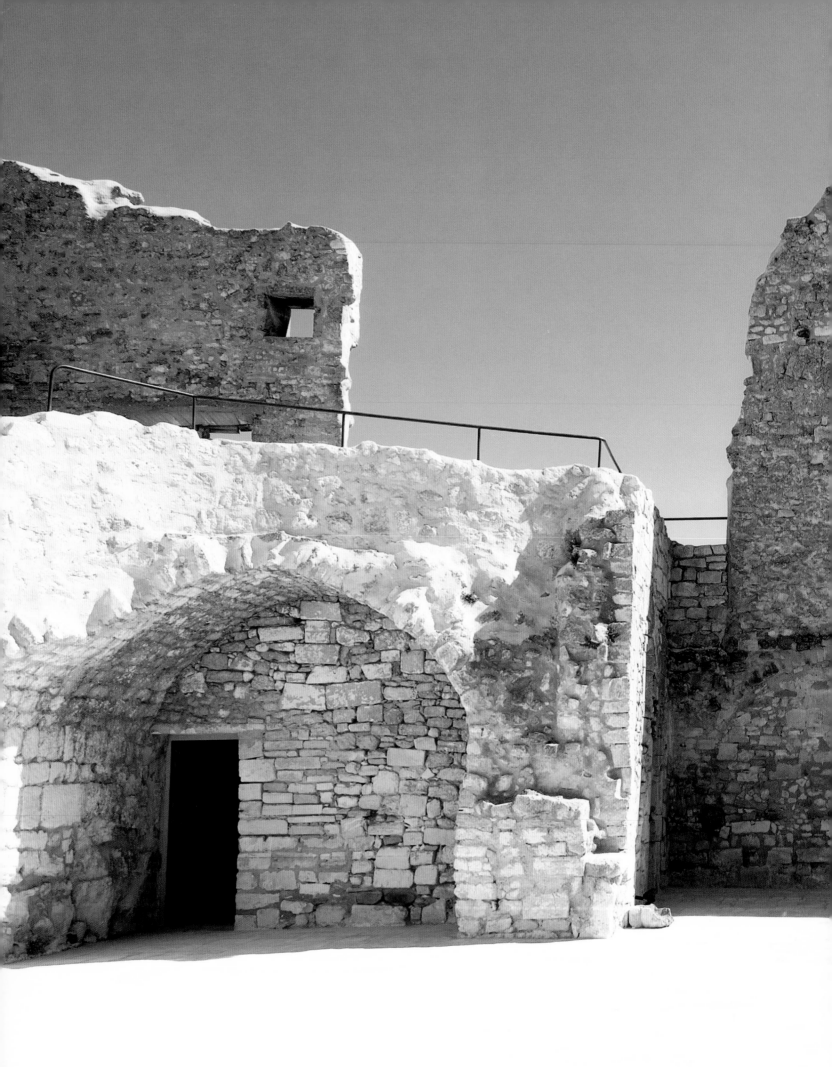

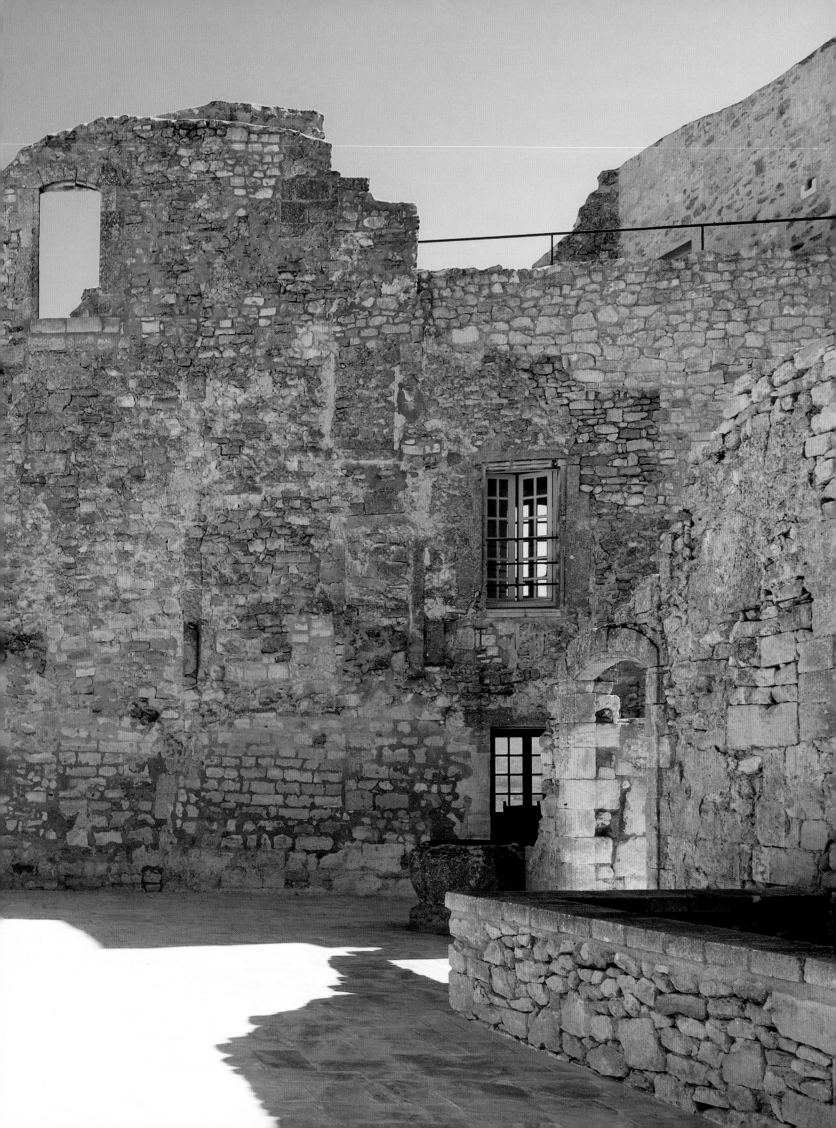

Cardin needed a builder. Crazy as it seemed, Cardin took on the challenge himself, employing, among others, a full-time staff of fifteen to implement construction projects. Of the former master of the house, Cardin remarked in his 2001 interview with *La Provence,* "He was an authentic character who challenged authority and lived a life of passion. He challenged and at the same time liberated moral standards. The château was in his day a place of debauchery, luxury, and shameless pleasures—but today, how childish all that seems! I will hold no orgies there, only libertine arts festivals."

Though the Vaucluse already had four theater festivals—Carpentras, Oppède, Orange, and of course Avignon—perhaps there was room for one more. As a designer, a businessman, and a patron of the arts, Cardin was excited by the prospect, and so was the municipality of Lacoste. Its principal heritage site was restored, and without public subsidy. Even if the commune could have afforded to acquire the château, the costs of the necessary repairs would have been untenable, and maintaining and running the venue equally prohibitive.

Cardin's plans were ambitious; it took several years to realize his dreams. Today Cardin's festival presents performances of music, opera, theater, and dance annually in the château's courtyard and in the nearby quarry, seeking primarily to attract audiences of tourists, who are numerous in summer. Lacoste's ancient stones guarantee the site's authenticity. In addition to the 1,200-seat quarry theater, there is an open-air theater that seats 1,000, and a third theater whose 1,600 square meters (over 17,000 square feet) can hold 800 seated or twice that many standing. Another outdoor venue with a platform stage accommodates 400, and two nearby theaters for experimental work 300 each. The spectators of the festival's numerous events

Above: Pierre-Alain Leleu in *D.-A.-F. Marquis de Sade,* a play by Leleu directed by Nicolas Briançon and presented at Ciné 13 Théâtre in 2013.

Opposite: Bass-baritone Nicolas Cavalier as the Marquis de Sade, at the Festival de Lacoste in 2005.

Following pages: Une évocation de Sade by Ève Ruggieri, with the orchestra Musique sur Mesure, conducted by Pierre-Michel Durand, in the château's main courtyard in 2005.

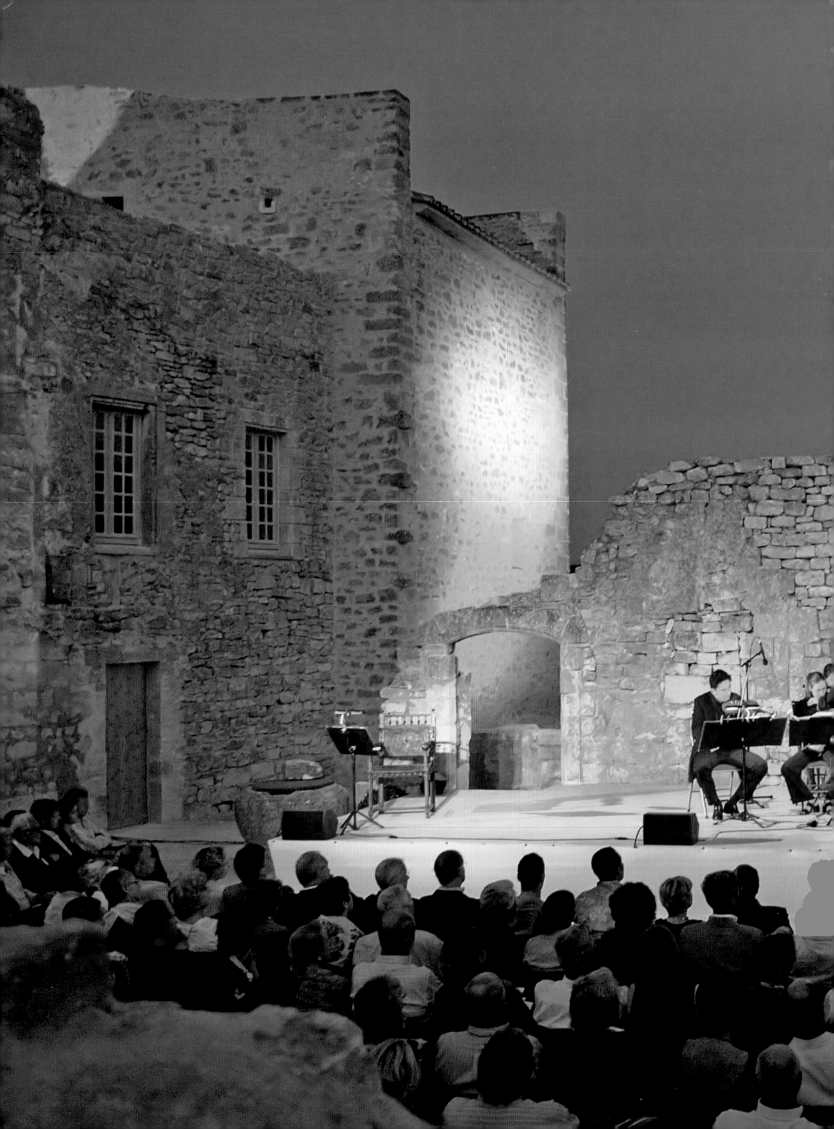

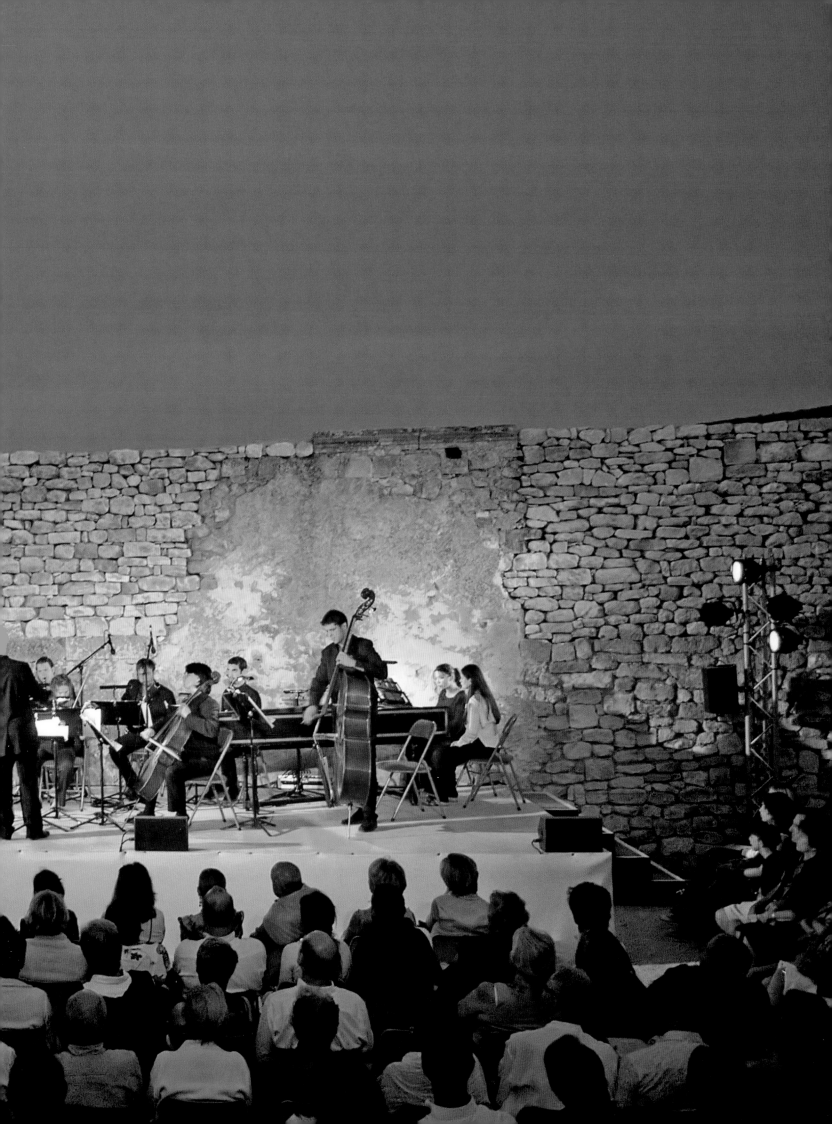

can pause in the village to eat at the Café de Sade. A favorite menu item: the Salade Justine.

Recently, the Monuments de France, a federal agency, has required Cardin to put an end to his restoration projects at the château. With his purchase of several houses in the village and investment in some restaurants, not a few fear that he might turn Lacoste into a sort of Saint-Tropez of the Luberon.

———◆———

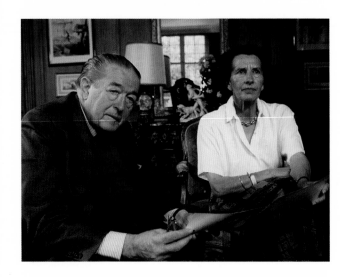

Below: The Comte de Sade (1922–2010) and the Comtesse de Sade (1926–2013) at their home, the Manoir des Hamardières, in Fondettes, Touraine.

Opposite: View of the Château de Lacoste during its restoration, in 2005.

Following pages: (left) Sculpture by a student at the Savannah College of Art and Design (SCAD), the first art school in Lacoste, founded by American painter Bernard Pfriem; *(right)* a wrought-iron gate at the château, with a view of the adjacent terraces.

At Lacoste, time and history have ruined Sade's castle beyond repair. Of his paintings and other artworks, his sumptuous furnishings and decors, nothing remains. In the Rue Basse, the façade of a house now owned by Cardin is adorned with two lovely doors, which formerly belonged to the château.

Not far from there, in the village cemetery, lies the Abbé de Sade, seigneur of Saumane. Donatien, however, has vanished into thin air; we can only assume that he would have liked to lie at rest in his home country of Provence, near his uncle, the one who opened "so many doors" for him, who gave him his start in life. As for the old fort, thanks to the passion of two men, it still seems to defy eternity from the top of its new stone walls.

1. André Bouër, "Un épisode de la Révolution à Lacoste."

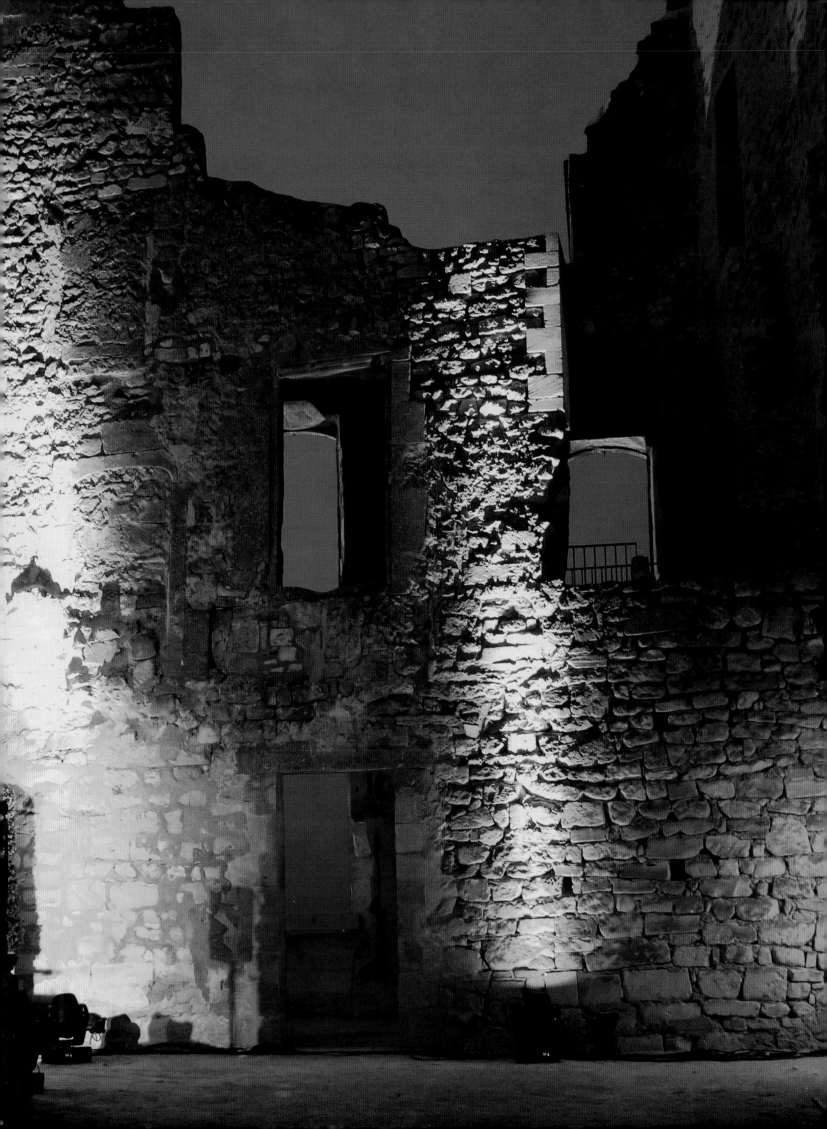

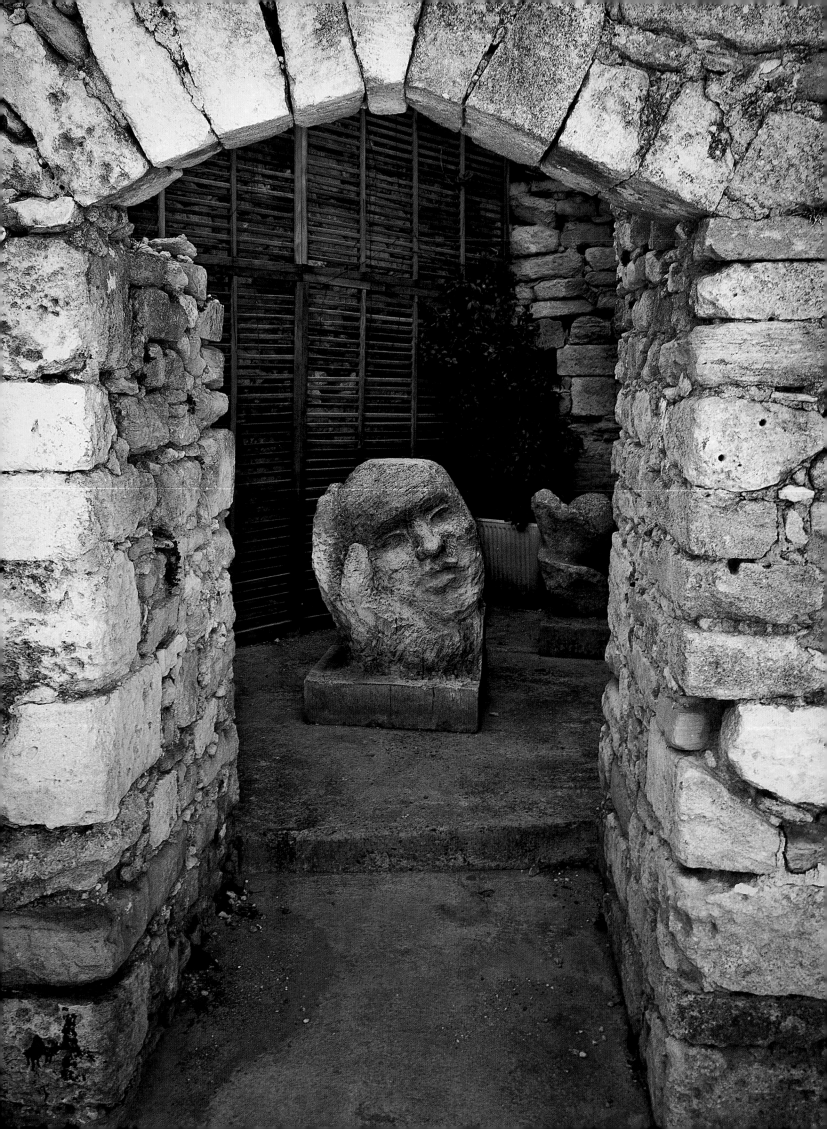

CONCLUSION

In 1990, Sade was published for the first time in the canonic Bibliothèque de la Pléiade, the most prestigious literary imprint in France. Without necessarily realizing it, literature, and perhaps society too, thereby turned a page, beginning a new chapter in literary history—if not history, period. After having been denounced, imprisoned, condemned to silence, deprived of his papers and his dreams, Sade was back. Once, the regimes of the monarchy, the Consulate, the Republic had all sought to silence him; in its early days, even the Fifth Republic still endeavored to do so. And yet, Sade had passed through the filter of time: There he was, speaking to us, praised, crowned with laurels. Ever since, theater, cinema, and literature have seized upon him: From Maurice Blanchot to Simone de Beauvoir to Michel Foucault, Sade has been read, studied, reevaluated. He is judged scandalous and/or brilliant. How he would have loved that!

Yet if sex was often the axis and motor of Sade's existence, we must realize that it was not his only motivation, and that in this Sade was no different from many other men, to this day. Sade is first and foremost a libertine. Yet he sought to discern the social and moral limits of his era in order to transgress, shatter, reformulate, and reconstruct them. Perpetually dissatisfied, he rejected the morality of his time in a quest to conceive of another morality, beneath the veneer of civilization. A little like Paul Valéry, Sade was fond of his own contradictions. For transgression to be possible, the forbidden must remain forbidden. In this sense, Sade was only libertine, not libertarian. In relying upon his own fantasies and those of other men, Sade compelled literature to tear off its mantle of hypocritical propriety, and lit the way for a great number of other

Above: A padlock dating from the Marquis's time in patinated bronze from the Château de Saumane.

Opposite: Imaginary portrait of the Marquis de Sade, 19th-century engraving.

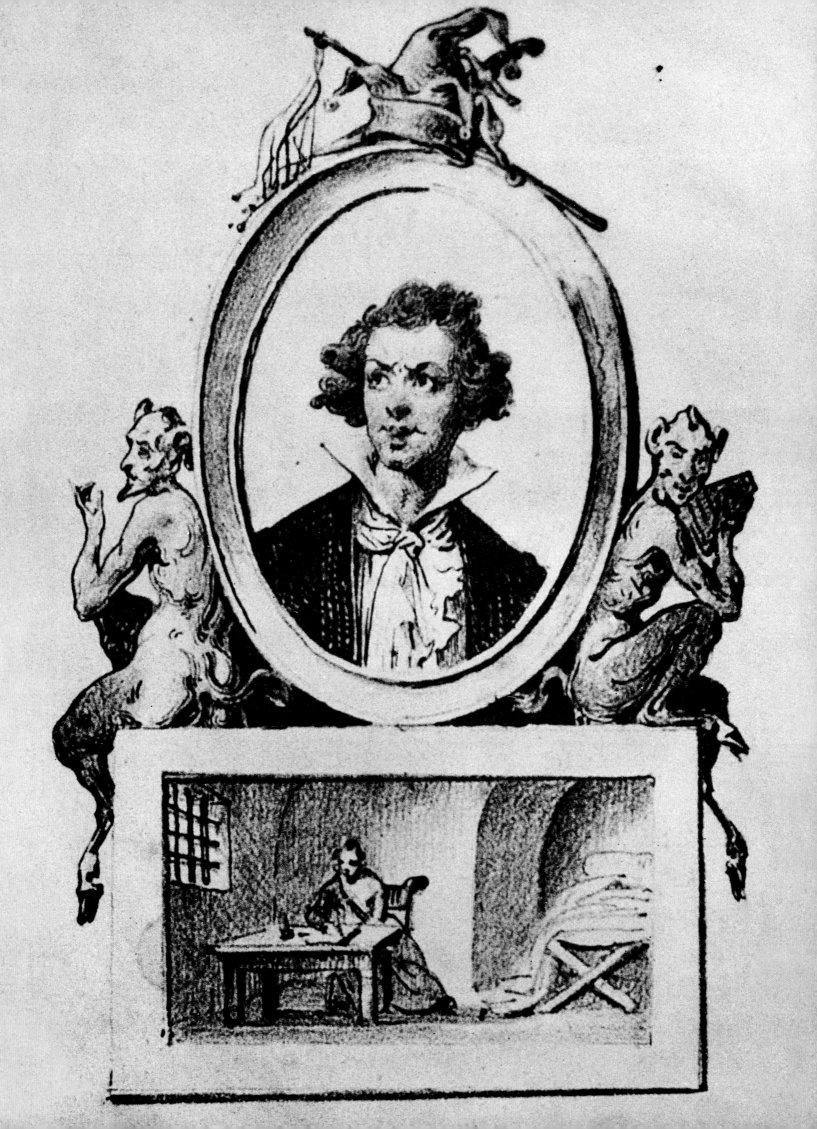

" Tolerance
is the virture
of the weak. "

Marianne et le Chevalier (Marianne and the Knight), color lithograph by Salvador Dalí
from the artist's 1969 portfolio *Le Marquis de Sade*.

9/7 1967

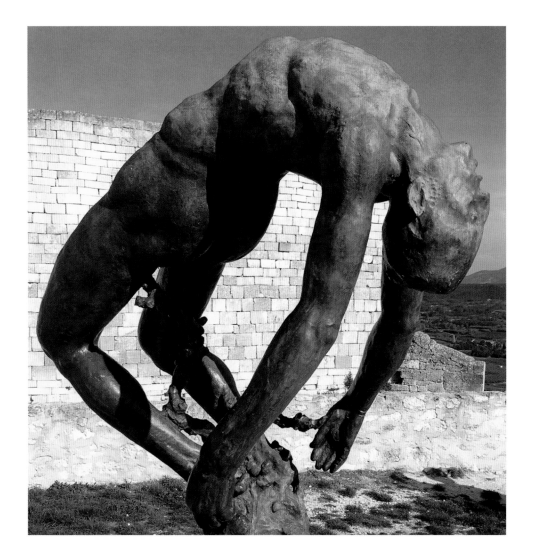

Opposite: Illustration by Georges Gorvel (1866–1938) depicting, at top, the Château de Lacoste, and in the other quadrants, three of the prisons in which Sade was incarcerated.

Left: L'arbre de la vie (The Tree of Life), bronze sculpture by Ettore Greco (2010), installed on the esplanade of the Château de Lacoste

writers. He not only transcended cultural taboos, he created new ones, outlining a new norm.

The reading public still believes that what Sade said and wrote, he thought should also be done. Yet, with Sade, we are dealing with a system of thought, not a prescription for action. He does not say, *I did this,* but rather, *One could do that*—a crucial nuance. The range of Sade's fantasy is sufficiently elaborate and perverse that it cannot help but touch us, move us, and also arouse us sensually.

In his pride and defiance of God, Sade might have been condemned to oblivion with the other fallen and rebel angels—yet he seems still to watch over us, perched high atop the mountain of his writings.

SADE'S WORKS ON STAGE AND SCREEN

It is interesting to discover how a given work, whether literary or "scandalous," has proven to be adaptable to the theater or cinema in ways that do justice to its author.

On film, worth noting are:

– *L'Âge d'or* (*The Golden Age*, 1930), directed by Luis Buñuel, in collaboration with Salvador Dalí

– *Hurlements en faveur de Sade* (*Howls for Sade*, 1952), an experimental film directed by Guy Debord (with voiceover only, no images)

– *Le Vice et la Vertu* (*Vice and Virtue*, 1963), directed by Roger Vadim, starring Annie Girardot and Catherine Deneuve

– *Marat-Sade* (*The Persecution and Assassination of Jean-Paul Marat as Performed by the Inmates of the Asylum of Charenton Under the Direction of the Marquis de Sade*), directed by Peter Brook (1967), with Patrick Magee (in the role of Sade) and Ian Richardson—a truly extraordinary film

– *La Voie lactée* (*The Milky Way*, 1969), directed by Luis Buñuel

– *Salò ou les 120 journées de Sodome* (*Salò, or The 120 Days of Sodom*, 1975), directed by Pier Paolo Pasolini, an exceptional film that explores arbitrariness and borrows from Dante the idea of a journey through the circles of Hell

– *Sade* (2000) directed by Benoît Jacquot, starring Daniel Auteuil.

Theater adaptations of Sade's works at a high level of artistic achievement:

– *Marat-Sade* (*Die Verfolgung und Ermordung Jean-Paul Marats dargestellt durch die Schauspielgruppe des Hospizes zu Charenton unter Anleitung des Herrn de Sade*), by Peter Weiss (1963); performed in English under the title listed above, famously directed by Peter Brook for the Royal Shakespeare Company in 1964

– *Madame de Sade,* by Yukio Mishima (1965)

– *Notre Sade* [Our Sade], by Michèle Fabien (1985)

– *Sade, concert d'enfers* [Sade, Concert of Hells], by Enzo Corman (1989)

– *D. A. F. marquis de Sade,* by Pierre-Alain Leleu (2013)

BIBLIOGRAPHY

Barbedette, Gilles. *L'invitation au mensonge: Essai sur le roman.* Paris: Gallimard (NRF Essais collection), 1989.

Barthes, Roland. *Sade, Fourier, Loyola.* Paris: Seuil (Point Essais collection), 1971.

Beauvoir, Simone de. *Faut-il brûler Sade?* Paris: Gallimard (Les Essais collection), 1972. Originally published in the journal *Les Temps Modernes,* edited by Jean-Paul Sartre, in December 1951 and January 1952.

Bouer, André. "Un épisode de la Révolution à Lacoste: Le pillage du château." *Mémoires de l'Académie de Vaucluse,* 6th series, vols 3 and 4 (Avignon, 1969–70).

Chessex, Jacques. *Le dernier crâne de M. de Sade.* Paris: Grasset et Fasquelle, 2010.

Béatrice Didier, ed., *Les crimes de l'amour.* Paris: Le Livre de Poche, 1972).

Fauville, Henri. *La Coste: Sade en Provence.* Saint-Rémy-de-Provence, France: Edisud, 1984.

Flake, Otto. *Le marquis de Sade.* Paris: Grasset, 1993.

Foucault, Michel. *Histoire de la sexualité.* 3 vols. Paris: Gallimard, 1976–84.

Hauc, Jean-Claude. *Les châteaux de Sade.* Paris: Éditions de Paris, 2012.

Jammes. Patrick. *Le brave marquis de Sade.* Paris: Dualpha, 2010.

Lambergeon, Solange. *Un amour de Sade: La Provence.* Le Pontet, France: Alain Barthelemy, 1990.

Lely, Gilbert. *Vie du marquis de Sade.* Paris: Mercure de France (Essais collection), 1989.

Leroy, Pierre, and Cécile Guilbert, eds. *Cinquante lettres du marquis de Sade à sa femme.* Paris: Flammarion, 2009.

Lever, Maurice. *Donatien Alfonse François, marquis de Sade.* Paris: Fayard, 1991.

Lever, Maurice. *Je jure au marquis de Sade, mon amant, de n'être jamais qu'à lui...* Paris: Fayard, 2006.

Mousnier, Roland, and Ernest Labrousse. *Histoires générales des civilisations 5: Le XVIIIe siècle.* Paris: Éditions des Presses Universitaires (PUF) de France, 1967.

Ost, François. *Sade et la loi.* Paris: Odile Jacob, 2005.

ACKNOWLEDGMENTS

This book is a homage to all those who have led me to love Sade and Lacoste.

For their generous help, I wish to thank Rose de Sade, Pierre Cardin, Pierre Leroy, Hugues de Sade, Elzéar de Sade, Thibault de Sade, Enguerrand de Sade, Marie-Aigline Huon de Kermadec, Marie-Cécile de Sade, Bruno de Lesquen, Marie Aline Marcenat, Patrick Sanois, Charles Méla, Michèle Brun, Frédéric Lhermie, Bruno Gerthoux, Marido Liègeois, Jérôme Faggiano, Fabienne Fillioux, Hélène Soalhat, Anne Vegnaduzzo, Éric Gillard, Christian Dubost, Delphine Lebourgeois, Sigrid Colomyès, Crystal Woodward, Paul-Louis Ferrandez, Thierry Burban, Louis-Philippe Breydel, Guillaume Soularue, Ève Ruggiéri, Daniel Adel, Guy Hervais, Nick Rowell, Gian Paolo Giannotti, Antonio Crepax, Roberto di Costanzo, Alexandra Brière, Fabien Dumas, Anne-Marie Lemer, Anne Lamort, and Daniel Vial.

I wish to express my special appreciation to publishers and friends Martine and Prosper Assouline, as well as to the entire team at Éditions Assouline: Charles Fritscher, Valérie Tougard, and Cécile Bouvet (Paris); and Cécilia Maurin and Amy Slingerland (New York).

Jean-Pascal Hesse

Assouline would like to thank Gilles Bensimon.

CREDITS